Dear Church

To my late husband

*Carl G. France, my partner and helpmate in ministry,
who believed for the fifty-one years we served together
that nothing was impossible.
There were no barriers that could not be removed
or no tasks too difficult
as long as we continued to believe that we could
do all things through Christ who strengthened us.*

Dear Church

Intimate Letters from Women in Ministry

Dorothy D. France, ED.

CHALICE PRESS

ST. LOUIS, MISSOURI

Copyright © 2010 by Dorothy D. France.

All rights reserved. For permission to reuse content, please contact Copyright Clearance Center, 222 Rosewood Drive, Danvers, MA 01923, (978) 750-8400, www.copyright.com.

Bible quotations, unless otherwise noted, are from the *New Revised Standard Version Bible,* copyright 1989, Division of Christian Education of the National Council of the Churches of Christ in the United States of America. Used by permission. All rights reserved.

Scripture quotations marked (NIV) are taken from the HOLY BIBLE, NEW INTERNATIONAL VERSION®. NIV®. Copyright © 1973, 1978, 1984 by International Bible Society. Used by permission of Zondervan Publishing House. All rights reserved.

Scripture quotations marked (NLT) are taken from the *Holy Bible,* New Living Translation, copyright © 1996. Used by permission of Tyndale House Publishers, Inc., Wheaton, Illinois 60189, U.S.A. All rights reserved.

Cover art: Lushpix/Unlisted Images, Inc.
Cover and interior design: Elizabeth Wright

Visit Chalice Press on the World Wide Web at
www.chalicepress.com

10 9 8 7 6 5 4 3 2 1 10 11 12 13 14 15

EPUB: 978-08272-06427 • EPDF: 978-08272-06434

Library of Congress Cataloging-in-Publication Data

Dear Church : intimate letters from women in ministry / [edited by] Dorothy D. France.
 p. cm.
 ISBN 978-0-8272-0639-7
 1. Women clergy–United States. 2. Christian Churches (Disciples of Christ)–Clergy. I. France, Dorothy D. II. Title.

BX7326.D43 2010
286.6'73082–dc22

2009047125

Printed in the United States of America

Contents

Acknowledgments ... vii
Preface ... viii

Introductory Letters
LETTER 1: To My Second Home–*Sharon E. Watkins* ... 1
LETTER 2: Setting the Pace–*Dorothy D. France* ... 6

Local Pastors and Co-Pastors
LETTER 3: The Mothering Church–*Deborah L. Carlton* ... 16
LETTER 4: Making Weak Points Strengths–*Rebecca Heller* ... 19
LETTER 5: Tears but No Regrets–*Janet Hellner-Burris* ... 22
LETTER 6: Always the Preacher–*Janet A. Long* ... 27
LETTER 7: In Joy and Pain–*Linda C. Parker* ... 31
LETTER 8: Becoming the Norm–*Gina T. Rhea* ... 35
LETTER 9: God Tapped My Shoulder–*Julie Roberts-Fronk* ... 39
LETTER 10: Trusting God's Faithfulness–*Jane M. Stout* ... 44
LETTER 11: My Heart's True Home–*Cynthia K. Stratton* ... 49
Letter 12: Funny God-Things–*Ginger Jarman* ... 54

Associates
LETTER 13: Ministry Saved My Life–*Elaine W. Austin* ... 58
LETTER 14: Busy Enough to Pray–*Mary Jo Bray* ... 62
LETTER 15: Finding My Own Voice–*Lee Hull Moses* ... 67

Regional Staff
LETTER 16: God Is Able–*LaTaunya M. Bynum* ... 71
LETTER 17: Finding the Blind Spots–*Cathy Myers Wirt* ... 76

General Staff

LETTER 18: Consider Your Heart–*Kaye Edwards* 81

LETTER 19: The Daily Call–*Amy Gopp* 85

LETTER 20: Listen! God Is Speaking–*Julia Brown Karimu* 91

LETTER 21: Gifted to Serve–*Ellen L. Mitchell* 94

LETTER 22: Increasing Our Diversity–*Jennifer L. Riggs* 96

LETTER 23: Never Heard a "Call"–*Marianne Scott* 101

Academic Staff and Students

LETTER 24: Waiting for a New Call–*Sarah Webb* 104

LETTER 25: Natural Thing to Do–*Lisa Davison* 109

LETTER 26: Called to Do the Impossible–*Carolyn R. Higginbotham* 114

LETTER 27: From Broken Child to Champion
Tamara Nichols Rodenberg 119

LETTER 28: Gratitude for Grace–*Sarah Woodford* 124

Publisher and Editor and Retired

LETTER 29: Call as a Journey–*Verity T. Jones* 127

LETTER 30: Continuing the Journey–*Narka K. Ryan* 132

LETTER 31: Missionary Ignorance–*Virginia M. Taylor* 136

Mothers/Daughters

LETTER 32: Called in a Faithful Community–*Cynthia W. Twedell* 140

LETTER 33: The Supportive Church–*Jackie Twedell* 144

LETTER 34: Follow Your Heart–*Deborah M. Wray* 146

LETTER 35: The Call Came Early–*Tabitha Knerr* 149

EPILOGUE: Ten Commandments for Clergywomen–*Dorothy France* 152

Acknowledgments

My deep gratitude is extended to R. Jeanne Cobb, Archivist and Coordinator of Special Collections (retired), Bethany College, for her willingness to share her boundless knowledge of all things "Disciple." Her immediate recall and response is inspiring. I remain grateful to Judy Pyle, Executive Assistant, Center for Institutional Advancement, Bethany College, who has graciously taken the time to answer questions, make contacts, offer suggestions, and let me invade the hospitality of her home. Thanks to Peter Morgan for his guidance and support; he always has more facts and knowledge than one can imagine. To the staff at the Pension Fund and the Historical Society, I am appreciative of your willingness to listen and answer one more question no matter how unimportant it may have seemed. To members of local congregations who inspired me by your feedback and positive memories of leadership provided by women clergy and to all who have shared your letters, I say thank you. I owe a debt of gratitude to those at Christian Board of Publication/Chalice Press, both past and present, who gave me my first opportunity to write and who have continued to provide encouragement, allowing me to put my thoughts on paper for these past fifty-four years.

Preface

I checked in at the General Assembly in Charlotte, N.C. (2003), received my name tag, purchased a cup of coffee, and proceeded to a nearby table to wait for a friend. Across the table sat a young African American woman enjoying her salad. We acknowledged each other's presence and let silence ensue. Then she noticed my name tag.

"Are you a minister?" she asked.

"Yes," I replied. "I'm now retired."

"How did you survive so long? This salad can wait. We need to talk." She pushed the salad to one side. This was not the first time I had been asked that question nor will it be the last. We talked and shared concerns and joys for quite a while. A recent seminary graduate, she shared her anxiety about when and where she would be called to serve.

A day or so later we met in a hallway. She ran to me saying, "I've been looking for you. I've been asked to sing for the service. I'm so nervous. Will you pray with me?" We found an out-of-the-way spot, held hands, and prayed. During worship as she sang, "In this very room there's quite enough love for the all the world," I truly felt the presence of God and knew we had been brought together for a reason. She had the most beautiful voice I have ever heard.

During my meeting with Rev. Shauna McGhee, God planted the seed that led me to pursue the book you now hold in your hand. On these pages, thirty-five Disciple clergywomen share their heart-rending and inspiring stories of love, pain, disappointment, faith, and hope for the future—all part of their journey—as they shared the good news in local churches as regional and general staff, as publisher and editor, in academic settings, and on the mission field.

My prayer is that those of you who read their letters will find words of encouragement and promise whether you are clergy, a member of a congregation, a seminary student, or just beginning to hear God's call to ministry.

Dorothy D. France

Dear Church
Introductory Letters

LETTER 1: *Sharon E. Watkins*
General Minister and President
Indianapolis

To My Second Home

Dear Church,

I suppose I am in ministry now because you have always been a second home to me. As a child, I went to be with you every Sunday without fail—and often in between—for pitch-in dinners, special events, and eventually youth group. You showed me a bigger world than I knew in my Indianapolis neighborhood.

So many of those church dinners honored missionaries home on furlough. I remember the mysterious "dot" on the forehead of the woman from India, the dances from the Philippines, the picture of our Living Link Missionary on the wall of the Cornerstone classroom, the model of the Palestinian house in my own second grade class. I remember after one church dinner, when I was about ten years old, having just listened to a missionary speak, hearing a voice in my head. It was as clear as if the words had been said out loud: "You will be a missionary." It startled and scared me. I pushed the thought to the back of my mind—even forgot about it until later.

You taught me to think.

I remember the arguments among friends in Church School as we discussed the issues of that time from a faith perspective—civil rights,

Vietnam, the first Earth Day. Any topic was fair game. I remember those good laymen who were willing—seemed even to enjoy—being with us through middle school and high school, guiding us, as we sought to find the language of faith to clarify our convictions. I remember the more intense debates at assemblies where we struggled as one church to find one voice—even as we knew that, as Disciples, we're not likely to find a single voice on most issues.

You nurtured me.

I remember my confession of faith—when my minister, Dr. Lowell C. Bryant, looked into my eyes and told me, "Jesus said when we confess him on earth before people, he will confess us before God in heaven. Sharon, I think we know what God is doing right now!" It moved me. The memory brings tears to this day—the sense of being part of something so big, of Almighty God paying such close attention to me.

You nurtured me in so many other ways. You learned my name, asked after me, noticed my accomplishments, big and small. You fostered my talents, helping me to sing, giving me opportunities to lead. You provided an opportunity for youth to gather—to learn, to play, to serve. You helped me learn to worship God.

You challenged me—not always in a good way.

I remember when my minister strode into a youth service in full swing, a regional youth service hosted by our congregation. But the band was too loud, the worship too exuberant, the era too recent for anyone of his generation to understand—and he stopped it. I remember the embarrassment, the hurt, the anger.

I remember, as Christian Youth Fellowship president, seeing adults behave at church board meetings in ways we wouldn't have been allowed to in CYF.

I remember the confusion of learning that sometimes the differences of opinion cannot be resolved and that separation results.

You challenged me in good ways.

You challenged me by pushing me—and supporting me—to lead when I didn't know I was ready. I remember learning things that were difficult, that racism is a challenge bigger than my feelings of personal prejudice or my ability to overcome that prejudice.

You taught me to pray at Camp Barbee, in northern Indiana, during the silence of morning watch, looking out over the green fields with golden hay bales under the blue sky, feeling the presence and majesty of God.

Perhaps I should not be surprised that when I had graduated from Butler University in Indianapolis—had my economics and French degree but no

desire to go into business, banking, or teaching—you gave me a job. You sent me to Kinshasa, the capital of the African country then known as Zaire, as a short-term missionary to work in an adult literacy program—my first experience as an adult. I learned so much about you—how very big is the Body of Christ, how diverse, and how precious is the part of the Body that is us, Disciples, with our longing for unity among Christians, for wholeness within the entire family of God. I learned so very much about me—that I could be competent, that I had learned a few useful things in college after all, that my faith would support me, and that I still had so much more to learn about both life and faithfulness.

It wasn't until my return from Zaire (now known as the Democratic Republic of Congo), that I began—finally—to hear your call. It came first through the people who worked around me in the Missions Building. "Your future is with the church, you know," they said. Then one day, Dr. Robert A. Thomas, president of the Division of Overseas Ministries, said to me, "Sharon, go to seminary. Everyone knows you will someday. Do it now and get it over with!"

I still thought the goal was to clarify my own faith story while training as a social worker. So I went to Yale Divinity School, a seminary that offered a dual degree: Master of Divinity and Master of Social Work. At Yale, I met Rick Lowery, a second-year student, who was just moving into the Disciples fold from the Churches of Christ, the tradition of his upbringing. We married the next summer.

Your call came more insistently still, through the voice of my new husband—"You've got to try ministry, Honey—parish ministry. Take a field placement in a congregation." At Rick's continued urging, I did take that field placement in a local congregation. At the Spring Glen Church (United Church of Christ) in Hamden, Connecticut, I knew I'd come home.

With "home" came clearly the call to ministry.

Of course, as in any home, you don't always make it easy. In seminary, I heard the stories of "the walking wounded," as Professor Letty Russell called them—the women whose calls you'd rejected or challenged too severely. We learned their stories even as we learned to be grateful for their courage, for the path they had cleared, a path that we could now walk down with greater ease.

I found that being a woman in ministry worked just fine—if I could only get in the door. Sometimes that door slammed shut in my face, but when it opened (often with the help of a strategic-thinking regional minister such as Howard Goodrich in Indiana), the journey could be amazing.

I had a baby in each of my first two congregations served—Bethany, arriving just before Christmas while I was still serving at Spring Glen Church, and Christopher just before Palm Sunday while at Boone Grove

Christian Church in Boone Grove, Indiana. What a joy that was both times! You embraced our children as your own and loved them.

You embraced me, pregnant, post-partum, all.

You served up the normal challenges, of course; congregations with their own life stories, their conflicts, their moments of glory and moments of disastrous short-sightedness. Over the years, you showed me your many facets–through committee work in both the Indiana and Oklahoma regions (stewardship interpretation, commission on ministry, regional assembly worship planning, regional minister search committee, and eventually Moderator of the Oklahoma region.) You introduced me to the general expression of our church through participation on the General Nomination Committee, the General Board, and the Administrative Committee. You helped me understand our ecumenical partnerships as I served on the Ecumenical Partnership Committee with the United Church of Christ, the Stone-Campbell Dialogue, the National Council of Churches Governing Board and Executive Committee, and Presidential Panel.

You called me to work in higher education.

You called me to work as director of church relations for Phillips University, as director of student services at Phillips Theological Seminary, as adjunct professor in the areas of worship, spirituality, and practical ministry–again learning more of you as I followed my husband in his calling to teach. Our early marriage pact was to take turns in our respective careers. While he was still in graduate school, I would take my first solo pastorate. When he had his Ph.D. and a call to a tenure track position, I would seek a call near to where his job had taken us. Such joy overflowed when eventually we both had "our turn" at the same time–Rick as professor of Hebrew Bible at Phillips in Tulsa and me as pastor of Disciples Christian Church in Bartlesville, Oklahoma. Both of us were doing what we felt called to do–at the same time, living in the same house, and Rick's forty-mile, open country commute seeming as nothing.

Now this lifetime of exploring and learning your many parts has led me back to Indianapolis, back to the geographical home of my childhood. Here you have called me to serve God in the most challenging and fulfilling ministry yet –as General Minister and President. All I have learned and experienced in congregational life and regional, general, and ecumenical work serves me well as I face new challenges every day, as I move into a volume and range of work I could never even have imagined before this. I marvel at the journey that has led to this place, and I give thanks for all the people who have helped me along the way. Even more, I pray I will be open to God's guiding and that I will know to join hands with all of those who are called to be partners on this journey together.

I know, Church, that you are, even now, calling others, women and men, young and old, to serve God by serving through you. I know that some of them are covering their ears to your calling as I once did, that others are running in the opposite way, that still others are responding and getting mixed signals as the challenges become larger than the fulfillment.

I can only hope, dear Church, you will nurture, challenge and open up the world to these others as you have done with me, so that their rich talents will be available to you—to us. I pray that in you many will find a home, a place of hope and possibility—as we seek to be faithful to God's calling to be Disciples of Christ, a movement for wholeness in a fragmented world.

Sharon

LETTER 2: *Dorothy D. France*
Editor
Retired Director of Refugee Resettlement (CWS),
Virginia Council

Setting the Pace

Dear Church,

Ministry has been a long, exciting and fulfilling journey.

On June 11, 2008, at the age of eighty-one, I traveled back to Bethany College, Bethany, West Virginia, so I could stand in front of the Old Meeting House (designed by Alexander Campbell and constructed in 1852) and reflect on my journey. My late husband, Carl, and I were ordained there fifty-eight years earlier (June 11, 1950) at 7 a.m. on graduation morning along with fellow students Herbert Lambert, Billie Joe Hannon, and Austin Coe. My dad, Arthur R. Daniel, participated in the "laying on of hands" along with President W.H. Cramblet, many Bethany professors, and elders of the Bethany Church. We believe I was the first woman to be ordained in the Meeting House.

That place–that space–is where we were taught, shown by example, nurtured, encouraged, and made to believe that we could do and be anything we wanted to do and be. There I first learned that *"all life is connected"* and confirmed my call to ministry. I have always tried to live up to the honor Bethany placed upon me on May 2, 1992, when my daughter, Gail Frankle, class of 1977, presented me the Outstanding Achievement in Ministry Award.

You called me to be ecumenical.

I grew up in the small town of Blackstone, Virginia; Carl in the even smaller town of West Middletown, Pennsylvania. We were nurtured in the church. In Blackstone Christian, I was led to be ecumenical long before I ever heard the word, much less knew how to spell or pronounce it. I suppose in the 1940s and '50s, all small towns were church towns. Life centered around the church. Everything was closed on Sunday, especially the local theater. A 1938 newspaper article titled "Pioneer Club Organized" reported that junior age boys and girls had organized a Pioneer group with programs scheduled for Sunday afternoons. Dr. Dennis, pastor of the Presbyterian Church, was made sponsor. Miss Elizabeth Holden and

Miss Dorothy Daniel (me) were named pianists. I was only twelve, but Dr. Dennis believed I could do it! When we became teenagers, the "in-thing" to do on New Year's Eve was to attend the joint Communion Service at the Episcopal Church. There I learned to respect and appreciate the way others observed the Lord's Supper.

You called me to be sensitive to the racial divide.

During my high school years, I first confronted the racial divide that existed in the 1940s. World War II had begun, and Camp Pickett was built just outside of town. Life changed! While the war was being waged in Europe, savings bond and stamp drives were being promoted. I was aware of this because my Dad was behind the action. Several of us were recruited to make posters and deliver them to the schools. All except the "colored" high school were nearby. We walked the half mile to the "other" school. Once inside, we went down the hall to the principal's office. We hadn't gone far before we came upon a section blocked off with chairs. As we came closer, we saw that the chairs were there to make sure that no one fell through the hole in the floor.

I remember telling Dad that evening what I had seen ... not just the hole in the floor, but walls badly in need of painting as well as broken windows. I asked why they hadn't been fixed. Couldn't he do something since he was on the town council? He shared his concern but told me that I would learn as I got older that some things I could not do alone. It would take time. Those words have echoed in my mind during my journey in ministry.

You introduced me to my life partner.

I planned to attend college, but my mother was uncomfortable having another child leave home. I obtained a position at Camp Pickett with the Army Directory Service, a part of the United States Postal System. Along about the same time, a young sergeant, Carl G. France, was invited to speak for a Sunday evening service at the Christian Church. It was my turn to play the piano. We sat on the front pew and picked out the hymns. That evening I gave thanks for the times I had played at the Presbyterian Church. At least I knew how to play hymns.

The rest is history. Carl was shipped off to serve in Europe. I even stamped his APO card. When he returned, we enrolled in Bethany College, married on August 6, 1946, and entered Bethany in September. What a marvelous journey! He was my companion and rock as we ministered together, each with our own areas of expertise and calling, for more than fifty-one years.

To be sure, we encountered bumps in the road but none that we couldn't find a way over or around. When the school year began, the six government army barracks, one of which was to house six married couples and the other five single men, were not completed. We rented the parlor in the house next

to Chambers Store, a landmark even to this day. A leather sofa served as the bed, with one side held up by a footlocker where our clothes were stored. We finally moved into our apartment on campus lavishly furnished with an army bunk bed and a small chest for the combination living/bedroom, a large army table and a six-foot ice box for the kitchen, and two small desks that fit snugly in the closet. In the winter, we placed pans of water on the front stoop to freeze. The next morning we had ice for the "box." I wouldn't have traded it for a mansion.

My sophomore year, one of my religion professors suggested I drop out of college and work. He thought carrying a full course and working as assistant to Dr. Paustian, head of the sociology department, was too much. "Besides," he said," *the minister's wife doesn't need a college education."* Dr. Dwight Stevenson, my counselor, nipped that thought in the bud. I remain grateful for his advice.

We returned to Blackstone each summer. I worked as director of recreation at the Memorial Center teaching crafts and ballroom dancing to teenagers and servicemen. My qualifications: I took dancing lessons as a child and received instruction to teach during my volunteer days with the U.S.O. I even took tap lessons at Bethany! I'll have to admit that when I was young, my dream was to be a dancing instructor. Some used to tease me saying I did my "sinning" before I was ordained. At youth camps, dancing was called "folk games" to satisfy some of the church folks.

Yes, at Bethany *I learned that all life is connected, even dancing and ministry*! When visiting water and gardening projects in Haiti for Communities Responding to Overcome Poverty (CROP), Church World Service's hunger program, in 1977, I found myself singing and dancing with the children who greeted us. Nothing shows someone you care more than interacting with them.

You endowed me with a sense of humor.

I was fulfilling my student teaching requirement at Wellsburg High School. One class included mostly football players. I had just begun speaking when one of the young "gentlemen" wadded up some paper and tossed it across the room hoping to hit the trash can. My comment was: "I hope you are not on the basketball team, because if you are we're going to have a tough year." As I continued, I saw Dr. Eliassen, my supervisor, sitting on the back row. Surely, I was in trouble. The next day he said, "I enjoyed your class. Your sense of humor will be a great asset in the years to come. You took control of that class in a hurry."

Years later, I was asked to supply a couple of Sundays for a church on the verge of closing. The first Sunday, the lead elder greeted me as I left the pulpit with "You are the first woman ever to stand behind *that* pulpit!"

I remembered Dr. Eliassen's comment about a sense of humor. So I said, "Let's check things out." We checked the floor and the ceiling. They were

both okay. We walked over to the windows. "The stained glass windows all seem to be okay."

He laughed and said, "I'm sorry. I guess that was an unkind thing to say." The last I heard the church was still open and a woman was behind the pulpit! A sense of humor does come in handy.

You taught me to be patient.

Carl was accepted at Duke Divinity School in Durham, North Carolina. Women weren't eligible. I compensated by taking college classes and attending workshops and seminars related to my employment. In the 1970s, I considered seminary but was advised not to go that route; my years of experiences here and in other parts of the world were of far more value.

Word spread that we were interested in serving in Virginia. Carl received a call to Crewe Christian in Crewe, Virginia. He would be at Duke from Tuesday through Friday. I would carry on the church duties during that time. Once again, I found that life was connected. The superintendent of schools, who happened to have been my high school principal, offered me a position. This began a pattern that blessed me all my life. I never once applied for a job. They all seemed to be there wherever we were.

We moved to Crewe and settled into a rented house while a parsonage was being built. A neighbor came to welcome us. I can still see the look on her face when I answered the door. After saying hello, she sighed and said, "Oh, I'm so relieved. We didn't know what to expect when we read in the newspaper that the new minister and his wife were both ministers!" She was relieved that I wasn't wearing a long print dress, black "stockings" and oxfords, and that my hair wasn't pulled back in a bun. "You look just like the rest of us," she said. To my knowledge, in the early 1950s, I was the only ordained clergywoman (along with a woman licensed in the Methodist church) serving in the Commonwealth of Virginia. I officiated at my first wedding in 1950, and Carl sang. The church was packed. I think it was because no one had attended a wedding in which a woman performed the ceremony.

I taught school and performed pastoral duties while Carl was at Duke. I spoke to Dr. Allen Stanger's classes of ministerial students at Lynchburg College on "The Role of the Minister's Wife" but never on the role of the minister. I fulfilled every duty expected of a minister but will never know whether I could have been called as *"the pastor"* in the 1950s.

You called me to write and inspire others.

At the age of twenty-seven, I was selected to represent the Virginia region at a Laboratory Training School for Adult Workers of Youth at Texas Christian University in Fort Worth, Texas. Christian Board was preparing new material for intermediate age youth. Individuals were invited to review the materials. Each of us was given a lesson to teach. The one I received

was more than a little dull. I obtained material from a nearby travel agent and reworked the lesson. After my session, one of my classmates asked if we could sit together for lunch. I was surprised to learn that the gentleman, Sherman Hanson, wasn't just an attendee from St. Louis. He was the editor of Bethany Press! I owe him a debt of gratitude for giving me—no, pushing me—into writing! He gave me my first writing assignment in 1954. It was an article titled, "Youth on the Telephone," for *Vision*, a youth magazine.

In 1961, I was offered a scholarship to attend an editor's and writer's conference at the Green Lake Conference Center in Green Lake, Wisconsin. I hesitated because Carl was now on the regional staff in Virginia, scheduled to attend a Men's Conference in Salt Lake City, and would not be able to oversee our daughter Gail's care. Christian Board assured me that would not be a problem. She could be a part of the lab school for teachers. We took a month, combining work and pleasure, and drove to Utah and then Green Lake. Carl dropped us off and returned home. Gail and I had a marvelous train ride home.

I had the privilege of revisiting Green Lake in 2001. My dear church, you were there to welcome and remind me of my journey. I visited the "Prayer Tower" to offer prayers of thanksgiving for Sherman Hanson and the Christian Board staff who had placed confidence in me and continued to give me the opportunity to write. I was able to use my writing skills wherever you have called me, including co-editing a manual on *Grouping in Reading* while teaching and the manual, *Welcome to the United States,* translated in numerous languages, for use by volunteer agencies when resettling refugees.

You called me to be international.

As was the custom in the '50s, I went where Carl was called. We moved to Richmond, Virginia, when he accepted a call to pastor Lakeside Christian, a new congregation. We had no building and no parsonage. I was "very much" pregnant. Gail was born shortly after the move. Naturally, she chose Sunday as the time when Mom should go to the hospital.

Several years later, I was invited to speak for a women's luncheon at First English Lutheran Church. During lunch, I learned that the program leader had saved a newspaper article (no picture) from a year earlier and invited me to speak based on the article. What faith! I met Dorothy Eckert, the minister's wife. She asked me to speak for World Day of Prayer. I was introduced to what was then United Church Women. Although I didn't realize it at the time, this was one of the "defining moments" in my life. I was introduced to issues of international and cultural concern, racial inequality, poverty, domestic and world hunger—all issues that eventually became front and center in my life and ministry. It reaffirmed my ecumenical beginnings as a child.

To mark the twentieth observance of World Community Day (1964), United Church Women sponsored a program at the new Church Center for the United Nations in New York City. The purpose was to train selected women leaders for effective peace action, and 160 selected women leaders were called together for intensive in-service training in international affairs. I was privileged to represent Virginia women. As I entered the conference room, the words on the banner displayed in front of the room struck me: "*Not to decide is to decide!*" What powerful words! I returned to Virginia committed to world issues. I led numerous adult seminars to the U.N. in cooperation with the Virginia Council of Churches.

In the spring of 1966, when I was almost forty, I was the program chairman (that's what women were called then) for the Church Women United Assembly. Dr. Margaret Shannon, a Presbyterian, had just become executive director. She chose the Virginia Assembly for her first official appearance. I guess I was too young to realize that I should be frightened and nervous about having a new executive present. I went about doing the best I could to make the experience meaningful.

Early that fall a message came over the intercom to my classroom saying that I needed to return a call to New York. It was Margaret Shannon inviting me to be a part of United Church Women's first Christian Causeway to Africa. I still remember her reply when I told her I was not qualified. "Let me decide your qualifications," she said. "Anyone who can stand up in a green wool suit and preside over a Communion service for Protestant, Orthodox, and Catholic women can relate to women anywhere!" Being a "Disciple," I assumed that everyone was welcome at the table. After much "soul searching," I knew I wasn't ready and used the fact that I had signed a teaching contract as my way out.

I did not participate in 1966 but agreed to go to Nigeria for a follow-up teaching assignment in 1967. Dr. Louise Clark, a physician friend, would go with me. We would be a teaching, preaching, and healing team. As preparation for the trip, in July of 1967 we attended an International Consultation at Anderson College in Anderson, Indiana, along with women from forty-two countries. But again, it wasn't to be! The Biafran War broke out just before our time of departure. The center in Enugu where we were to work was destroyed.

In 1968, Margaret called again, asking me to spend two and a half months in Africa with major emphasis in South Africa. I kept asking God, "Why me?" Carl assured me that God would not have called me three years in a row if I wasn't supposed to go. I listened and made the marvelous journey that truly changed the direction of my life. When we left the terminal in New York to board the plane to Monrovia, Liberia, I received an envelope with instructions not to open it until we were out over the Atlantic. When I opened it, I found these words: "God's Speed

and God's Speech (Margaret)." In that moment, I released Carl and Gail into God's hands.

In South Africa, we taught classes for the wives of the African Independent Ministers Association. The meetings were held in Soweto. Each day we linked arms as we marched in the middle of the road and sang our way to lunch. When Dr. Beyers Naude, our host and the director of the Christian Institute, picked us up to take us to the home of Olive and Percy Webber in Johannesburg, he told us that he heard we marched and sang on the way to lunch. He asked if we knew what we were singing. We didn't have a clue. With a smile on his face, he said: "You were singing 'We Shall Overcome,' which is banned in South Africa." Then he added, "If the security police had been around, you would have been picked up and given twenty-four hours to leave the country. Don't let the fear of being stopped keep you from sharing with the women. Keep on being who you are. They desperately need you to give them hope!"

Just prior to my departure for Africa, Carl accepted a call as minister of First Christian Church, Pulaski, Virginia. He would sell our house and move the furniture to Pulaski. He sent the papers to me in Port Elizabeth, South Africa, for signing. I took them to the American Embassy to be notarized. When I placed them in the mail, I realized that I would soon be moving to a new place filled with both opportunities and challenges. Two days after returning to the United States, the three of us flew to Kansas City for the General Assembly, then back to Virginia to pack the cars and journey to our new home.

You called me to feed the hungry.

Shortly after settling in, a call came from the director of New River Community Action stating that a staff person was retiring. He had heard of my work in the "hunger field" and thought I might be interested in becoming the director of community development. I accepted the position, which allowed me to continue and expand my concern in the areas of domestic and world hunger. In the summer of 1969, women's groups were organizing hunger workshops. These preceded the White House Conference on Food, Nutrition, and Health convened by President Richard Nixon in December of that year. I was chosen as a delegate and served on the Women's Task Force. Participants were guests at a White House reception where Mrs. Pat Nixon was a gracious hostess.

When the Senate Select Committee's report on hunger was released in 1974, I worked with leaders of other agencies to form the Virginia Coalition on Nutrition and became its first president. We obtained grants, hired staff, and began to address the hunger problems especially in southwest Virginia. A food stamp hotline was established, enabling those in rural and out-of-the-way areas to apply.

A major conference on the "Dimensions of Hunger" at Old Dominion University in Norfolk, Virginia, was partially funded by CROP. The Virginia Coalition staff provided support. Following the conference, I shared a cab to the airport with John Metzler from the national CROP office. He commented that I should be working for CROP. I remember saying to him, "Someday that would be nice, but I have to take care of the hungry in Virginia first. Then I'll take on the world."

You challenged me to broaden my vision.

My dear church, *you were continually challenging me to broaden my vision.* I received a call a few days after that cab ride offering me a job as associate for Virginia/North Carolina CROP with the responsibility of opening the Virginia office in 1975. I accepted. What a challenging and rewarding experience working with churches, colleges, schools, and civic clubs to raise funds for domestic and world hunger through walks, fasts, and sacrificial dinners!

In the late 1970s I never knew when and where the topic of women clergy would arise. I was in a TV studio in Lynchburg, Virginia, preparing to tape an interview regarding an upcoming CROP walk. The reporter and I had agreed on the parameters of the interview, or so I thought. When the interview began, the first question he asked was, "What do you think about the controversy in the Episcopal Church regarding the ordination of women?" I immediately stopped the interview and reminded him that we had agreed that the topic of discussion would be hunger.

You called me to be a peacemaker.

In 1971 I was amazed to learn how quickly we "Disciples" can act. While attending the General Convention in Louisville, Kentucky, I received a note from Robert G. Nelson, executive secretary of the Department of Africa, requesting that I have lunch with him. A few days later, back in Pulaski, Virginia, I had updated my inoculations, received my plane ticket and funding, and repacked my bags. The next day, I would be on my way to New York to represent Disciples as part of an ecumenical team of six denominations leaving for a Consultation in Southern Africa on American Corporate Investment in South Africa. After briefings in London, we obtained visas for several countries. We arrived in Johannesburg after a visit in Dar es Salaam, Tanzania. This was indeed a sensitive mission filled with moments of uncertainty, challenge, and opportunity. On our return, we reported to our particular denominations and met with leaders of the corporations we had visited. I served as a member of the Disciple Task Force on Investment Guidelines.

In 1974, I was privileged to participate in the Church Women United Causeway to Asia to explore with Asian women what it means to be

"builders of peace" in our time. Four peace caravans of twelve women each visited in two Asian countries. I led a team that visited Thailand and Vietnam. We visited Sister To Thi Ahn at the House of Peace in Saigon and heard firsthand their heart-rending experiences. Who could have imagined during my college years that one day I would be sitting in Saigon waiting for the opera to begin. As Ambassador Graham Martin opened with the roll of the drums, I remember grasping the "mustard seed" charm Carl had attached to my watchband when I left for South Africa in 1968. I offered a prayer of thanksgiving for Dr. George Hauptfuehrer, my organ professor at Bethany, who had insisted that we share in the weekly dinners in his home to listen to opera!

The caravans later came together at Tozanso, Japan, with eleven Asian women from eight countries and Japanese and Korean women living in Japan to participate in a Peace Consultation on the Role of Women in Peace Building. Following the conference, we boarded the bullet train to Peace Park in Hiroshima to participate in the World Day of Prayer Service written by the Japanese women. When we changed trains in Kyoto, I was thrilled to see the familiar face of one of my role models, The Rev. Thelma Hastings, as she waited to catch the train.

You called me to welcome the stranger.

Following my work with CROP and after serving as director of development for Virginia Institute of Pastoral Care, denominational heads convinced me of what I already knew – my heart and ministry were with the hungry and the refugee. I became director of refugee resettlement for Church World Service and Episcopal Migration Ministries, serving twelve denominations resettling refugees in Virginia. During my tenure, more than 2,500 individuals from twelve different ethnic groups were resettled. In 1986, I visited refugee camps in Asia (Hong Kong, Thailand, Malaysia, Singapore, and the Philippians) and in 1990 camps in Europe (Germany, Italy, Greece, Austria, and Switzerland.) As unbelievable as it may seem, I attended the opera in Vienna, Austria, as guest of the director of the refugee office. Best of all, I had the privilege of working with Jennifer Riggs, who continues to provide excellent dedicated leadership, not only to Disciples but to all of Church World Service.

As a clergy couple, Carl and I had experiences so deep and life changing that together in 1972 we led a study tour for teachers, doctors, and nurses to Africa and the Middle East. We led church groups to World Conventions in Australia, Jamaica, and Hawaii. Through all of these journeys, we came to appreciate and value new cultures, their welcoming of the stranger, unusual ways of travel, other cultures' creativity, and the inner and outer beauty of our "worldwide" family. It would take volumes to express the love I have received from "the least of these."

You called me to preach the good news.

Over the years, my dear church, you called me to interact on your behalf–denominationally, ecumenically, and with agencies and civic groups on the local, state, and national level. Their agendas have included the needs of people. While with CROP and Church World Service, I served as part-time pastor of Petunia and Galilee Christian Churches in Wytheville, Virginia, and Prospect Christian in Dinwiddie County. I was deeply involved with the local congregations of the twelve member denominations through whom I resettled refugees, participating in worship and attending committee and board meetings and women's and men's organizations.

While I was at Bethany College, some people kept saying, "There will not be a place for women in ministry." You, the church, offered a different view. You kept tugging and urging me on. You taught me to listen and absorb whatever was around me as if saying, "You never know when that might be helpful." Now that I am in my "golden years," you still allow me to write, lead elders and women's retreats, speak for anniversary celebrations, provide pulpit supply, and mentor and encourage young people as they prepare for ministry.

May we as clergywomen continue to have the presence and the vision to change the world by being the carriers of Christ's love, bringing unity to all of God's people wherever they may be. Sometimes God will call us to leave familiar settings and launch out into uncharted waters. He will never say where they will take us. We take him at his word, remembering that within each of us there rests a creative and perhaps powerful message just waiting to be shared. Capture those moments with patience and time and God will take care of the refining.

To those of you considering ministry or perhaps having stressful moments on your journey, this is not just the story of those whose letters are recorded here. It can and will be yours, too. Trust and prepare your heart and mind to follow God's leading and direction. Dr. Shannon, who first sent me on my way, once said that the symbol of fellowship is not the clasped hand but the "cocked ear." Learn to listen … really listen … so that you may receive both the challenges and the blessings that will be yours in the years to come.

Dorothy

Dear Church
Local Pastors & Co-Pastors

LETTER 3: *Deborah L. Carlton*
Gayton Road Christian Church
Richmond, Virginia

The Mothering Church

Dear Church,

You have been a mother to me in so many ways. I played on your church steps and hid in your baptisteries. I crawled through your organ pipe rooms and ran through your balconies. You scolded me when I needed scolding and complimented me when I needed lifting up. You expected something out of me immediately after my baptism. You wouldn't let me laugh or giggle in church or take my communion irreverently, but you indulged my humor. You taught me to sing out, carry my Bible, and help with the younger kids. You were my minister, my accordion-playing Sunday school teacher, my youth advisers, and my friends. Your love for me was embodied in these people, and they looked upon me with kindness and grace.

My memory of you is not tarnished.

When my teen years came, we didn't go our separate ways, for I still found life with you more than apart from you. Like other young girls, I demanded to wear pants to church, and our teenaged voices wanted the accompaniment of guitars instead of the organ. Rather than reject us, you slid over and made room. There I was, praying and serving in worship. You gave me a summer worship experience called camp. You gave me

the Word and expected me to know it. We worked and memorized those passages and sang songs with glad hearts.

When it was time to raise my own children, I knew you would help me. You looked so different from the church of my childhood and youth. I had to see you with the eyes of an adult. I noticed things about you that I didn't like; you noticed things about me that you didn't like, and yet we came together around the table.

I missed something the older I became: your feminine voice.

I knew you had one. One afternoon I heard it. At a district worship service, I heard your feminine voice pray from the table. Her name was Rev. Marilyn Taylor, associate regional minister for Virginia. I remembered a call buried deep. As a youth, I prayed at the table, I preached from the pulpit, I taught and worked with the younger kids. Our small church and even smaller youth group had been a place to cut my teeth–in leadership, in serving, in growing as a disciple. Could it be? Did I have a place behind the table and behind the pulpit?

Parts of you said *yes* and opened yourself to me as you did in my childhood and youth. Parts of you just weren't sure. How could you take me seriously when you knew me so well? We began a period of courting. We put on our Sunday best and began to get to know each other again. Was I really someone with whom you could place your trust? Would you really stand by me if I kept reaching for the unexpected?

Before we knew it, I was standing back in my home church, First Christian in Hopewell, Virginia, surrounded by a cloud of witnesses. That congregation was so good to me and gathered to offer love and support. They were joined by a few hardy souls from my first congregation in Orangeburg, Kentucky. The ordination service concluded with the laying on of hands, your hands.

The hands of Bobbie and Vance Swindell brought my ministerial robe and placed it upon me. Vance had called me months earlier. "You go and get yourself a robe, the best quality, one that will last, because I want you to be a preacher for a long, long time." My sons, uprooted from Virginia to Kentucky for mom to go to school, placed their hands supportively in that cloud of witnesses. My pastor and mentor, Rev. Randy Spaugh, raised his hands and gave the ordination prayer. To Randy I had first articulated my call to ministry. Randy purchased textbooks for my first semester of college.

The years of academic study at Randolph Mason College and Lexington Theological Seminary brought the hands of Dr. B.J. Seymour, Dr. Sharon Dowd, and Dr. Sharon Warner on me. Dr. Seymour, the first woman to serve on the faculty before Randolph Macon was co-ed, guided me to connect both head knowledge and heart knowledge in the study of religion. Dr. Dowd and Dr. Warner had guided me in seminary with a wealth of

knowledge and support, springing from their own commitment to Christ. These women were the very definition of teacher.

Yes, your hands were upon me even as you sent me out.

We struggled together in the rural church, and we struggled together in the suburbs. You called me to the northeastern corner of Kentucky and called me back to Virginia. Some of the experiences we would forget, those awkward moments of not knowing what to do, the gaffes and blunders that continued my education. You endured every sermon, even those early ones, from a daughter with so much to prove. You survived the unpolished pastoral care that had to be lived out and all of those firsts–funeral, wedding, surgery, words of counsel, baptism.

You taught me and you stood up for me.

In Kentucky, you called me your "lady preacher" in a county with none. In Virginia, you said, "We will hire the minister that fits with our congregation–male or female. My beloved congregation of Gayton Road called me as their partner more than ten years ago and gave me the opportunity to live out my call. I became their "Revy Debbie," and they opened their doors and their hearts to me. With them, I continued my education both in practice and in the classroom. I am so proud to be their pastor. So proud of whose they are!

Many of the struggles of women had already been lived out. I walked the trail already blazed and entered doors forced open long ago by women in ordained ministry such as Dot France, Sharon Warner, Sharon Dowd, Marilyn Taylor, and Virginia Taylor. I was the next generation and had all the benefits of those who came before me. I hope I have met the same responsibilities of the women serving in the congregation, women named Betty Harris, Dot Smith, Wanda Brooks, Holly McGinnis, Debbie Barnett, Gracie Tingle, Ioline Murphy, and Sue Crone. I could name many more!

Truth is, I have always been your daughter, and I have always loved you. I still prefer to spend most of my time with you. Yes, you can make me angry, and my goodness, I have disappointed you.

But you have never disappointed me.

We are beyond getting to know each other. Nonetheless, something happens inside of me when I see children running through your hallways and playing in your baptisteries. I know you feel it too. It's a future that has a ring of familiarity to it. It's an invitation to trust that the good work begun in us will be brought to completion by our Lord Jesus Christ.

Deborah

LETTER 4: *Rebecca Heller*
First Christian Church
Kent, Ohio

Making Weak Points Strengths

Dear Church,

You, the church, have always been at the center of my life–a vital element in my journey of faith. In you and with you, I have seen and experienced joy, wonder, abundance, nurture, compassion, grace, and love. Of course, I've come to know your shadow side as well. At your weakest, there is division, apathy, anger, and broken relationships. At these times we suffer and struggle together. Yet, in those situations the Spirit helps us recall when we have been truly united, inspired, and in community with each other and God.

Church, you are strong, resilient, and inspiring with Christ at your core.

I began to consider my call to ministry and vocational commitment to you when I was in high school. Church involvement, church camp in the Christian Church in the Upper Midwest, and my minister, Joel Aurand, all were significant elements in the process. A minister at camp once asked me, "Have you ever thought about going into the ministry?" Although the answer was "No!" at the time, I started thinking about ministry from then onward. Through our gracious God and the Holy Spirit, I worked through my doubts and fears (especially concerning public speaking and being under a magnifying glass), and accepted my call to serve Christ's church.

My three summers at the Christian Conference Center in Newton, Iowa, as Camp Staff Intern were transformational. Working with children and youth and getting to meet dozens of ministers and other dedicated people increased my confidence. I came to know and learn from so many different ministers–men and women–about styles and types of ministry and choices of seminaries. I heard tales of your role in the lives of others who also deeply love you. Through camp, Rev. Dayna Kinkade became my longtime mentor and friend. She challenged and encouraged me, named and affirmed the gifts for ministry she saw growing within me, and pointed me in the direction of Vanderbilt and the Disciples Divinity House.

While studying religion at Hamline University in St. Paul, Minnesota, and while working at camp, I accepted my call to ministry, to being a servant of the church. God and the Holy Spirit were stirring me to the depths of my soul, and I could no longer ignore their pull.

To be sure, I heard words of reservation others expressed when they heard I had accepted God's call and was preparing to go to Vanderbilt Divinity School in Nashville. Their words highlighted your challenging nature, turbulent relationships with some ministers, and your struggle to be open to growth, change, and transformation.

Some who know me well–family and friends–expressed some apprehension saying, "Sometimes you care too much; it is difficult for you to let go of hurt and disappointment." My love for you has remained strong, Weak points can grow to become strengths. God called me to your side, to you the church, and I have said, "Here I am."

I know God to be my faithful guide.

Your leading has taken me many places. In two summers of internship, my first experience working in the church, in Spencer, Iowa, where I began learning about ministry through the guidance and mentoring of Rev. Paul Davidson. Then to Nashville and the Disciples Divinity House living and working with other Disciples of Christ seminarians. This experience provided wonderful opportunities for learning and growth. Rev. Mark Miller-McLemore, Dean of the Divinity House, offered and continues to offer support and guidance. At the church in Paris, Tennessee, the wonderful people introduced me to southern food. In the Jacksonville, Illinois, church I received strength and steadiness of Midwesterners while in seminary. I had the extraordinary opportunity to work with Rev. Jerry McCaskey, a great minister and mentor in two different contexts. After graduating from Vanderbilt (December 2000) I served as pastoral associate at Cherry Log Christian Church in Cherry Log, Georgia, ministering with and learning from the legendary Dr. Fred Craddock.

In June 2003 I moved on to First Christian Church in Kent, Ohio, where I currently serve. My life has changed considerably since arriving here. I was married in September 2006, and my husband and I had our first child, a baby girl in August 2008.

Precious gifts have been received from each congregation and the ministers along the way. I will never forget the many Christians who have touched my heart.

To those who are considering ministry, listen for God's call. Listen with your ears, eyes, heart, mind, and spirit. Know that "church" is like all human beings because it consists of human beings. Sometimes it can be a source of disappointment and grief. It will show you the shadow side of

being human. But never forget it has great strengths, moments of brilliance, and an immeasurable capacity to love and serve.

You must be strong and centered.

My hopes for you, the church, are so great. You possess endless potential. God deeply desires to work through you. Be God's instrument. Remain open to the Holy Spirit who will move and guide you. You make such an impact when you operate out of centeredness, prayer, and unity. "Trust in the Lord with all your heart and lean not on your own understanding." (Prov. 3:5, NIV). You are God's church, you are Christ's church.

LETTER 5: *Janet Hellner-Burris*
Minister, Christian Church of Wilkinsburg
Pittsburgh, Pennsylvania

Tears but No Regrets

Dear Church,

How can I thank you or praise you enough for the gift of your call to ministry? When I first heard your gentle, but persistent call on my heart, I did not know any clergywomen. In fact, I did not know if women could be ordained. I remember asking my mother after a retreat during which I felt you move within my heart.

"Can women be ordained?"

She answered, "Yes. I know of one clergywoman. Her name is Thelma Hastings, and she is wonderful." My mother's "yes" as she drove me back to college started me on a journey that has caused many tears, but never regrets. Your call to ministry has deepened over these twenty-six years of ordination, as you have called me deeper and deeper into the heart of Jesus. Step by step, as I discern your leading, I have discovered calls within the call. Each call is like a thread in a beautiful weaving, as I become more and more an authentic child of God and a humble instrument of your healing and peace in a troubled world.

One of those calls within the "call" began when I was a child. In my play area in the basement of my home, I created my own little prayer center with a picture of Jesus. Before Jesus lay the open Bible, which I was given by my home church, the National City Christian Church in Washington, D.C. This prayer center was a quiet place for me to go to between Sunday worship services.

The call to prayer continues to be woven into every aspect of my ministry and life.

Daily I devote myself to prayer, and quarterly I go to a hermitage for three days of silence. Prayer is the way in which I listen for the calls within the "call" that you continue to weave into my life.

I love worship and understand it as the central act of every congregation.

When I was a teenager, a gifted associate pastor, Stewart West, challenged the youth of our church to create contemporary worship services.

From that moment on, I have heard a call to create worship–worship in every form and style from the silence of the Quakers to the shouts of the Pentecostals. Each week, the creation of a worship experience that lifts up the praises and the needs of our diverse congregation is truly the highlight of my week.

During my teen years, Rev. Stewart called me to work in the Summer Enrichment program for the children of our urban neighborhood. Those children, from homes burdened but not defeated by poverty, racism, drugs and alcohol, changed my life. You used those precious children to call me to a life of serving in the city with a passion for youth ministry.

On the day of my baptism, you deepened that call to minister in the city. It was the Sunday after Martin Luther King Jr. was shot and killed. Early that morning, the phone started ringing. Anxious parents of the pastor's class were calling my parents to see if they were going to church that day. As we drove to church in the heart of D.C., we followed the tanks from Fort Belvoir. I saw my first gun–every corner of the District had a soldier with a rifle in his hand. "Soul Sister" and "Soul Brother" were spray painted on businesses. Other buildings had been looted. The urban neighborhood around my home church was burning to the ground. While I was immersed in the peaceful waters of baptism, sirens blared outside the sanctuary walls.

Years later, I realized that my baptism into the faith was also a baptism into the call of racial reconciliation.

This unique experience of "baptism by fire" guided me years later when my beloved Wilkinsburg community nearly exploded in racial violence. An African American man with a history of severe mental illness went on a shooting spree just a block from church. He shot only white men and killed three, one of whom was a dear friend of our congregation and a frequent guest preacher in our pulpit. Instantly, you reminded me what a city looks like when it burns in the fires of racial hatred. I moved quickly to gather the clergy of the community together that night for a prayer vigil.

Ten days later, you led our church to create a Prayer Walk for the community as we retraced the path of hatred and violence with our prayers and tears. Before the Prayer Walk began, a colleague asked me, "How many people do you expect?"

I told him "I don't care how many come. I just know that we need to do this." Five hundred people showed up to walk our streets that day! Even the news reporters were wiping tears from their eyes as they reported the story of people from all races, cultures, incomes, and ages coming together to pray for the healing of our broken hearted community. Because of my leadership, the community honored me as Citizen of the Year. I gave the praise back to you, for you are the one who guided me during those terrifying days.

My call to work within the church was born out of the crucible of my brother's death to cancer at the age of twenty-two. Before Chuck died, I saw the church at her best as they cared for my family who were nursing him at home long before the hospice movement came to this country. Every weekend when I came home from college to help my family, I found church friends bringing dinners to my parents, washing dishes, taking care of household chores so that my parents could focus their attention on Chuck. Often a prayer group would gather in the living room of our home to bring spiritual support to Chuck and my family. Though his death was the most painful experience of my life, you used that terrible time to show me what a real church does when someone is hurting. As we rode in the funeral home limousine to the cemetery after his funeral, I looked back at the endless line of cars following us. It was then that you wove within my heart the desire to work within the church.

My call to work in the small church was born in Santa Fe, New Mexico. After my brother's death, I transferred to the western campus of St. John's College. On my first Sunday in Santa Fe, I walked two miles into town because I had promised my mother that I would attend the local Disciples congregation. Even though I was the only young adult in the church family, I fell in love with that dynamic small congregation. I was adopted not only by the pastor and his wife, Rev. Claude and Marion MacDonald, but also by nearly every member of the congregation. Their love and encouragement helped me to heal after my brother's death.

I learned to appreciate the personal attention and unique healing a small church can provide one-on-one.

At the First Christian Church of Santa Fe, I led the youth group and preached my first sermon, which was tedious for all to hear! After graduation, the congregation helped me to stay in the community as a VISTA volunteer, while urging me to apply to seminary "just for a year to see how it goes." They saw my ordination long before I did! What none of us knew at that time was how you would use my Santa Fe experience to weave within my heart a great love for the small church.

After graduating from Princeton Theological Seminary, I met my helpmate, Steve. Steve was a member of the First Christian Church in South Bend, Indiana, where I was serving as an associate minister. We started dating before I even knew we were dating because every time I needed help in the church, he raised his hand! Since I had decided that I would be single in ministry, (the men I had known up until that time felt threatened by this new phenomena of women in ministry), I didn't understand for months that I had fallen in love with this remarkable man. Now I realize that I could not do this ministry without him. Though he has never been ordained or licensed, he is a minister in every sense of the word–a full partner in this urban, diverse ministry we love.

Steve pushed me out of the comfortable nest of being an associate minister of the First Christian Church in Minneapolis, where I was honored to serve with the gentlest pastor I have ever known, Rev. Tom Shifflet. We loved the city and the church in Minneapolis, but Steve was the first to hear your call for me to pastor a church on my own at a time when few clergywomen were able to make the move from associate to solo pastorates. Furthermore, when you blessed us with not one, but three calls to three different congregations within forty-eight hours, Steve was the one who gave me the courage to accept the smallest and most challenging congregation. "You always wanted to be a missionary," he reminded me. "Now is the time to be one in your own country." Though the work here in Wilkinsburg has been painful at times, we have never regretted how you brought us to give our hearts to this urban neighborhood despite its economic decline over the past eighteen years.

Though I love Steve intensely, I was not sure that I could combine the call of ministry with motherhood. Ministry seemed so overwhelming that I couldn't imagine doing both. I also feared the backlash of those who barely accepted me as a woman in ministry. What would they think of a nine-months pregnant clergywoman waddling into the pulpit on Sunday morning? It took a number of years of prayer and discernment before I heard clearly your call to be a mother.

Far from taking away from my ministry, being a mother helped me to be accepted, especially by women, which was something I had not anticipated.

More importantly, being a mother has not only brought me great joy as I have watched my daughter, Kaitlyn, and my son, Ben, grow into faithful and mature adults; but it has also taught me a great deal about how to nurture a congregation toward becoming more faithful and mature. How profoundly grateful I am that you wove the call to motherhood into the tapestry of my life!

Needless to say, my life was full as a wife, mother, pastor, contemplative retreat leader, and community activist. Though I loved this life, I often struggled with being terribly tired. At times I even wondered if I could go on in urban ministry because I was so drained, despite taking care of myself. This exhaustion led in part to my diagnosis of breast cancer in August 2004, even though there is no history of this disease in my family. I still remember the taste of terror as the doctor pronounced my initial diagnosis. All I could think about was never seeing my son graduate from high school or holding my grandchildren in my arms.

Once again, you called the church to care for me.

Hundreds of cards flooded my mailbox. Emails poured in from every corner of the country. Local prayer vigils sustained me as I made difficult decisions about the course of my treatment. The church, the real church,

the Body of Christ, carried me through this horribly painful time. During those months, you became my guide, my peace, and my wisdom as Steve and I prayed through each complex medical decision. You helped me to fight for my life by calling me to turn this experience of cancer into a spiritual walk, a walk that I am now writing and speaking about with other breast cancer survivors. Only now, with the perspective of four years of survivorship, can I see how you used this experience of cancer to heal that deep exhaustion in my life.

Indeed, I see clearly how cancer and all of the tragedies and trials in my life have been a part of the weaving of my call. Like the prayer shawl that my sister and soul companion, Cheryl, knitted for me during my cancer journey, all of the threads, whether bright or dark, have worked to form a weaving of indescribable beauty. As I study this shawl, with each stitch representing a prayer for my healing, I give thanks for the many people you continually send into my life to clarify and strengthen my call to ministry. To list them all would take more pages than this entire book! Most of all, I give thanks that you are not through healing or leading me to go ever deeper into this call.

I trust you more than ever, great weaver of all of the calls within the "call."

Janet

LETTER 6: *Janet A. Long*
Senior Minister, Washington Avenue Christian Church
Elyria, Ohio

Always the Preacher

Dear Church,

I have never known life apart from ministry. My father was a pastor, as was his father whose initials I bear. My mother was a committed churchwoman. Never did my family doubt that my life would be centered in the church. I have never had a time of rebellion, of not going to church. My biggest rebellion was my decision to be baptized a week ahead of my classmates–on Palm Sunday, rather than Easter, so my first communion as a baptized Christian would be on Maundy Thursday.

I was always the preacher.

My foray into ministry occurred at the ripe old age of three. In an effort to give my pregnant mother a break, my dad took me with him to visit nursing home patients. I found welcome in the laughter and on the laps of those whose lives did not normally include children.

By the time I was in grade school, I was conducting backyard funerals for fallen birds and friends' pets. After school, I led impromptu worship services in the sanctuary of our church in Crooksville, Ohio. I assembled friends and my two sisters, assigning various roles. I was always the preacher.

Church was an extension of home.

Our family lived in the parsonage right next door to the church. When an education wing was built across the rear portion of our back yard, we incorporated it into our play area. We roller-skated on its smooth concrete floors. We used an office chair for rides down its long hallways. When tables and chairs were needed for a church dinner, we became the set-up crew. When an overzealous custodian left puddles of furniture polish on the pews one Saturday, we became the clean-up crew. I learned from my dad that ministry could be described as, "whatever it takes ..."

I recall my incredulous reaction to a friend who wondered if the church was a spooky place at night and if I was scared to go inside by myself. Church has always been a wondrous place to me–a place of love and grace, of family and friends, of hope and faith, of hospitality and welcome.

As a third-grader, I began calling on homebound members of the church who lived within walking distance. Sometimes I would take a friend

along, sometimes not. I made my rounds on Wednesdays after Junior Choir practice. My special friends were Mildred and Mrs. Everhart. They both were warm and loving, yet very different from one another. Mildred didn't hold back; Mrs. Everhart was reserved. Mildred didn't worry about fashion; Mrs. Everhart was elegant. I guess the fact that I called one by her first name and the other by her formal name tells the story. For years, I visited both of them in their homes every week.

Why, then, should I have been surprised when I found myself in the middle of the closing circle at Camp Christian (located near Magnetic Springs, Ohio) at the end of my first year of Christian Youth Fellowship Conference, responding to the invitation to consider a call to ministry?

Mine had been a life of ministry, but I had never considered the prospect of ministry as vocation.

I'm certain that was due to the fact that I knew no women pastors. I had known some missionaries, some Christian educators and some other prominent churchwomen who were ordained. But I knew no clergywomen who served as pastors.

That fact didn't change for a number of years. When I was in the office of my advisor, Dr. Richard Kenney, as a junior at Bethany College, he asked about my plans after graduation. I told him I expected to go to Yale Divinity School to focus on becoming an all-around associate minister: counseling, doing youth ministry, leading a church's music program, and doing whatever else was needed. He simply said, "If you want to do all that, why don't you just become a pastor?" Just become a pastor? I didn't know I could do that. "Well, of course you can do that." So, from that moment on, my call to ministry was solidified, strengthened and specific.

Instead of heading to Yale, I wound up at Brite Divinity School, the seminary of Texas Christian University. That decision had to do with an interview with Jack Suggs, Dean of Brite, an interview I agreed to out of sympathy. He was coming to Bethany on a recruiting visit, and no one had signed up to meet with him on that Friday afternoon. Thinking, "I can spare half-an-hour," I spent time with him.

He was charming and convincing. And I was headed to Texas.

Seminary was challenging but not for the usual reasons. Bethany had prepared me well for the academic rigors and had helped me deconstruct and rebuild my theology. What I wasn't prepared for was the reaction to female seminarians. Brite was accepting for the most part (I was elected moderator of the student body), but the southern culture was not. I found a congregation, South Hills Christian Church, which was on the cutting edge and willing to take a chance on me. I learned a great deal in that setting, thanks to the mentoring of Bert Cartwright, Pat Henry Jr., and Bryan Feille.

Then came my senior year. The search-and-call process began. In conjunction with my ordination interview back home in Ohio, I had meetings with two pulpit committees. It was very clear: my first pastorate would be with the Clyde Christian Church. The most excited recipient of the news was Jack Suggs, who told me that this was the first time in Brite's history that a woman had received the first call to its class of seniors. My four years in Clyde taught me much about the rhythms of church life and the realities of congregational life. It was time well spent.

When an inquiry came regarding a conversation with Washington Avenue Christian Church in Elyria, I agreed to meet with the pulpit committee. As I approached the imposing building on my first visit, I felt like a child "playing church" again. After twenty-three-plus years as pastor of the congregation, the mystique has faded. But the mystery of fit–of sharing the sacred within the covenant of pastoral ministry–has not faded.

My work continues to be a source of great joy and meaning.

The most fulfilling part of my ministry has been the opportunity to work with my father. He joined the staff of Washington Avenue Christian Church after I had been with the congregation a little over two years. For fifteen years, he served as minister of congregational care, serving God with a cheerful heart as he called on homebound members, created fellowship opportunities; covered my responsibilities when I was absent; and challenged stereotypes of the aging process. Some even referred to him as "the party pastor"! The day of his retirement celebration became instead the day of his memorial service. I officiated. Who else knew him like I did–as dad, as colleague, as friend, as mentor? What a gift it was to share a decade-and-a-half of ministry with the pastor whose example modeled the beauty, balance, and blessing of pastoral life!

"How can you stay so long in one place?" is a question I am frequently asked. I can respond on several levels. The congregation has been supportive of my ministry beyond its walls–into the community, the region, and the general life of our church. I have been blessed by their being proud of me, by their patience, and by their prayers–especially during my two-year term as moderator of our denomination. During that time, I chaired the General Board and its Administrative and Executive Committees and traveled on behalf of Disciples. I have also chaired two general unit boards–Christian Church Foundation and Church Finance Council–and the Mission Council. I have been involved in the region, having served on the Commission on Ministry, the Regional Board and its executive committee, and various other committees. I also spend a week each summer as a counselor at CYF Conference. Speaking and preaching invitations have come from within and outside Ohio. After my term as president of the Bethany College Alumni Association concluded, I have continued my volunteer service to my alma mater as a member of the Board of Trustees and its executive committee.

Search committee experience has ranged from hospital CEO to college president to interim regional and general ministers. But this global perspective of ministry would not be possible without the encouragement of the folks of Washington Avenue Christian Church, who share my time as part of their commitment to outreach. Had they not shared this commitment, I wouldn't have lasted.

The longer I stay, the more we are family to one another.

Conflicts are more difficult and personal, but trust runs deeper than trouble. Funerals are more difficult and personal, but love runs deeper than loss. I am blessed by the unwavering devotion to faith, to philanthropy, to family, and to my husband, Dan Clark.

I met Dan at EduCare, a now-defunct program sponsored by Disciples and the Church of the Brethren. My interest was in the leadership track of the workshop offerings. I was trained to lead that segment of the curriculum. Dan was a student in my first and only workshop. The workshop came close to being cancelled. All but one of the congregations that signed up to send leadership teams of three had backed out. My co-leader said it wasn't worth his time and effort. I got a call pleading for the workshop for the one remaining congregation. I agreed to make the trip. I already had made my travel arrangements and secured a guest preacher to cover for me.

As it turned out, Dan almost didn't come to EduCare. Nearing the end of his military career, he had just been reassigned and would be leaving the congregation outside Washington, D.C., where he had become a Disciple. Others on the leadership team prevailed by reminding him that, though he wouldn't be there to carry on the work of the leadership committee, his presence at EduCare would allow the congregation to benefit from the experience of the other two on the team. Little did either of us know how life-changing that conference would be!

While I can't guarantee that ministry will lead one to find the love of her life, I can guarantee that ministry will lead one to find the love *in* her life–the love of God in Christ. That love is what makes possible the impossible task of responding to the call to a life of servant leadership. The call is filled with heartache and joy, challenge and fulfillment, worry and wonder. Most of all, it is filled with grace.

Sharing the sacred moments of life and the sacred acts of faith with God's people is sheer grace. I received great advice when told, "If you can picture yourself doing anything besides ministry, go do it."

I still cannot picture myself doing anything else.

Janet

LETTER 7: *Linda C. Parker*
Senior Minister, East Side Christian Church
Evansville, Indiana

In Joy and Pain

Dear Church,

"I thank my God every time I remember you" (Phil. 1:3, NIV). So Paul greeted the church at Philippi. Most of the time I can add my voice to his, but not as I write.

I think not only of the joy the church has brought me but also of the pain.

Most of my childhood memories involve the church. My grandparents were members of a Disciples congregation in Miami, Texas. I grew up hearing stories about Minnie and Spence Parker caring for the sick and their lifelong involvement in that church in the Texas Panhandle.

My father, a Disciples minister, was educated at Phillips University and Brite Divinity School. He served small congregations in Texas. I spent hours coloring away at the back of the room while budgets were being discussed and plans made for some upcoming event. I folded bulletins, ran mimeograph machines, stapled newsletters, dusted pews, moved tables and chairs, and picked up trash in the parking lot. My memory filters tell me the churches Dad served were short of money and staff–short on money, because we certainly never had any to spare. My mother always had to work, and we often got down to the last can of beans in the cabinet before payday.

I recall one painful experience when the folks really hurt my parents. I don't really know the situation that induced the pain, but dad was asked to leave this particular church. We had to move out of the parsonage before he could find another position. Our belongings went into storage, and we rented a house near the regional office. We camped out on the floor until a church offered him a job. In spite of the pain and hardship, my father's devotion to his work and his commitment to ministry were an inspiration and example to me.

I come to this work honestly.

I entered Texas Christian University in Fort Worth, Texas in 1971, swearing that I would not go into ministry. I was going to be a social worker. Caring for others was part of my DNA, but I had had enough church. During

the four years at TCU, through discussions in required religion chasses, the relationships I developed with professors and friends, and the echoes of my past experience, I discovered how important the teachings of the church, scripture, and traditions were in my life. If I were going to help someone in need, I couldn't "not" talk about things like forgiveness, grace, the healing of memories, and the power of God to transform not only individual lives but also to change the injustice in the world.

I decided to attend seminary and become an ordained minister. I entered Vanderbilt Divinity School in Nashville, Tennessee. Classes, professors, friends, field education positions, and the church I attended challenged and sustained me there. That educational community helped me through a divorce. On January 9, 1979, I was ordained at Vine Street Christian Church with my brother, Paul, preaching the sermon. I have been privileged to serve as the moderator of the Tennessee Region, chair of regional committees, and member of the general board. In 2001, I earned a doctor of ministry degree from Drew University Divinity School.

At times I have been gravely disappointed in the Church.

The prejudice against women, people of color, and varying orientations still exist. Naturally, over my thirty years in ministry I have found individuals who are uncomfortable with a woman minister. In their worldview, "it just isn't right!" I try to honor their discomfort. As they get to know me, those opinions usually change.

I consider myself reasonably smart, articulate, and compassionate but believe because I was a woman I have been passed over for positions that I was well qualified for. I also realize there may be some reason other than gender. I might just be more sure of myself than I need to be.

Being a woman in ministry has its advantages and challenges.

The first church I served was Highland Park Christian Church in Des Moines, Iowa. I was the associate minister and worked with Jim Robertson, this larger-than-life guy. One day we visited a woman in the hospital. We knew she was dying. The woman had cancer and was in great pain. The only thing that seemed to bring relief was for one of her family to crawl into bed and hold her so she could sit up while the person gently rubbed her back. Her family had valiantly kept vigil for over a week.

When we arrived at the hospital, her daughter had been sitting in bed with her for several hours. She was exhausted. Jim took the woman's husband and son to get coffee. I positioned myself on the bed and held her in my arms so that her daughter could rest and relax. I doubt that a man would have been able to do that. Both the individual and her family were comfortable with and grateful for my presence.

My best ministerial experience was at Vine Street Christian Church in Nashville, Tennessee, where I was the associate for thirteen years. I had a

wonderful collegial relationship with Dan Moseley, the senior minister for ten years of my service there. In many ways, because of Dan's leadership style, we shared the ministry and developed a real sense of shared partnership for which I will always be grateful.

During eighteen years of my ministry, I was married to John. We have two wonderful children, Kennedy and Grant. Raising a family and maintaining a relationship while ministering a congregation can be challenging. John and I were divorced near the end of my time of service at Vine Street. The congregation was a great support during that difficult time in our lives. Our children, now grown, remain active at Vine Street, where the church has truly been a family of faith for them.

I have had three opportunities to take sabbaticals during my ministry.

What great experiences those were! Travel, study, rest, renewal, and extended time with family and friends helped me regain a sense of perspective when I had grown weary and felt drained from ministry. I do encourage congregations to help their ministers experience a time of sabbatical.

East Side Christian Church in Evansville, Indiana, where I currently serve, is a place where faithful people are working hard to be church. They have welcomed me with open arms. Like many Disciple congregations, the membership is an aging one with membership declining with each passing year. In 2006, they took a leap of faith and decided to use a bequest to try and turn things around. Travis Hacker is now associate minister working with youth and young adults. He engages in community ministry, preaching, teaching, and sharing with me in ministry. We haven't yet had enough time to see real change, and the funds for his position are going to be a challenge.

Ministry is hard for anyone.

At times I have wished I hadn't been called and could find something else to do. One of my professors at Vanderbilt, Dr. Peggy Way, told us when we were wading through feminism that a woman's authority in ministry could not always be found in the church, in tradition, or even in scripture. Our authority came from possibility. Because God had reached down into our hearts and whispered our names, that possibility is what gave us authority.

Is this really a love letter?

Do I love the church? Do I love doing ministry? I do love standing with people on the thresholds of life, birth, death, illness, and transition. I love to study scripture and give voice and contemporary meaning to the stories of our faith. I love the openness of the table in this church and the grace that is poured out and offered to all people in spite of their color, sexuality, or

their past. I love bearing witness to the holy emerging in our daily lives. I love many, even most, of the amazing people who are part of the church.

I must confess that the grind of ministry—the pettiness, complaints, judgments that people bring—often zaps my energy and leaves me drained. I don't like that I must struggle financially as a single woman to help my children pay for their education and to plan a reasonable retirement for myself. I don't like pretending to be more conservative than I actually am. I don't like being guarded so as not to offend when I want to stand up for peace and justice issues in the world. I do it out of respect for others, but it hurts my heart and wounds my spirit. I don't like the grueling hours and often repetitious meetings where nothing gets accomplished.

Pray a lot!

If you are a woman in ministry or considering ministry, I encourage you to pray. Pray a lot because you are going to need something bigger than yourself. Find a way to celebrate the Sabbath. Get away from the church, ministry and its work for a whole day each week. Have friends with whom you can be yourself. Laugh. Laugh a lot. Keep your perspective. Know that what happens in your life and in the church is not about you. Some broader plan is at work.

Study the scripture, latest cultural trends, and leadership. Take classes. Retool every year because you will need all the latest information and church wisdom you can find.

Know that this work is not glamorous or easy. Not all the people at church will be nice. You will be constantly humbled by how much you don't know. You will be humbled by how much your role as minister gives you access to people's private sorrow, grief, and fear.

Depend on God and believe in God's steadfast love.

Because I love you so much, I say to the churches: take responsibility for yourselves. Work with your ministerial staff. Offer them your gratitude and support. Pay them a living wage. Encourage them to take care of themselves and their families. Realize they are not there just to care for you but to help you learn how to serve God and the world.

Just as I believe in the possibility of my own call to ministry, most days I believe in the possibility that is alive in the church. There is grace enough for all of us. I ponder my own and the church's possibility in my heart as I struggle daily to serve. I would say to others—"enter at your own risk." I guess that's what faithfulness and possibility are all about.

Linda

LETTER 8: *Gina T. Rhea*
Senior Minister, First Christian Church
Radford, Virginia

Becoming the Norm

Dear Church,

When I was in junior high school (probably an eighth grader), an event shaped my sense of call to ministry, though I was unaware of its influence at the time. On a Sunday evening I was, as usual, attending a church youth group meeting. For some reason, I was momentarily out of the room. The phone in the hallway by the church kitchen started to ring. Because no one else was around, I answered it.

I recognized the caller as the mother of another member of the youth group. Her voice was strangled with grief as she asked for Mr. Holland, our pastor. I went to get him and watched as he spoke to my friend's mother. As soon as he hung up, he hurried out the door with a worried expression on his face.

I learned later that the caller's twelve-year-old daughter was dying in the hospital. In that terrible moment, she reached out to her pastor to ask for support, and he responded immediately. He went to her side to offer the ministry of presence and to convey the love of God and the love of her church family.

Some years later, I finally recognized the incident for what it was–a call from God and a formative moment in my understanding of pastoral ministry. It occurred in an expected place–my home church, Wheeling Avenue Christian Church in Tulsa, Oklahoma. There I learned about God and Jesus. There through leadership in youth groups, serving as substitute organist, and watching my parents teach Sunday school for years, I began to understand how the church works. There I was first encouraged to consider a church vocation.

The church was like a womb nurturing and nourishing me in the faith.

Church involvement continued at Texas Christian University in Fort Worth. I joined the student congregation at University Christian Church adjacent to the TCU campus and continued learning about church dynamics in a different and larger context. I majored in religion. The religion department faculty members, especially the late Dr. Paul

Wassenich, encouraged me to go to seminary. He recommended Union Theological Seminary in New York. My intention in going there was to obtain a Masters in Religious Education degree so as to become a director of Christian education.

Going to Union Theological Seminary and New York City shifted all my assumptions.

Not only was the city an exciting place in which to live, but being at Union at that particular time, the fall of 1969, was exhilarating. I discovered many strong, vibrant women enrolled in the Master of Divinity program. They were planning to be ordained and serve churches as pastors. I remained at Union for a semester and then left to return to Texas, to get married, and to go through a discernment process as to the nature of my call.

After several years in various jobs and communities—secretary to the minister to the University at TCU; secretary to the director of the Infant Laboratory at Educational Testing Service in Princeton, New Jersey; aide in a Montessori School in Lubbock, Texas—I decided with the support and encouragement of my then-husband, Richard L. Rhea, to go back to seminary. I entered Union Theological Seminary in Richmond, Virginia, in the summer of 1975 for Greek School. My brother, Rev. G. Thomas Tate, pastor of Plaza Presbyterian Church in Charlotte, North Carolina, also was a student at Union. We think we were the first brother/sister pair to graduate simultaneously from UTS.

While in seminary, I served as part-time pastor of Gilboa Christian Church at Cuckoo, Virginia, in Louisa County. We lived in Goochland County, where Dick served two rural Disciples churches. I commuted into Richmond for classes. I was active in Princeton Seminary Women, an organization that was part consciousness-raising group and part advocate for women in ministry.

The direct seminary sojourns and an experience when I worked while my husband attended seminary at Princeton affirmed my sense of call to ministry.

Following ordination in June 1978, I continued serving the Gilboa Christian Church until Dick and I received a call to become co-pastors of First Christian Church in Radford, Virginia. We began that ministry in August 1979. Few women clergy were in the area at that time, and no clergy couples served as co-pastors. This was not an obstacle for First Christian. The congregation enjoyed being on the cutting edge of ministry. Twenty-nine years later, I continue to serve as their pastor.

I have been richly blessed in their acceptance of me as a female in a male-dominated field.

Colleagues, congregations, family, and friends provided needed affirmation. In particular, the elders of First Christian, Radford, have proved a

source of strength and support. During two particularly painful experiences, they stood by me as we worked through difficult issues.

One of those experiences was the dissolution of my marriage in 1988. The elders were unanimous in their desire for me to renegotiate the call to First Christian to serve as pastor. They led the congregation in that process and ministered to me at a time when I was emotionally spent and confused.

The elders have truly been partners with me in ministry.

The other painful situation involved a group from within the congregation who experienced a transformation in their attitudes about life, faith, and ministry. They became convinced that it was no longer acceptable for women to exercise spiritual authority in the congregation (meaning the pastor, teachers, elders, officers). Again, the elders took a leadership role in handling the conflict. They followed biblical principles in speaking with the individuals involved, listening to their concerns but respectfully disagreeing with their conclusions. Eventually, the dissenters left to join a non-Disciples church in the community. Their departure was painful for everyone, yet they had clearly moved away from Disciples values and practices.

I would not have been able to minister so long in this setting if First Christian, Radford were not a healthy congregation.

The members have a deep respect for the ministerial office, an attitude that was in place long before I came. They respond faithfully to crises–a tragic accident in 2001 in which two of our members were killed; a fire in 2005 which resulted in our being out of the building for nineteen weeks. They are loving and forgiving. They are committed to being a witness in the community through various ecumenical ministries, and they expect their pastor to be involved in those as well.

With their enthusiastic support, I have served in many capacities in the Radford/Fairlawn Ministerial Association, including as president on four occasions. I have been active in district and regional work in the Christian Church (Disciples of Christ) in Virginia, serving as district president three times, as chair of various regional committees (personnel, clergy, long-range planning), and as moderator of the Christian Church in Virginia in 1997–98. All of this was with the blessing of the congregation. Conversations with Disciples and ecumenical colleagues have revealed that this is not always the case. Many congregations apparently begrudge their pastors the opportunity to serve in community and denominational ministries, failing to understand the value of that witness. Again, First Christian, Radford, had this commitment long before I came.

First Christian has also been an incubator for birthing ministers. During my tenure, four people have been ordained–Rev. Elaine W. Austin, Rev. Russell Boyd, Rev. Dr. Lisa W. Davison, and Rev. Christine Reisman. One

member, C. Eugene Akers, serves as a licensed minister in our district. The minister who serves as chaplain at the local hospital, Rev. Jonathan Webster, chose to make the transition from another denomination to Disciples ranks through First Christian. Two former ministers' wives– Rev. Nancy Saunders and Rev. Jean Elmore–went to seminary after leaving Radford and were ordained.

In August of 2004, First Christian and I observed our twenty-fifth anniversary together. Clearly, the celebration was not about my ministry. It was about *our* ministry. We are partners in the gospel and partners in ministry.

Our mutual respect for one another has been the cornerstone of a long-term and fulfilling pastorate.

One of my proudest moments occurred in October 2007. My niece, Jessica E. Tate, was ordained in the Presbyterian Church in the United States. She now serves as associate pastor of Fairfax Presbyterian Church in Fairfax, Virginia. In June of this year, she and her parents (my brother, Tom, and sister-in-law, Joanne) attended a surprise celebration for me at First Christian marking the thirtieth anniversary of my ordination. In addition to being a healthy and caring congregation, First Christian can be sneaky. Jessica spoke at that event about how there had never been a time in her life when she had not known a woman minister. As she put it, it was simply part of the "family business."

Her comment took me back to that moment at Wheeling Avenue Christian Church more than forty years ago when I answered the phone and felt that first, though unrecognized, tug toward ministry. Even though I had a deep and abiding love for the church, being a woman minister did not occur to me as a possibility. Thankfully, it is different today. In fact, for some it is the norm. Several years ago, after I exchanged pulpits with an Episcopal priest for the Week of Prayer for Christian Unity, a young child came up to me during youth group. He exclaimed, "Did you know, we had *a man* preaching for us today?!" His inflection indicated that he thought it was the weirdest thing he had ever seen. I was delighted to explain to him that men can, indeed, be ministers. At the time I do not think he was convinced.

On the last night of the Tulsa General Assembly in 1991, I was served communion by the same woman who had called the church that long-ago night needing her pastor. She was still a faithful Disciples elder ministering in her capable and caring style. She and I never talked about the night of her phone call. I do not even know if she knew that I was the one who answered the phone. In that moment of communing all those years later, something in my life came full circle. Tears flowed in her eyes and in mine.

I felt again the compelling truth that, for me, the church is home.

Gina

LETTER 9: *Julie Roberts-Fronk*
First Christian Church, Pomona, California

God Tapped My Shoulder

Dear Church,

Twenty years ago. I sat in a small reflection group in theological school with other first-year Master of Divinity students recounting stories of call to ministry. The stories I heard included extraordinary visions as well as stories of being encouraged by church people to pursue ministry as a vocation. For weeks on end, I listened to my fellow students recount these stories that anchored them firmly in the knowledge they were on the right path. For weeks on end I wondered what on earth I was doing there and how soon would they discover I was an imposter, a person without a call.

What was I doing in this place?

What brought me here? Was it merely a series of life circumstances? Getting fired up about youth ministry after counseling at high school camp was motivating, but was that my defining moment? I knew some might think I just followed my husband, who had already been a member of the seminary community on his way to ordination. I sat in that group, waiting weeks for my turn to share and wishing it would never come. Did I really have a story worth telling? Then, somewhere along the way, I remembered a day I sat in worship at Huntington Park First Christian Church, a day God tapped on my shoulder.

All the God "Aha" moments I've experienced are almost mundane. They come as a simple knowing, a basic acknowledgement of what is. This moment in worship is the first memory of such an experience. I was all of nine years old, minding my own business as the preacher spoke from the high and lifted pulpit in that grand Tudor-style sanctuary. I looked up from whatever scribbling occupied me, watched the preacher for a moment, and a voice in my head said, "I could do that." I immediately returned to my inner musings.

"I could do that!"

A thought had bubbled up and then returned to some subterranean depth, completely forgotten for fifteen years. At the age of nine, nothing in my life would prompt me to come to that conclusion. Yet, my memory

retained a deep knowing, a lifeline from the child I was to the adult I'd become. "You are not an imposter," were the words on the life preserver, and I clung to that in the sea of others' certainty. A dear friend and I spoke of our uncertainty, that someday "they" would find out we didn't know what we were doing and that we were the imposters we felt ourselves to be.

Discernment is hard work.

This is my word to my sister clergywomen who struggle with their call, who question their call from time to time. Don't get yourself in a knot about "call." When your work is difficult and your confidence low, the problem is rarely about your particular call to ministry. Women were and still are acculturated to be less confident than our male counterparts. "Call" is not a switch that God flips on and off. Call is a lifelong process of discerning and discovering. When clergy have certainty about call, I'm suspicious. All the stories of call in the Bible contain confusion, disbelief, uncertainty, and resistance. Complete and certain confidence is a sign of a closed mind.

When my parents learned I was starting the journey toward ordination, they panicked. My mother contacted the pastor whose preaching distracted me the day God tapped me on the shoulder. That minister had left local church life altogether, weary of its contentiousness. At my mother's behest, he called me and half-heartedly tried to convince me how hard life as a local pastor was. He made sure I knew my parents were concerned about what I'd be subjected to. Apparently, they'd been through some brutal times as lay leaders.

I realized my mother's concern had much more to do with my refusal to read from the script she'd written for me and little to do with genuine concern over my "being thrown to the lions." She never voiced any objection to my being a "clergy wife," even though spouses of clergy are often subjected to even greater scrutiny.

Despite my mother's expectations for my life, I was reading a different script for myself. I had picked it up going to church. It was God's script in which Jesus says we can make the world a better place and people's lives more whole.

Somehow the message I had received told me that the church is an instrument of hopeful change in and for the world.

The words of scripture, hymns, and songs got under my skin at a young age: words about "to every woman, man, and nation comes the moment to decide," words about a "child is born who shall be called Prince of Peace," words that "the Spirit of the Lord is upon me because God has anointed me to preach good news to the poor." The world was an unjust place. By the second grade, I knew I needed to be a part of God's work to bring justice.

The church was the only place I heard a possible answer to the injustices I saw and experienced.

In the past four years, I have been able to find expression for this work personally, pastorally, and institutionally. The work of institutional/community organizing gives me a framework for addressing the world as it is to help it become the world it can be. First Christian Church, Pomona, California, the congregation I serve, decided to become a member institution of Industrial Areas Foundation(IAF): a broad-based organizing network of faith communities, nonprofits, schools, and unions. Our mission is to build power–relational power–among institutions in Los Angeles County. It's an enormous and wonderful challenge. We are encouraged to grow as leaders and challenged to root our work in our values, the traditions of our faith. We are becoming more deeply engaged in the community and more effective at leadership development. We are in more significant relationships with other congregations and schools in our area.

The work of organizing is time-consuming, sometimes frustrating. Nevertheless, it is providing some of the deepest hope I have for the future of the church. Learning alongside other leaders from various faith traditions, with their diverse leadership styles, from a variety of institutions such as schools and unions, is helping reshape our own leadership. These relationships continue to provoke my own growth as a leader. I wish IAF community organizing had been included in some way in my theological education. I have learned how to look for talent and encourage it. I have learned that failure is a necessary and wonderful teacher, a thing to celebrate. I am grateful to my teachers, some who are paid organizers. Other teachers include people whose first language is Spanish, overworked public school teachers, principals, parents, and priests.

I have been blessed with other teachers and mentors.

Darwin Mann was the senior pastor when I first came to Pomona. I didn't know what I was doing half the time, but he still treated me as a colleague. Working alongside this patient, encouraging, and hopeful saint provided me a safe place in which to learn. William (Bill) P. Backstrom is another minister who provided this kind of environment when I was still in theological school. Arla Elston came to Pomona upon her retirement and almost immediately became a mentor. Her no-nonsense manner was something I needed. She was a good listener and sympathizer, but she didn't let me off the hook when that was needed. She has been a trustworthy colleague. To so many others I am exceedingly grateful. The entire congregation of First Christian has patiently learned with me for twenty years. Here I have received some of the most encouraging reinforcement for my call. In this congregation, I also heard a very clear challenge to my capacity to be a pastor.

"You can't be a minister, you're a mother."

A member of the search committee fifteen years ago told me this emphatically. This woman, who did not really know me, had a script for me just like my mother. She voiced a conviction prevalent in our culture then and now. Because her experience was different, she could not imagine a woman working both inside and outside her home. If a woman had children, the woman's loyalties would be to her children, period.

I responded with something like, "I'm doing that now." What I would like to ask today is, "What about all the male ministers whose loyalties were turned away from their families and toward their congregations? What about pastors who were also fathers and the sacrifices their children made without being asked because Dad had a call to serve the church?"

Parenting and pastoring in tandem is not easy by any stretch of the imagination, but it's not impossible. My children have learned that at times family plans go on hold. I am blessed to have an able partner in ministry, my husband, Mike. Late night hospital calls and other emergencies are shared along with family care. I also am blessed to serve a congregation that learned with me that if family comes first for them, the same needs to be true for their pastors.

I've observed in all of us who love the church–clergy, lay, women, and men–we all can be pretty demanding of ourselves. The balls we juggle don't stay in the air all the time. We need to give ourselves more grace when one of them momentarily hits the ground. A lack of grace for ourselves erodes our spirit and empties our minds of creativity.

A dear friend and sister clergy helped me in recent years to move from living out of the culture of judgment into a culture of grace. Emily's words of accountability when I was full of judgment woke me to the grace I was missing, the grace that was before me and in me all the time, the grace that tapped me on the shoulder when I was nine and I discovered, "I could do that."

Find grace. Grace is all around you and in you.

Grace is in those people and actions that make you fully alive. Irenaeus wrote: "The glory of God is the fully alive human being." Being fully alive happens as we serve where we are planted, but serving can also drain us of much needed nourishment. We also need to attend the soil of our own lives and not expect all the grace to come from the work we are doing. We become boring servants if all we do is "church work," clergy and laity alike.

I never planned to be in one place for twenty years. One of my "growing edges" is patience. Perhaps it is God's sense of humor that I have served this long with one congregation. I've learned that people come and go. It is a demographic fact that people move more on either coast; it is a more

transient population. I don't get anxious when they leave because more people will come. They always do. I have also learned that what most people are looking for when they wander into our church is acceptance, healing, and hope. They need a community of grace.

Today God is likely tapping the shoulder of nine-year-old girls in your church. They need a community of grace, a community recognizing their gifts and encouraging them to use those gifts. I never had anyone in the church encourage me in any vocation, let alone ministry. My male counterparts tell me they did hear and receive words of encouragement.

Women, newly ordained and ordained for years, need a community of grace that recognizes and wants to receive those gifts.

The gifts of clergywomen are still ignored, even while some doors of opportunity have opened. I know from experience and observation that women clergy still face barriers of sexism within the church. We are still an anomaly to people outside church and in other than mainline traditions. I was told as recently as today, in 2008, "I've never met a woman pastor." Then the woman who said that touched me, as if I was a holy object. It caught me off guard. Was she checking to see if I was real? Or was she touching me because she wanted what she perceived I had? I don't know. I think the mere fact I am a pastor represented something special and significant for her. Maybe I represented a possibility, a hope she harbors. All I can do is pray to be a good representation of the possibility and hope of God, whose Spirit harbors in me.

Julie

LETTER 10: *Jane M. Stout*
Minister, First Christian Church,
Wilmington, Ohio

Trusting God's Faithfulness

Dear Church,

The sanctuary is quiet. Echoes of hymns fade as the week progresses. I find comfort and peace in this space. In a sanctuary much like this one I first heard the whispers of God's call on my life. It would take me many years to answer that call and even longer to understand and accept it as a call to ministry.

As a small child, I wandered through the church to sit on the back pew of the dark sanctuary. I could hear the laughter and talk of my mother and other women as they prepared for the rummage sale. I listened to the silence and found peace and a sense of God's presence. As I grew, my listening became more intent. I was searching for direction and a path for my life. I often returned to your sanctuary as a place to "be" with God. I did not share these times with anyone.

It was difficult to express my thoughts and feelings.

I was baptized into the fellowship of First Christian Church, Dawson Springs, Kentucky, at the age of eleven. Only later did I understand my baptism in the context of the Body of Christ and my call to ministry. I was blessed with parents and grandparents who shared their faith and served the church in many ways. They modeled the role of servant leader: deacon, deaconess, elder, trustee, teacher. I learned from others in the church as well: greeter, choir member, board member, youth adviser. I connected with each new minister and watched as he served the people. They were all men. The role of pastor that I was to accept in later years was never filled by a woman in that congregation.

As I grew in faith and age, I became more active in youth groups and camp. The church gave me opportunities to lead worship and even preach while still a young teen. They suffered through these and smiled when I finished. As I look back on those formative years, I see God's hand and recognize the work of those called to guide me to ministry.

They may not know the role they played, but I do. God does.

At camp, I met and made friends with youth from many places, many backgrounds. Camp gave me a broader perspective on the meaning of

church. At sixteen, I was given an opportunity to stretch my understanding of church and faith. I was one of five from Kentucky who attended the International Affairs Seminar, now known as the U.N. Seminar, in New York City and Washington, D.C. We studied the apartheid system in South Africa and toured several urban ministries. We met with members of congress and sought to understand faith through a wide lens. This amazing experience helped shape my understanding of the many ways God works through people.

When I was seventeen, three major events changed the direction of my life.
 The first was attending the General Assembly of the Christian Church (Disciples of Christ) in Louisville, Kentucky. Listening, sharing, and seeing people of a broad mix of age, race, gender, and theology leading worship gave me hope that someday I might find a place to serve. I wanted more. The second was being elected as a co-district youth president. Being somewhat shy and lacking confidence, I was encouraged to start moving out of my shell into a more adult role beyond the safety of my home church. A youth trip to central and eastern Kentucky was the third event. We visited places connected with Disciples and toured Transylvania University in Lexington, Kentucky. I knew at that moment where I would attend college. My call to ministry grew during college.
 It was difficult to understand the call to ministry, but Elizabeth Hartsfield, associate regional minister for the Christian Church in Kentucky, encouraged me to consider a career in Christian education. I found few people to talk to about ministry. Those who encouraged me were often not Disciples. I had even fewer female role models. I continued to listen, seek, and pray. Again I found myself in quiet sanctuaries or out under shade trees pondering the question, "What now, God?" I struggled with that question for three years.
 Through a series of encounters with strangers and friends, I made the decision to enter seminary. I had been in Lexington for four years and wanted a new venue for learning. A friend suggested Brite Divinity School in Fort Worth, Texas. I applied and was accepted. I had not visited the school or even been to Fort Worth, but in August of 1976, I loaded my car with my worldly possessions and set out on the adventure of a lifetime. What I did not realize was that I was setting off on a lifetime adventure and answering my call from God.

I was unprepared for the challenges.
 I struggled with balancing my old perceptions of church and ministry with the new ways I was learning. Again I struggled with ideas of lay and ordained ministry, gender roles, self identity, and awareness. Once again, God provided. I met Steve Stout at Brite. We shared only a few classes but lived near each other in student housing. He was older and almost

finished with his degree. We soon started dating and before long were talking marriage. In December 1977, we were married. Steve graduated the following May. We had a choice to make. Would Steve seek ministry in the area around seminary? Or would I quit school to follow him, seeking to live out my call to ministry as his spouse?

No opportunities came near enough for me to remain in seminary. I made the choice to follow him and serve God in a different way than I had planned. Through the years of parsonages and church dinners and moving from place to place, I became adept at finding work and settling into new communities. I was active in local, district, and regional church work in each place we settled. Still the sense of my call remained a distant echo in my heart. Someday I would go back to seminary, and Steve and I would share ministry together as colleagues. It took thirteen years for that to happen. Our son Ben was about eight when I returned to seminary. I was thirty-six. At any age, seminary is meant to be challenging and transforming.

I was still arguing with God about the definition of the call on my life. I learned to receive it in God's time, not my own.

God sent people who helped me to understand and trust that call. Jan Linn served as my spiritual director, helping me to understand the meaning of call and to articulate my faith through writing. He encouraged me to remain open to the ways of God's leading. Jan Ehrmantraut, my supervisor for field education, offered quiet wisdom and friendship. When we first met, she was a pastor of a congregation and served as the role model I had longed for. Steve continued to offer me encouragement and space to explore my call. On May 13, 1994, I graduated from Lexington Theological Seminary. It was Ben's twelfth birthday. On May 22, I was ordained at First Christian Church in Dawson Springs, where I heard my call. I was forty years old.

I returned to my family and waited for a call, for a call from any church. It was a long wait. I interviewed, but either I did not sense God calling me there, or the church did not feel God's call. It was a torturous time. It was hard not to question my calling. It took eighteen months. Steve had to give up his ministry and take a leap of faith that he would be called to a church near me. It was not an easy decision. Should one call to ministry take precedence over another? Steve made the move for me and was called to his new ministry the night we moved into our new residence. God was faithful.

The churches were twenty miles apart. I was called to First Christian Church in Newton Falls, Ohio, and Steve to Cortland Christian Church, Cortland, Ohio. I was the congregation's first full-time female pastor. It was truly a learning experience for all. I will always cherish the opportunity to serve with them. I learned the joys and heartbreaks of being a pastor.

I learned about faith, service, and sacrifice from the people I served for almost ten years. I learned that ministry takes many forms and cannot be isolated within the walls of the church building.

Community and faith go together.

Steve was busy at Cortland helping them build a new fellowship hall and kitchen and working for seven years on his Doctor of Ministry degree at Pittsburgh Theological Seminary, graduating in May 2003. It was a joyous time. We found a rhythm of sharing ministry, participating in the other's church as much as possible while encouraging them to work together in some ministries.

From our earliest days together, Steve and I had dreamed of sharing ministry in the same church. Our dream died on January 23, 2004, when Steve was admitted to the hospital with a suspicious mass on his brain. Surgery followed, and he was diagnosed with the most aggressive form of brain cancer. The prognosis was death within six to twelve months. We were devastated. We were scared.

We lived far from family, but the churches rallied around us and became our families during that difficult time.

Steve proved the doctors wrong more than once. He continued to serve as pastor at Cortland. I continued at Newton Falls. When he could no longer serve the church as minister, he went on disability. I left First Christian to become interim minister at Cortland. As Steve's health deteriorated, I came to a point when I needed the church in a way I never had before. I was used to giving, not receiving. It was hard to ask for help, although both congregations continued to stand by us. In March of 2006, I resigned as interim and began a period of family leave. Steve had lived two years and seven months after his diagnosis, dying August 31, 2006.

During this time our son, Ben, served in the Navy, met and married Amanda, served on board ship for six months in Central and South America, and gave us our first grandchild, Stephen. Steve was able to be part of those life events.

We were blessed with time we thought we would never have.

Suddenly, Steve and I were no longer active pastors of the church. The region did not know what to do with us. Traditionally it is expected that the former minister would quietly disappear from the scene, if not move away completely. I commend Rev. Bill Edwards, Ohio regional minister, for listening and responding with compassion.

My story does not end with Steve's death. His illness was very public. His death touched many. I continued to live in Cortland for three months. In December of 2006, I packed up my worldly possessions once again

(although there were movers to help) and stepped out in faith. I moved to Florida to be near our son and family. Several months were spent being "grandma" and learning to live alone. I needed to grieve and to do it away from the public life of ministry. I also needed to revaluate my call. I had to ask the questions: "Do I stay in full-time ministry? Do I seek another pastorate or seek to do ministry in some form other than the local church? Had my call to ministry changed now that it was no longer intertwined with Steve?"

In seminary I had written in my journal about a vision I had of a crossroad. I now found myself at that place. I waited for direction. It seems whenever I ask God for direction, time is always involved, lots of time. I have learned to trust the process and, more importantly, to trust that God is in the midst of the process.

That trust in God's faithfulness led me to my new ministry.

On January 1, 2008, I became pastor of First Christian Church, Wilmington, Ohio. Most days I steal away and go to the sanctuary to listen. Echoes of music, scripture, and fellowship linger like whispers. Here I am most at home. Your sanctuary, dear church, is still a place where I come to seek God whether in the celebration of worship, the reflection of communion, or the quiet of the weekday.

Like those before me, I live out my call to ministry in part, by helping others discover God's call on their lives.

Jane

LETTER 11: *Cynthia K. Stratton*
Senior Minister, Bon Air Christian Church, Richmond, Virginia

My Heart's True Home

Dear Church,

I can't begin to think of how different my life would have been if Jane Rawlings had not asked me to that first church camp. Of course, her lure emphasized lots of cute guys there. As it turned out, the girls outnumbered the guys three to one. Yet I have to say, hats off to you, Jane, because you led me to a place where I could find my heart's true home. There I had the good fortune of meeting Bill McDonald, who changed my life.

Through Bill McDonald I saw miracles happen.

I saw people who were sad and lost find encouragement and hope because he was a conduit of God's love. He was the "coolest" person I had ever known. Through him I knew that being a minister had to be the absolute coolest thing anyone could ever want to be. And it is cool! Not the proverbial bowl of cherries, but I cannot imagine doing anything else that could have meant more to me.

I still remember walking into Bill's office and talking with him about my hope to enter ministry. It was a shock to me but never to him. He was the almost "Reverend," almost all-knowing one, at least to those of us who had the good fortune to be in his youth group.

He showed us all by his example what it means to be a great minister.

He has been and will always be my number one role model. I saw how he touched people's lives. I saw how he took goofy overemotional teenagers like me and gave them hope by embodying God's love in such an accepting and caring way. And he was funny! I had never met a funny minister before, but it was certainly a plus. His side kick, Mike Moore, the associate minister, was another person who helped me see what a profound difference ministers make in the lives of hurting people. The two of them opened a whole new world for me. Midway Christian Church and its youth group were a lifeline during my turbulent adolescent years.

I must pay tribute to the most extraordinary woman I have ever met. Talk about good things coming in small packages. She was small in stature but mighty in spirit. Mrs. Ruth Roach, my Sunday school teacher, sent

postcards to us at church camp. She would often pile us in her station wagon and take us wherever we needed to go. Her front porch swing was always available if you needed to talk. It was really special to have her accompany me to my ordination interview. I knew she was proud of me. My life was so wonderfully blessed because of her friendship.

Never underestimate the power of a good Sunday school teacher.

It never occurred to me that I would face challenges because I was a woman entering the ministry. I do remember my political science professor predicting that I might end up in "Outer Mongolia" because women were in short supply and even shorter demand for ministry at that time.

I will never forget the guy I went to see in the hospital who told me: "I don't like women doctors, I don't like women lawyers, and I don't like women ministers." I said to him, "I can try to study harder to be smarter, work harder, try to preach better, but there are some things I just cannot change. God is the one who called me. That is good enough for me whether or not it is good enough for you." Actually, he kind of liked my response. To be sure, I have had the unfortunate experience of becoming all too familiar with discrimination since those youthful naïve days.

All in all I have been more blessed than I could have imagined or hoped.

What a great privilege to be able to get up and go to work in the morning and have the opportunity to be a part of the most important moments of people's lives. What could be better than to be able to share with others the love of God and to have work that births hope out of the ashes of disappointment? The churches that I served as a student graced me by teaching me what it really means to be a minister.

Somerset, Kentucky, was my first official position in ministry. As minister of youth and education, I learned that half the job was showing up. People needed a presence. They expected no magic words. Being there, caring and offering a hand to hold meant an awful lot. Coming to the office made more of a difference than one would imagine. It sounds almost silly, it is so simple.

I have found ministry is often about being there and offering God's love.

In Maysville, Kentucky, as an associate minister, I learned that you had to stand for what you believed in, even when it wasn't popular to do so. People respect you for holding your feet to the fire for your convictions. Through the years I have learned that if it isn't hard, then you probably aren't being mindful of the challenges of ministry.

As refugee resettlement consultant on the regional staff in Florida in conjunction with the Division of Homeland Ministries, I saw how the love of church members transformed lives. These people were lost, with no

home and no worldly possessions but what they carried in their hands. These refugees were wrapped in love and given a place to call home and begin a new life.

At First Christian Church in Shenandoah, Virginia, I was pastor. They did me the wonderful turn of introducing me to my husband-to-be and helped me see what it really meant to be a "pastor." Between the Massanutten and Blue Ridge mountains, surrounded by the majesty of God's good creation, a congregation not large in numbers but mighty in spirit blessed me with the privilege of serving. They knew far more than I did about what it means to be soaked in the Word of God, but they were patient enough to teach me. They fed me damson preserves and the best homemade nonfat food ever. More importantly, they fed my spirit and graciously welcomed my ministry in their midst.

My present pastorate at Bon Air Christian Church in Richmond, Virginia, has with kindness allowed me to be their pastor for more than two decades. They are an amazing, vital congregation. They have met many challenges and continue to grow and thrive. They have celebrated the birth of my youngest child and grieved with me the death of my husband. They have nurtured my three children, and I have dedicated, baptized, married, and buried their family members. The closeness I feel for them is beyond words. While serving at Bon Air, I have had the privilege of being involved in the whole church by working with our denomination's district, regional, and general manifestations, as well as sharing with my colleagues in ecumenical events.

Ministry has never been an easy job.

It really is work, as well as a calling. But it has been brilliant. I cannot put into words the absolute happiness I have when I baptize someone into the faith, into Christ and His church. How can you describe the beauty of a young person emerging out of the waters of baptism with water dripping down the face and joy beaming from his being? What a wonder when parents place their baby girl in your arms and we pray for God's blessing. What greater honor could there be than to be invited to be a part of peoples' most moving, most poignant, most tender moments of their lives?

I have had the humbling privilege of standing with people at the most significant times of their lives. It has moved me to stand before a man and a woman as they vow their lives to one another forever. And yes, while my heart has overflowed with joy as members have celebrated, it has also broken with sadness when the members of my congregation were hurting.

Likewise they have stood alongside me. Through the happy days with children and the aching pain of my husband's death, the church has ministered to me in deep and abiding ways.

The church has truly been my family.

It is home, the place where we go when we sometimes don't know where else to go. I have known, as Dickens said, "The best of times and the worst of times" at church. Like any family, it can also include discouragement. At times I feel like a sieve. I am trying so hard to allow God's grace to flow through me, and I am such a wanting vessel. Who hasn't felt unappreciated and exhausted? In my pouting times, I know I have waited too long to get back to the well, to dip my life into the living water. I have let my life get parched, and I am useless. Sometimes giving and giving and giving leaves me as my grandmother would say, "Give out." I do have some great members who are wise enough to say, "Take a break."

One of the great joys in my ministry came when the Bon Air congregation celebrated the ordination of a young woman named Amy Spangler. It was magnificent. I know Amy is out there touching lives and making a wonderful difference in the world. I hope and pray she will always know that our prayers surround her and that she will carry within her being the incomprehensible strength of God's peace.

Another young lady in the congregation has considered ministry. Her mother informed me that Sydney watched a little too much of the television program "7th Heaven" and is perhaps less enthusiastic about dealing with the insidious trivialities that sometimes descend on ministers. Apparently the show includes a discussion about the color of shoes that the minister wears, perhaps even more discussion about his wife's shoes. Having dealt with the weighty issue of shoe color and style, I can tell you that church members have varying views on appropriate shoe selection. Sydney, I would say that before you consider a workplace with greater shoe acceptance, let me tell you a little more about how the shoe fits in surprising and wonderful ways. To any person who is considering ministry, I could not have asked to do anything that would have meant any more to me than what God has so graciously allowed me to do in these past twenty-seven years.

Even through such a flawed vessel as me, God can create wonder and beauty.

Bill, I will always be grateful to you for showing me the way. You cleared a path for me. Your friendship and your kindness exemplified for me the difference a minister can make in the lives of those who ache for the good news.

I thank God every day for every single person who has touched my life with their kindness, their encouragement, and their support. I continue to be unbelievably fortunate to be able to go to work every day and love what I do. I also know that apart from God I can do nothing. I remember times when suddenly I saw the good news break forth in someone's life. They got it! They took it in. The love of God became real to them.

I am so thankful to be part of the transformation that the holy one makes.

I have seen no other community that could be a more powerful witness to hope in the world than the church. It is my great joy to have been called to serve.

A special thank you to my children, who have graciously survived being "preacher's kids." Robin, Chad, and Micah have been to every conceivable kind of church meeting there is. They have kept me sane with their love.

Cynthia (Cindy)

LETTER 12: *Ginger Jarman*
Co-Pastor, First Christian Church,
Las Vegas, Nevada

Funny God-Things

Dear Church,

Many years ago, at a Pension Fund breakfast, the late Dr. Granville Walker shared with us "A Funny Thing Happened on the Way to the Pulpit." I would have to say that many funny things, and many "God-things," have happened to me on the road to ministry.

I have often said I had no role models for ministry, but the truth is many have mentored me. My mother, then a deaconess and now an elder, modeled pastoral care, taking me with her to deliver ceramic personalized baby bootie gifts to new mothers, and freshly baked bread or a casserole to those suffering grief and loss. My grandmother kept *The Secret Place* and *The Upper Room* in her bathroom and modeled daily spiritual discipline and Bible study as she prepared each week to teach an adult Sunday school class. My father as a teenager planned to become a minister; but along came a war, and he was needed as a pilot instructor. He demonstrated his love for God through teaching, lay preaching, serving as an elder at the Lord's Table, and going the second mile as he provided leadership for a small mission church. He often took me along to play the piano for the children to sing "Jesus Wants Me for a Sunbeam."

My pastors and youth ministers communicated God's love with commitment and compassion.

When I was four weeks old, my parents carried me to church in a picnic basket and tucked me under the pew. First Christian Church, Abilene, Texas, was an extremely active and vital congregation, with excellent Christian education and youth ministry programs. I remember being there every time the doors were open. In the seventh grade, I thought I wanted to be a school teacher and coach. By the summer after eighth grade, I knew I wanted to prepare for ministry. I was fifteen years old when I clearly heard and responded to God's call and publicly committed my life to fulltime Christian service. My parents affirmed my call, but suggested I should also get a teaching certificate just in case no church jobs were available for women.

I believed that to do so would be evidence of a lack of faith on my part.

I was sure that since God had called me to ministry, God would provide a place for me to serve. At first, I thought I was being called to youth ministry or Christian education. After three years in a "summer apprenticeship" in an Arkansas church, I realized that God was calling me to pastoral ministry.

We had three church-related colleges in my hometown. My parents thought I should attend one of those. I was insistent that it was important for my undergraduate education to be in a Disciples school, specifically Texas Christian University, Fort Worth, Texas.

I was anxious to get started, so I obtained a church vocations grant and attended an early admission program at TCU in the summer of 1964. After high school graduation, I spent eight years on the TCU campus, completing B.A., M.Div., and D.Min. degree programs, plus clinical pastoral education and pastoral counseling training.

Seminary was a wonderful experience of living in Christian community, balancing the challenges of student ministry field education positions with the academic demands of graduate theological education. The student body was 95 to 98 percent male. All faculty members were white males, mostly Disciples. Years later, I envied the women seminarians who had the opportunity to study with women theologians and professors of various ethnic and denominational backgrounds.

During my four years at Brite Divinity School, the student body numbered approximately 200 with no less than three and no more than ten women enrolled each semester. While we didn't fully understand the label pioneer, we women seminarians of the early 1970s were part of a nationwide movement paving the way for women to have equal opportunities to live in seminary housing, to sing in the seminary choir, to play on the seminary softball team, to preach in university chapel, to model inclusive language, to serve in student solo pastorates, and to have safe space for supervision.

Toward the end of seminary I began to wonder if God intended that I serve in ministry as single and celibate, or if God would provide me with a ministry partner and spouse. When I was twenty-three, I asked my parents if I could use the money they had saved for my wedding and go on a three-week seminary trip to the Holy Land. On my twenty-fourth birthday, I told my pastoral care professor that I didn't think I would ever marry. I had become good friends with many of my classmates, but the one I had been dating for more than a year was just a dear friend.

Then I realized, wasn't that what love is about, a relationship with a dear friend?

Our friendship grew into a deep love and great respect for one another. David Jarman proposed on the back row of an empty chapel at TCU one

evening the following summer. It was fitting that our engagement was discussed and our decisions made in God's house. We married between the end of our Master of Divinity degree and beginning of our Doctor of Ministry programs. David's father, Robert Jarman, a Disciples minister, officiated at our wedding in the same Robert Carr Chapel where we had become engaged. It has been a wonderful journey in marriage, ministry, and parenthood. Our two daughters, Elizabeth and Jennifer, experienced the very best that the church has to offer, but also witnessed the church at its worst in some unhealthy church politics.

In my early years, I had the opportunity to serve as hospital chaplain, pastoral counselor, campus minister, youth minister, associate, interim, and senior minister. As one half of a clergy couple, I always felt it was important to be flexible and prepared to do a variety of different kinds of ministry. Even if I had never married or if I had married someone who was not in professional ministry, I think the Disciples' relocation system would have been a difficult one to navigate. Not all clergy couples work well together. We received excellent advice.

We were advised to establish separate identities and develop self-confidence and competence in our own individual ministries before trying to work together.

We are now serving in our fourth co-pastorate. It took a while for our current congregation and us to find each other. They had been searching for more than a year, and we for more than two. After a lengthy process, which included several interviews but no real opportunities for both of us to serve except in churches at least forty miles apart, we embarked on an Alaskan cruise, a gift from my mother. As we were riding along on a river raft, it became clear that we were free to go anywhere God wanted us to go. Yes, we had experienced hurt, as many pastors and their families have. We had "hung in there," too long perhaps.

Within a very short time after our return, we were called for an interview with First Christian's search committee. Our visits with the congregation convinced us that it was a good match and that God indeed was calling us to yet a new adventure. If I had made a list of 100 places I thought God might send us, Las Vegas would not have even been on the list.

Six years later, we remain grateful for this very special congregation and its openness to calling pastors over fifty-five, including a woman as co-senior minister.

I am passionate about many areas of ministry. Ministry to children and youth is at the top of the list. In addition to our offerings, ministry in the community and world through hands-on mission and service are important. That includes Korean, Haitian, Hispanic, Filipino, and African American congregations who are now nesting in our church facility. Three of these

congregations are led by women pastors. The Miracle League, which provides a special baseball turf and program for special needs children, has one now under construction behind our church. This will be the first Miracle League field in the nation to be located on church property.

Today I am thoroughly convinced that God calls women and men, children and youth to ministry. If it is truly God calling, you will always have a place to serve God's people. While I was still in seminary, I received a letter from my mother. She had carefully folded and included an article from my hometown newspaper. It told the story of a United Methodist laywoman who, upon learning that the bishop was sending a woman pastor to serve her church, confessed, "I had been praying for God to send us a wonderful pastor, and I believe that God calls women to ministry. I just didn't want one to be my pastor." In time she grew to love her new pastor.

My boyfriend throughout high school was Catholic. Upon graduation, knowing that I was going into ministry, he, an artist, presented me with a framed, hand-lettered quotation. It reads: "I will not follow where the path may lead, but I will go where there is no path, and I will leave a trail." There have been times when I resented being called a "pioneer" or a "trailblazer."

I just wanted to be a pastor and not have to spend time on "women's issues."

I would not be completely honest if I did not say that some of my sisters in ministry never found meaningful places to serve. Sometimes repeatedly paired as an associate with a male senior minister who was somehow threatened by her presence, talents, and gifts for ministry, some of my sisters experienced difficult times before finally deciding to leave the ministry. A few who tried serving as a clergy couple in team ministry ended their marriages. Still others met major hurdles after being hired because one or two individuals in the church made life miserable for the new minister who was a woman.

One of my favorite mentors, the late distinguished pastoral care professor Dr. Charles Kemp, used to say, "Jesus did not call us to be successful, only to be faithful." I am grateful for the journey–all of it. Those of you who may be considering your call, listen for that "still, small voice," on your faith journey.

You may find funny things happening to you on the way into ministry. Be grateful for your journey, too. All of it!

Ginger

Dear Church
Associates

LETTER 13: *Elaine W. Austin*
Minister of Youth and Family Ministries
Westhampton Christian Church, Roanoke, Virginia

Ministry Saved My Life

Dear Church,

How do I write you a letter that truly encompasses my passion for ministry?

Ministry saved my life twenty-eight years ago! Now it has become my life.

I grew up at First Christian Church in Radford, Virginia, participated in all of the things that kids do, but church was not a "passion" for me. When I graduated from college, I had no idea what I wanted to do with my life. I went to college only because it was the thing to do, an easy out. I was miserable after the first year. I left my home church to baby-sit for another congregation and did not consider returning until Richard (Dick) Rhea and Gina Rhea came to First Christian to be our co-pastors.

My call came at such a desperate time in my life. In the summer of 1980 Dick asked me to serve as a counselor for the regional church camp he was directing. I was frightened, but knew that I loved kids. Once when I was nine or ten years old, I had attended the Craig Springs Conference Center, operated by the Virginia region, but no one ever encouraged me to go again. I had forgotten about that wonderful place.

I enjoyed my first year of counseling. It proved to be a much better experience than I expected. I loved the community feeling and worshiping

around a campfire or out under the stars. I experienced such joy that the next summer I asked the regional office to sign me up to counsel. That proved an intimidating experience! When I arrived, I knew no one. By the end of the week I had made relationships that have lasted to this day. The next summer I signed up for two weeks, and the next summer, for three.

Each time I went I felt a pull to return.

Camp was the place I was the happiest, the place I felt accepted for who I was. I didn't have to pretend. You know I am not an athletic person and usually avoid getting involved in sports. At Craig Springs, I felt so accepted that you couldn't get me off the volleyball court or the kickball field. At camp I could laugh at myself as much as anyone else. What a wonderful feeling to be accepted and loved! God was pulling me. In between camps, I was spending a lot of time in Dick's office, wrestling with my feelings and asking him what was going on. He did a wonderful job helping me to discern that God was calling me to ministry.

I kept saying, "But I don't want to preach. I am not good enough to be a minister. I am a woman!"

During this time, I also was blessed to be able to watch Gina Rhea as a pastor. It was the first time I had been around a female clergyperson. Ironically, she came to First Christian pregnant with their first child. It was encouraging to watch and see how she nurtured the parishioners. She added qualities to ministry that I had never seen before. Dick was the "human side" allowing me to see that I didn't have to be perfect to be a minister. Gina was the female allowing me to see it was okay to be a woman, a mom, and at the same time an effective minister.

All my hours in Dick's office helped me to realize that God was calling me to work with children and youth.

In the fall of 1985, I began my studies at the Presbyterian School of Christian Education in Richmond, Virginia. I finished my degree in May of 1987 and was ordained in September. I was already serving as the associate Minister at Memorial Christian Church in Lynchburg, Virginia.

My childhood dream was to get married and have children. During those young adult years when I wrestled with God's call, I had no prospects of marriage. When I made my decision to enter graduate school, I gave up on that dream. I decided that God had other plans, and somehow I would be able to let go if I continued to focus on God's call. At times that dream kept interfering with my happiness, but I forged ahead. In 1990, God called me to a new position at Broad Street Christian Church in Martinsville, Virginia. It may not have been the most exciting place for a young adult to be, but I went because God called me there. My friends and family kept telling me, "Elaine, you will never find a husband in a small town like that."

My heart told me that I should go.

I felt very lonely at first. Then an amazing thing happened. I began dating one of the members of the congregation. I probably would not recommend dating a member of the church where one is serving, but I know that God brought Bill and me together. Three years later, we were married at Broad Street. Two years later, I resigned to become a full-time mother.

Giving up my full-time ministry and committing myself to being a mother proved difficult. I felt like I was neglecting God and avoiding what I had been called to do. Looking back, I know that I was wrong for feeling that way. Being a mother is an extremely important role for a woman and committing to it full-time was what I needed to do. God blessed Bill and me with two beautiful children, Sam and Mallory. Even though we experienced financial difficulties, I stayed at home through their young years. I never stopped going to camp. Our children grew up at Craig Springs and fell in love with it just as I had done. To this day, it is their favorite place to be.

Motherhood is the most stressful "ministry" I have ever done but the most rewarding.

Through all of my life, I have found my mother, Peggy Wilson, to be a great inspiration. She was a stay-at-home mom who committed her entire life to raising three daughters. She put our needs before her own. She sacrificed her happiness for ours. Her faith has always amazed me. When we were young, she taught Sunday school, led the junior high group, and attended worship faithfully. No matter what was going on, Mom always found a few moments to sit and read several passages of scripture before she went to bed. She had battled cancer twice and a heart attack, but those events only strengthened her faith. Mom and I have always been very close. One of the toughest things I ever did was to leave her when I went to graduate school. She was able to let me go because she knew that God was calling me.

I am challenged at times for not going to seminary. I have a Masters of Arts degree but not a Master of Divinity degree and am ordained with full standing in the Christian Church (Disciples of Christ). I stand strong believing that God called me to work with children and youth. I have spent hours working for children's causes, trying to be their voice in the midst of a broken world. I have committed time to traveling around the country training churches in a program endorsed by our denomination called Children Worship and Wonder. This wonderful worship program allows children to worship God at their developmental level. I try to teach congregations that children are born with a relationship with God and that we need to offer them a sacred space in which to grow. I work to promote

child protection policies in congregations so there will be a safe haven from the cruelties of the world around them.

Sometimes I still wrestle with where my priorities should be—motherhood or ministry.

I love them both so much. I know I have married the best man in the world. Whenever possible, even though he is employed full-time, he plays "mom" so I can do what I need to do. The children complain, just as most "PK's" (preacher's kids) do, but I know that we have instilled in them a commitment to the Church and an understanding of the need to be accepting and loving to all of God's people.

I had an "aha" moment today. As I was sitting in a coffee shop composing this letter to you, someone stepped up to me and called my name. I looked up to see a young woman, Kristen Mann, whom I had not seen for years. She was one of the many campers I had counseled. When she asked me what I was doing, I said, "You won't believe this, but I was just writing about you." She sat down, and we spent some time catching up on our lives. I could not believe the irony of that moment. I am sitting and writing about my call to ministry and the relationships that I had found when I became involved at church camp, and in walks Kristen.

God was giving me a special reminder of what I have always known.

My prayer is that this letter will give you reason to celebrate the many gifts of ministry. I hope that you will be sensitive to female parishioners who might be wrestling with their calling. I also pray that you will be open to the many avenues of ministry that are needed in the Church.

Ministry is a tough profession with many blessings but also with many struggles. The biggest difficulty I have found in my twenty-two years is that congregations try to put ministers in a box with all other professions and jobs. They do not understand that ministry is not a job or a profession. Ministry is a life! I have been asked by many personnel committees to give an account of the hours I spend doing my "job." It is always impossible, for ministry is 24/7. I find it very hard to leave my job. Even on my days off or on vacation, I am "working," wrestling with an idea or a sermon or thinking and praying for a parishioner who is sick.

To women who might be wrestling with their calling, I encourage you to listen to God, listen to the people whom God has put in your lives. Most importantly, listen to your heart.

We have a compassionate heart and have the instinct to care for others.

Elaine

LETTER 14: *Mary Jo Bray*
Associate Minister, First Christian Church
Wauseon, Ohio

Busy Enough to Pray

Dear Church,

I am a woman. I am a minister. At times, one does not necessarily have anything to do with the other. At other times, the two are so intertwined that separation is impossible. Those are the most difficult times. In my mind, being a woman has little to do with my vocation, although I do acknowledge that as a woman I bring certain qualities to ministry that perhaps men do not, such as the ability to handle more than one thing at a time, the ability to see the emotional side of things, and the ability to listen to women in crisis.

I've never been particularly comfortable with the label "woman clergy" or "women in ministry." Such labels conjure up an image of one who is "different," "out of the loop of modern women," and "no fun." I am none of these things. God has blessed me with a sense of humor and an ability to laugh at myself, essential qualities in life generally but exceptionally helpful in womanhood and in ministry.

I am a product of a Christian home, a solid church family, and Camp Christian (the summer camp of the Christian Church in Ohio). Although God did the calling, all of these played a role in leading me into ministry, a calling I ignored at the beginning because it sounded dull and no fun. Ministry was certainly not in my plans. After a disastrous first year of college, and several people saying, "I told you so," I abandoned my plan. I said "yes" to God's plan and was on the way to a career in parish ministry. I attended Bethany College, worked at Camp Christian in the summers, and enrolled in Lexington Theological Seminary, from which I graduated in 1990.

Being a woman—a single, young woman—basically took the center stage in my first church out of seminary, the Clyde Christian Church of Clyde, Ohio.

Single ministers must make congregants uncomfortable or invoke a sense of obligation to remedy the situation. It didn't take long for a well-meaning church member to "fix me up" with her friend. Her friend became my friend, and eventually my husband. A whole church family watched us date, celebrated our engagement, and threw a wedding celebration complete with white-coated deacons who seated guests and served communion. This

same church family supported my husband and me through the illnesses and deaths of our fathers within three months of each other. Then the children came. Being a "pregnant woman minister" has a dynamic all its own, as I'm sure you can imagine. It's out there for the entire church family to see what we had been up to in the off hours!

With joy, this loving congregation developed a maternity leave policy (a first for them) and celebrated the birth of their first "community grandson." They brought gifts of beautiful handmade baby blankets and food to the house. They threw a baby shower fit for a prince. Our son had been born prematurely and so became the guest of honor at his own party. All in attendance passed him around. I continued to work full-time during his early years, often taking him to work and laying him on the floor of my office and then hauling him to nursing home and home visits in the afternoons.

Our daughter was born three-and-a-half years later with much the same excitement, but not nearly the folderol as the first. Soon after that, I felt a strong maternal pull to be home with the children and not work full-time while they were little. I also grew tired of coming home to "Tornado Alley" on the days dad was in charge. After much prayer and with heavy hearts, we said good-bye to this congregation who had helped us with the growing pains of becoming successful adults. We had become very close to these wonderful people. The relationship I shared with this congregation as their pastor was one that I had not experienced before or since. Many of the relationships we formed there remain strong to this day.

It certainly was an unusual relationship, definitely more parental than pastoral.

At this point God was preparing me to be not only a mother to my children but also a daughter/caregiver to my mother, who had developed a dementia-related illness. God provided a way for me to move back to my hometown and care for my family. This arrangement lasted approximately eight weeks when I realized rather quickly that God did not create me to be a stay-at-home mom.

God called me to be the part-time pastor of Fayette Christian Church, a rural congregation in Fayette, Ohio, approximately eighteen miles from my home. It was an ideal job, with wonderfully committed people who cared about each other and worked well together. Serving this friendly church was a tremendous blessing. I worked four days and stayed home with the children the other three. I cared for my mother, which enabled her to stay in her home where she wanted to be. I served the church for another eight years. I was able to raise my family, care for my mother, and tend to the flock, not always in that order.

My journey has come full circle since I accepted a call to serve as the associate pastor of my home congregation, First Christian Church in Wauseon, Ohio. Several people cautioned me against serving my home

congregation. They said it wasn't a wise idea, too many possible conflicts. But I began a full-time pastorate. To me the benefits were many. My family did not have to move, my children did not have to change schools, and no more commuting thirty-six miles to the office and back. I could care for my mother, reap a full-time salary, and perhaps the biggest draw, the opportunity to work with a senior pastor, Mitchell (Mitch) Maxted, who had been a seminary classmate and friend throughout the years.

Our ministry is a team venture.

The experience of serving my home congregation has been an interesting one. It had been nearly twenty-five years since I had been in the sanctuary. Many faces had changed, both geographically and physically. I occasionally hear, "I remember you when you were younger," which I consider a joy.

I pastor my mother and several cousins. Recently I officiated for the funeral of my uncle. The joys of being a pastor to my biological family have far outweighed the challenges.

Our son is now fifteen, and our daughter, nearly twelve. They are certainly preacher's kids. I don't mean that they are just the biological offspring of a preacher. I mean they have preacher's kid mentalities. They know lots more people are watching their behavior and listening to their words than to many other kids their age. They also know how to play that to the max. The flip side is also true.

Our children, as preacher's kids, have the loving support and guidance of many people who care about them and want to see them succeed, more so than most kids.

Our "PK" son has a wonderful heart and a growing love for the Lord. He will also push the envelope in terms of speech and behavior, especially around church members. A balcony at the church is actually a separate room with a glass wall overlooking the sanctuary. It seems to be a popular spot for the youth to gather during Sunday morning worship. I can see them from below goofing around, laughing, and not particularly paying attention to what is happening in worship. I said to my son, "No more sitting in the balcony. From now on you sit in church with Dad." (Insert teenage resistance here.)

The next Sunday at 10:43 a.m. (the service begins at 10:45), I'm lined up, dressed in the usual regalia, Bible tucked neatly under my arm, looking the epitome of ministerial. I'm taking a step into the sanctuary, following the acolytes, when I feel a tap on my shoulder. My son says, "Mom, can I sit in the balcony?" To which I snap, "No!" To which he asks, "Why?" I'll only let the reader imagine where it went from there. Rest assured the conversation continued after services that day.

I should mention my daughter who is nearly twelve going on seventeen. She arrives at church for Sunday school dressed like Paris Hilton because a high school friend had shared "hand-me-downs" unbeknownst to me. Let me just say that the two most unchristian hours in our home are the ones before and after church. It starts with "get up" and ends with "you did what during Sunday school?" I will interject at this point that one of the biggest reasons I can succeed in this vocation, in addition to God's guidance, is that I have Bill, a loving and supportive spouse, who understands the demands of a congregation and accepts the pull on my time. If you have that as a woman in ministry, it is a triple blessing to be sure.

The biggest challenge for women in ministry today is balance, and the greatest joy is prayer.

Today women are pulled in so many different directions. We get too many "irons in the fire," some by our own choosing, others out of obligation. I have served on boards and committees throughout the Ohio region and am extremely involved with our regional Christian Youth Fellowship Commission. I serve as an assistant director for one week of summer camp and chaperone the United Nations Seminar for Youth through the Christian Church in Ohio. Something had to give. I had to make some choices about what stayed and what went.

When our lives get so out of balance that the vision is blurred, life seems out of control.

This is due in part because we let the world tell us how many directions we need to go. To balance a career in pastoral ministry, care for a flock, raise a family, and take any personal time is a challenge. Prayer is what keeps the balance. Whether, in increments such as a thirty-minute prayer time during the day or seconds such as breathing quick conversations with God on the way out the door, our life requires prayer. The real value of any pastor, male or female, is not personality or leadership skills or facility or knowledge. The real value of a pastor is the presence of Christ in his or her midst. That presence is made real through the power of prayer.

Ministry and life require communication with God.

A treasured passage of scripture is an out-of-the-way story in the gospel of Luke about a woman who had been crippled by an evil spirit, so much so that she was unable to stand up straight. It just so happened to be the Sabbath when Jesus called her to him and healed her. The *New Living Translation* says, "Then he touched her, and instantly she could stand straight. How she praised God!" (Lk. 13:13, NLT).

As women, not only those in ministry, life can burden us and cause our shoulders to slump. The life stories people bring to us, the responsibilities

we accept, the pressure the world places on us, the weekly administrative demands are all causes for us to be crippled like the woman in the story. Like he did for her, Jesus calls us to him, touches us, takes the burdens, and allows us to stand up straight. It is no coincidence that this happens on the Sabbath, our Sunday. For in the house of the Lord we find strength and can be renewed.

For women considering ministry or already preparing for ministry, the number one priority for your life and vocation is developing a healthy prayer life.

That life of balance will bring a transformation into the wonderful, multifaceted, unique person God created you to be. No one else can do the things you do. We did not choose ministry for ourselves. Who in their right mind would choose such a job? A job that requires twenty-four hour "on call" service, compromises family time, requires a business head and a compassionate heart, a job in which the complaints often outweigh the compliments.

Ministry is a wonderful, rewarding, evolving, challenging, frustrating, breathtaking vocation. It is also one in which we should not take ourselves too seriously. We must not lose the joy! To be the presence of God for people who are often at their most vulnerable and weakest moments is humbling to be sure. It is also the highest calling one can claim.

Thank you for what you have done for me, O Church. You have been my strength in time of need, a joy in time of celebration. Please forgive me when I have called you "The Church of the Long Face."

Nowhere else can one find such peace, peace that comes from knowing God's forgiveness, grace, and never-failing love.

Mary Jo

LETTER 15: *Lee Hull Moses*
Associate Minister of Faith and Family Ministries
First Christian Church, Falls Church, Virginia

Finding My Own Voice

Dear Church,

Someone asked me recently if I considered myself a "pioneer" as a woman in a traditionally male profession. Many women in ministry challenged and changed the church through their faith, courage, patience, and perseverance. They inspired me and paved the way for me to do what I do. They are pioneers. I don't consider myself one of them.

It never occurred to me that I couldn't do this.

The church I grew up in always had a male senior minister, Rev. Richard J. Hull II (my dad), but we almost always had an ordained female minister on staff. I went to church camp and met women who were leaders. I participated in youth activities in which the girls were in charge. In fact, a woman at camp–I don't remember her name but I specifically remember the conversation–first suggested to me that I might want to consider ministry.

On September 15, 2001, I moved into the Disciples Divinity House of the University of Chicago to begin my preparation for ministry. I again found myself surrounded by female peers and mentors: Kristine A. Culp, the dean of Disciples House; Rev. Alison Boden, dean of Rockefeller Chapel and head of religious life on campus; and Rev. Cynthia Lindner, the director of ministry studies. More than half of the entering class were women. The terrorist attacks four days before had changed the world. None of us were quite sure what that meant for ministry, but we never questioned that women would be involved.

I remember a significant moment during my second year of divinity school. I was taking a preaching class, my first. While I never had any doubt that women could be ministers, I did have some serious doubts about my ability to stand up in front of people and deliver anything resembling a sermon.

At a chapel service one evening, Liz Myer Boulton, a ministry student a few years ahead of me, stood up to preach. I had heard women preachers before, but until that point in my life, the dominant preaching voice in my life had been my father's.

When Liz preached the word that day, I realized that I needed to find my own voice and that I could.

I know I still sound like my dad sometimes when I'm preaching, and I'm glad for that. But I think—I hope—I also have echoes of Liz, and Kris, and Alison, and Cynthia, and many others, whispering in my ear.

I currently serve at First Christian Church, Falls Church, Virginia, where women fill both full-time clergy positions. Our senior minister, Rev. Kathleen Kline Chesson, and I sometimes find ourselves in the unusual position of looking for male leadership. We work hard to include men as worship leaders to balance out our two female voices. We've talked about this concern with our board of elders and our worship council, along with others in the congregation. For the most part, the congregation tells us not to worry about it ... but I'm not so sure. I don't want today's little boys to think that only women can be leaders in the church, any more than I want our girls to think they can't be engineers, police officers, or doctors. I've also noticed that the majority of our new members in the past few years have been women. That may be true even in male-led churches.

I want to be sure that we haven't swung so far in the direction of female leadership that the whole church becomes irrelevant to men.

My generation of clergywomen may not be pioneers, but we're forging another frontier. Many of my female mentors are a generation older than I am. They are married to partners who are also in the ministry, teach theology, or otherwise work for the church. I know women who have served the church faithfully as minister's wives, but who might have been ministers if they had been born into a different generation.

I don't think that's true for my generation. I'm part of a support group for younger clergy in my region. Eight of us get together monthly. Five of us are women. All of the women are married, but none of us are married to ministers. Our husbands are scientists, social workers, consultants, IT professionals. I know a few clergy couples but, especially among my closest Disciples colleagues, they are rare.

This may just be my experience, but I do wonder what this change means. Is the church more welcoming to women in leadership than in the past, and therefore women my age feel more comfortable finding a place in the church on their own? Is our culture simply becoming more accustomed to women in demanding jobs of all types?

Is the church beginning to understand that a healthy ministry begins with a healthy minister who balances life and work?

Our husbands not being clergy does mean that our lives do not belong entirely to the church. Monday through Friday my husband works hard at

a job he loves. His job has nothing to do with the church. If I have church activities on Saturdays and Sundays and weeknights, we have to work hard to carve out family time together. One of us always has to take time off if we want to leave town for a few days. (Of course, these are challenges shared by male clergy whose wives also work full-time.)

As I write this, my daughter is approaching her first birthday. My church had never had a pregnant minister before, never had a need for a family leave policy. They took it in stride and loved me through it. In the final weeks of pregnancy, they encouraged me to take it easy, to go home and rest. They stepped up and took over programs so I would be assured things would run smoothly while I was on leave. They lovingly left me alone while I was away. I felt grateful for the network of other mothers in the church who passed on advice and hand-me-down baby gear.

I sometimes wonder what people outside the church do for support.

After my maternity leave was over, I was able to take my daughter to work with me for a few months. I was grateful to be able to keep her close, and for the grace the congregation showed me—especially the other staff—during those months when I was not particularly efficient or productive in my work. Like other working mothers, I hated leaving her at the babysitter's for the first time, imagining all day that she was crying for me. I cried myself the day I realized I couldn't keep up with her need for breast milk, despite the fact that I had a private office in which to pump and supportive and understanding coworkers, benefits many working mothers don't have.

If anything, this—navigating the role of minister and mother—is the frontier that my generation of women clergy is forging, though I'm not sure that the challenges we're facing are any different than those any other working mothers face. Across professions, women are figuring out how to balance career and family. I'm discovering that what I suspected all along is true: the church is a good place to raise a child.

I love watching my daughter at church events, especially now that she is toddling around from one adopted aunt or uncle to another. We live far away from her grandparents, so I'm grateful for the extended family of the church.

About the time I went back to work, someone asked me if I found myself wishing I could stay home with her instead. While I miss her every day, I also love my job. I'm pretty sure I am a better mother if I can use my gifts to serve the church. I suspect I am better able to minister to the families in my congregation because I now know what it feels like to arrive at work after getting my daughter fed, dressed, and to the babysitter, only to discover spit-up stains on the shoulder of my good suit.

Becky was one of the first people I met when I came to Falls Church. She was six years old. I could tell already that she was a child of deep faith. One day, she asked if she could talk to me after church. We sat in one of the back pews in the sanctuary, and she told me she'd decided she wanted to be a minister when she grew up. She wanted me to give her lessons.

A lot of times in that first year I wished someone would give me minister lessons!

Sometimes Becky would follow me after church as I went upstairs to my office and hung up my robe. We talked about the different color stoles I wear, and what the colors symbolize. We talked about what a minister does, and brainstormed ways that she could already serve the church.

Our "lessons" have slowed down in the past few years, as Becky, now nine, has gotten more involved in other things. She remains deeply committed to the church and often suggests activities and mission projects that reveal her generosity of spirit.

If Becky decides to go into the ministry when she grows up, the church will be blessed by her gifts and graces. I hope she explores lots of other possibilities before she decides. I hope she considers science, or education, or law, or medicine.

I'm glad that she knows there is a place for her in the church.

Lee

(Now senior minister, First Christian Church, Greensboro, North Carolina)

Dear Church—
Regional Staff

LETTER 16: *LaTaunya M. Bynum*
Associate Regional Pastor, Christian Church in Ohio

God Is Able

Dear Church,

 I want to put in writing what you and I have talked about for a while, expressing my eternal gratitude for the life and call you have given to me.

 I am grateful for my parents, Charley and Alvah, who took me to Sunday school and children's choir rehearsal and nurtured me physically and spiritually. Most of all, they lived their faith much more than they talked about it. They always told my sisters and me that "God is able." They believed it, and we came to believe it, too. I am grateful for the other adults that nurtured my growing faith–the people at my home church, United Christian in Los Angeles, and Enoch Henry, the pastor of my childhood and adolescence.

He baptized me and encouraged my faith in Jesus Christ.

 I am so thankful that I know Dennis Short, who for a year was the youth pastor at United and my chaplain during my senior year at Chapman College in Orange, California. Dennis, a Caucasian man, introduced me to people who lived and worked at the intersection of the church and social justice. He introduced me to Christian Youth Fellowship and regional leadership. Learning to participate in the life of the church then has led me to fall in love not only with God, but with the church. I am grateful for Vance

Martin, one of the best laymen I know, and for the call to ministry that I heard at Loch Leven, high in the San Bernardino Mountains in Southern California. It is truly one of God's great church campgrounds.

Those are the people and places where my journey into ministry began. Those women and men are among the earliest influences on my trek toward ministry. They gave me the spiritual map and compass I use today.

One of my personal goals is to never betray the trust of the people who put such great faith in me.

God, you placed me in a circle of family and friends who modeled faithfulness to you, a love of every aspect of the church, and the pride and blessing that for many of them had helped them to withstand the racism they had to deal with in and out of the church they faced.

You know they did not always find life easy then. It is not always easy now, so it has been my clear sense of your presence and the support of positive and affirming people that have strengthened me along the way. I knew I was good at ministry. You had blessed my introverted self with the ability to speak clearly, sometimes approaching eloquence, with a gift for prayer, and with a mind that can synthesize and analyze information. Ministry felt like the one thing I was called to do. I cannot think of anything I would rather be doing with my life and with the gifts you have given to me. I know you issued a call, because I am naturally hesitant to be the first one to speak. I like to listen and absorb information. The hesitancy goes away when I am moved, and in the church I am often moved.

You allowed me to use my shyness as a gift, a blessing that allows me to listen carefully and to observe.

I am smart, called, and committed to living the gospel. I stand humbled by the highlights of my ministry. I have grown in every place of ministry you have sent me, even when I did not want to go.

Life is not about where I wanted to go. It has always been about where God has sent me. So off I went after a challenging interim ministry, after vowing never to leave Southern California, to a great adventure in ministry. At a friend's suggestion, I applied and was accepted in the Clinical Pastoral Education (CPE) program at St. Elizabeth's Hospital in Washington, D.C. "St. E's" is a sprawling federally run mental health facility. I was a chaplain intern in the forensics unit. The patients were often there because the court system found them guilty by reason of mental defect.

Our supervisors told us that "the mentally ill are just like us, only more so," and it is true The tensions and anxieties, joys and hopes are the same, but more acutely and deeply felt than among those of us who are emotionally and mentally "healthy." I continue to be madly in love with

the D.C. area and am grateful for the experience, despite having to live in a mental hospital the entire time I was in Washington.

As I prepared to move from Saint Elizabeth's to the general staff of the Christian Church (Division of Homeland Ministries, Director of Women in Ministry), the director of our CPE program told me that working with the mentally ill was great preparation for working with clergy. His statement was less a comment on the mental health of clergy than it was an affirmation of the tensions, anxieties, joys, and hope ministers carry for themselves and others.

I am thankful for the twelve years I was on the general staff. Because of that experience, I became and remain an advocate for women's creative leading involvement in every aspect of the church's life. From service on boards and committees, to pulpits, to regional minister and heads of General Ministries, the inclusion of women (not the exclusion of anyone else) is vital to the health of the church. What an additional privilege it has been to develop dear friends and honored colleagues, including Bill Edwards with whom I now work, Fran Craddock, Joyce Carlson, and Ozark Range who taught me much about ministry, as well as with each of the last general minister and presidents.

It has been a blessing indeed to work with clergy and laypeople whose tremendous love for the church is evident.

I was privileged in those years to preach at regional assemblies and do pulpit supply, to travel to Switzerland and Zimbabwe, and to serve as an elder and Sunday school teacher at Faith United Church of Christ in Indianapolis. Walking into the office of the president of Disciple Home Ministries to be told my "portfolio" was being eliminated was decidedly not fun. Still, I count it all joy and an opportunity to learn.

The next surprising place for me was in Lincoln, Nebraska. Based primarily on a phone interview, I was called to a nine-month interim at Bethany Christian Church. I found the people there to be warm and welcoming. There I learned again what it means to be a pastor who stands alongside people at their moments of high joy and deep sorrow.

I rediscovered the agony and ecstasy of preaching every week to the same congregation.

Bethany was great preparation for my eleven-year ministry at Broad Street Christian Church in Columbus, Ohio, a congregation that understands the radical hospitality of welcoming with no regard for race, age, gender, or orientation. They are not without their fears and struggles, but they are good people whose lessons about what to do and what not to do as a pastor remain with me always.

My tenure at Broad Street gave me the opportunity to serve on local ecumenical boards and on the board of the Ohio Council of Churches. As I write this, I am concluding a term as president of the governing board. I was a member of the Commission on the Ministry, the Regional Board (now Church Council), and on ministry teams in the region of Ohio. I have been on several boards of the General church, including the General Commission on Ministry, the Standing Committee on Renewal and Structural Reform, the Board of Trustees of the National Convocation, and the General Board. The General Board and Administrative Committee elected me to chair the search committee for the General Minister and President that led to the call and election of Sharon Watkins as General Minister and President. Thanks be to God!

All of these experiences were preparation for my current ministry as a regional associate pastor in Ohio working with several ministry teams, including the Anti-Racism Team and Ohio Women's Ministries. I also work with search committees as they work, pray, and think together about whom God is calling to be their next pastor.

Each place of ministry has been preparation for the next place. I am especially grateful that in each of these places I received the gift of wisdom from women and men who have done ministry for a while. Now that I am one of them, I pray that I have wisdom to share.

God has given me the gift of black skin and a female body.

These gifts empowered me to struggle against racism and sexism as I have faced it. I have learned patience and perseverance. I have developed a strong belief in equality, justice, and fairness. I have been angered, disappointed, and emboldened by the rejections and the loss of trust that occurred when I knew I was qualified and right for a particular place in ministry, but for reasons of race and/or gender, I was not called. It's all good, and it all worked out. I am ultimately stronger for being subjected to the fear of search committees and other decision makers.

I do thank God that while I sometimes lost trust in church members, I never lost faith in the call you placed on my life. I am happy to encourage any woman of any age who is discerning a call or who has answered a call to ministry. Here is what I say to her: pray, discern, listen to your heart, find role models, and ask them questions. Read about women in ministry, support women in ministry, and affirm yourself.

I know some women in seminary are struggling to find their place in school and in the church. My advice to them is the same as it is for women thinking about responding to a call to ministry, but I would add these three things. The first is to simply hang in there; the church needs your gifts, your passion, your faithfulness, your energy. The second is that as you hang in there, embrace the call of God in your life. Ministry comes in many forms.

Discover the sheer joy of the one that best suits who you are and your gifts. The third extra piece of advice is to explore the nagging questions that will not let you loose.

Listen for the answers, identify roadblocks, and find ways around and through them.

 I am grateful for every gift, but I hold this one close to my heart and soul. Thanks be to God that in spite of every voice that said to me, "you can't," God said over and over, "I am with you, and will never abandon you. You can!"

 And for your presence, I am eternally grateful.

LaTaunya

LETTER 17: *Cathy Myers Wirt*
Co-Regional Minister, Christian Church in Oregon

Finding the Blind Spots

Dear Church,

A few months ago I stopped by a local drive-through espresso stand. The young barista asked, "How are you?"

I replied that I was fine.

I then asked him, "How are you?"

"I'm good. Well, I guess I shouldn't say it that way. It's not good grammar." Then off he went on a ramble that ended with, "Well, at least you are not an English teacher." Next he told me about how hard it was to find the words he needed to express himself. All the while the line behind me grew. Finally he blurted, "I had no idea this conversation would get so deep. It's a good thing you're not a minister!"

Pause. "Well, actually, I am." His jaw dropped, and so, almost, did my coffee. "You are. Really?" I could see the wheels turning in his head as he thought.

"But you are a woman," he blurted.

I took my coffee and drove away realizing that though I have been at this ministry stuff for almost thirty years, the world is slow to move with me. Sometimes I have felt like the movie character Forrest Gump, always observing the big events in history by being an eyewitness to the action—in my case the events in Disciples of Christ denominational history. My family attended and watched the first General Assembly in Seattle as the Disciples of Christ learned to be a church and not only a movement. I remember the song about the new Sunday school curriculum and the youth with their fists in the air that shut down business on the floor. I remember singing in the choir for communion time.

My church felt very big to me.

In my teen years in Oregon, my church youth group and friends were my central focus. I served on the regional "department of young churchmen," as the regional Christian Youth Fellowship vice-president and as the regional delegate at the 1973 General Assembly in Cincinnati. I listened to the debate about amnesty and new ways of interpreting our global mission presence.

My church felt relevant to me.

When I began college, I had few images of clergywomen beyond a few women I knew that did children, youth, women's ministries, or mission work. For some reason, I did not consider them ministers. Looking back, I realize that I had been unaware that some of them were ordained. My church seemed led by men in the "big jobs," and I did not question this reality.

While in college, I met a college chaplain who changed my life. Her seminary field work for a degree from Princeton brought her to my college in the Midwest wearing her T-shirt that said in big letters, "Sexism isn't Christian." I remember the day she talked to me about inclusive language. I said, "Kristine, when they say mankind, they really do mean everyone."

She shook her head and said, "Little Myers, what will I do with you?" In the months I spent with Kristine, I began to understand that the church was changing, that women were coming into new leadership. I started to understand that I was feeling a deep pull to be a part of this huge sea change in the church. I changed my major to religious studies and took almost exclusively religion classes my last two years of college. I worked in the chapel and I played on the religion department volleyball team –"The Teleological Suspension of the Ethical."

My church now reflected to me a vehicle by which my life could help to change the course of history at some level in my own denomination.

During college, I was elected to the General Board of the Christian Church. I served on that board from 1977 until 1985. During those years, I also served on the Administrative Committee, the General Nominating Committee, and the General Minister Search Committee. These general church connections profoundly shaped my concept of ministry and my place in the church. The people I met in those years were giants of faith to me: A. Dale Fiers, Ken Teegarden, Howard Dentler, Jean Woolfolk, Bob Thomas, and Chris Hobgood, to name a few. One of my favorite saints was Lambrini Stergiopal, Ken Teegarden's secretary. I enjoyed helping her collate General Board rewritten resolutions typed on Selectric typewriters late into the night for the following day. I watched and listened and learned the mechanics of denominational church life.

In 1979, I graduated from Macalester College in St. Paul, Minnesota. I went back to Oregon as the receptionist for the Ecumenical Ministries of Oregon, a Council of Churches group. During that year, I married the man I had dated since age seventeen. He was seminary bound. A group of clergywomen in Oregon adopted me into their group and helped me work up courage to consider seminary. Among these saints were Marge Green, who worked in the inner city with kids and teens; A. Lynnette Biggers (ordained in the 1950s), who had been on regional staff in Oregon, at the

Yakama Christian Mission, and on faculty of Northwest Christian College; Faye Feltner, missionary to the Congo; Jane Nesby, a pastor in a small rural congregation; and Myrna Phillips, a pastoral counselor.

They helped me to hear through my questions and fears to the clarity of a call to ministry.

During that year, I put out a fleece. I applied to the Rockefeller Foundation's Fund for Theological Education and won a full tuition scholarship to go to seminary. A truly committed introvert, I pondered how I could possibly make it especially through the preaching classes. On arrival at Pacific School of Religion in Berkeley, California, in the early 1980s, one of my first courses was, of course, a preaching class. Our assignment the first week consisted of telling a three-minute personal story that connected to an assigned biblical text. I seriously considered dropping out rather than speaking in front of those six people for three minutes. But the intellectual rush gathered me into the experience. I found a paradise for a budding Christian feminist. I re-thought scripture from a feminist frame, learned church history, and grappled with my call to ministry.

In those years, I met Doris McCullough, who would mentor me deeply and would place her hand on my head and pray the prayer of ordination for me. Until she died in the late 1990s, she continued to offer wise counsel, warm laughter, and hard questions into my life. On days when I'm exhausted or discouraged, I go back in time and listen to the memory of her voice singing above my head on my ordination day the song, "Be not Afraid."

One of those seminary days, driving to a clergy event in the Northern California region, I remember two clergymen talking in the front seat. They told me I had to be patient with them while they got used to the idea of women ministers. My twenty-something self, using a lack of manners my mother did not teach me, blurted out, "What should I do while I wait for you to decide I can be a minister?" The ride seemed long after that interchange, yet that type of question was real to me in those days. What should I do while the church becomes ready for me to serve?

I felt like I dwelt in the "blind spot" of a church that was changing lanes.

In 1983, at the Lafayette Christian Church, I became an ordained minister in the Christian Church. A month later, I preached the ordination sermon for my husband, Doug, at the First Christian Church in Portland where we had met and married. That same summer, Doug and I became the co-pastors of the Mallory Avenue Christian Church, half-time each. The church was an inner city, urban mission center church. We had "tent-making" jobs on the side as cooks and office workers. Serving as co-ministers confused some people. We were a novelty of sorts and fielded

questions such as, "Who is really in charge?" We shared our work equally and as full partners. We knew it could work. Over the years, this pattern has been our favorite.

Our ministries have taken us far and wide. Doug served as pastor for seventeen years in three congregations. Over those seventeen years, I served as a pastor in two congregations, staff in two regions, a program director for Disciples Home Missions (part of that time as the director for Women in Ministry and editor of the *Daughters of Clara* newsletter for clergywomen), and as a pastoral counselor having completed an M.A. in counseling psychology in 1997. During those years, we gave birth to three children and suffered the death of our daughter, Angela.

Our travels for the church have taken us many places. I traveled to Zimbabwe (Woman-to-Woman Worldwide) in 1993 and Mexico in 2007. Doug traveled to The Democratic Republic of Congo, the Republic of Congo, Lesotho, Botswana, and Ecuador.

We have had wonderful highs and some soul-wrenching lows during these ministries and have known the harsh realities and the deep graces of Christ's church.

In 1999, I started a doctor of ministry program at the San Francisco Theological Seminary in San Anselmo, California. My dissertation project examined the lives and spiritual formation of clergywomen in the Disciples of Christ ordained from 1976–1986. Before this time, few women were ordained. By the end of this time period, almost half of all seminary students were women.

In 2001, Doug and I were called to Oregon to serve as co-regional ministers, sharing the work of regional ministry as equal partners.

In 2005, I witnessed a sight unimagined in my younger years. One of the women I had interviewed in my doctoral project during a 1999 sabbatical time, Sharon Watkins, was a woman pastor in Oklahoma. She was introduced as the new General Minister and President during the General Board meeting. I said under my breath, over and over, "In my lifetime, in my lifetime." The first night of the General Assembly in Portland, Oregon, when Sharon Watkins was installed, I stood on the stage as one of the regional ministers of Oregon and welcomed my church to our region. As I sat down after speaking, I remembered the twelve-year-old girl I was at the Seattle General Assembly singing in the choir.

I pondered how different the church had become in such a short span of time.

The church has changed a great deal from the days of my first memories of separate deacons and deaconesses and all male elderships, of Women's Day once a year when a woman would preach a sermon; and the days when the Christian Women's Fellowship operated as the women's auxiliary arm of the church with its own budget and power base. As the roles of

men and women have shifted in society, so, too, the roles have moved in the church.

In my lifetime, I have seen changes of earthquake size. During church camps of my childhood, the boys were talked to as a group about who among them might be called to ministry. Now at church camp when I announce that I'd like to meet with people who feel a pull toward ministry, I see as many girls as boys in the circle.

The grace of this image comes to me these days as a message that I am a small, small part of a large, large change. Like Forrest Gump, I am an observer and part-time actor in a drama beyond my making or understanding. Day by day, in my conversations, prayers, meditations, programs, and meetings, I'm watching for my part of the changes God is making in our part of church.

I love this piece of church with a deep affection that sees its flaws and its gifts with equal clarity.

I no longer feel like I'm in the church's blind spot. I stuck around long enough to be seen and heard. These days I crane my neck looking for our current blind spots and trusting in God's grace that if we stick together, we can tell each other about the parts of life we cannot see ourselves. My hope is fueled by the new congregations joining the Disciples of Christ who will bring our awareness to new blind spots that will become revelation that leads us to new roads that will bring us new blind spots, and so it goes.

Cathy

Dear Church

General Staff

LETTER 18: *Kaye Edwards*
Director of Family and Children's Services,
Division of Homeland Missions, Indianapolis, Indiana

Consider Your Heart

Dear Church,

I was more than halfway through my twenties before I took specific actions to answer the call to ministry—a call that had been sounding in my life since elementary school. Assumptions (my own and those of others), the need to please, flawed advice, and prejudices (again, my own and those of others) kept me from settling into what is now the most joyful and satisfying work of my life—ministry with children.

During my early years, I didn't receive many words of encouragement or discouragement. People just didn't talk to me about my chosen career of Christian ministry. My answer to the question, "What do you want to be when you grow-up?" received responses such as, "Isn't that sweet." or "Really? How interesting." Those who did take me seriously assumed that I would teach. I would be a director of religious education in a local congregation. I, on the other hand, assumed that any kind of teaching was the last thing I wanted to do. In about fifth grade, I did sign one of those church camp cards indicating my interest in a ministry vocation. In the late 1970s, when I applied for standing in the Region of Kentucky, I discovered that the boys who signed those cards had been followed and encouraged by both the region and their local congregations. I had heard not a word.

Throughout my childhood, I did have many wonderful role models, both women and men.

Students from Lexington Theological Seminary were always working in my home church of First Christian Church (Disciples of Christ) in Paris, Kentucky. We had people such as Bob Bradley, Millie Slack, Ellen Frost, to name just a few. All of these students went on to serve the church in a variety of ways. The male students would go on to be senior ministers in local congregations. They would serve as regional and general staff persons in everything except Christian Women's Fellowship and Christian education. These areas were the ones in which the female students would serve.

Since no one ever discussed ministry possibilities with me, my childhood prejudices stayed firmly in place.

I did know women who served as missionaries. My home church had frequent congregational dinners at which missionaries spoke. I usually did not hear their presentations. Playing hide-and-seek in the scary towers of our old church building was a much more interesting option. Everyone thought missionaries were wonderful, brave people. Always wanting to please others, I thought perhaps I could be a missionary when I "grew-up."

In the fall of 1966, I entered Lynchburg College, Lynchburg, Virginia. Well-meaning staff and friends suggested I add an education major to my already double major in religious studies and sociology. This way I would have something to fall back on when I couldn't get a job in my chosen field. Even though I had no interest in teaching, this seemed like sound advice at the time. My adviser did not see elementary school teaching as a worthy career goal for anyone and strongly advised me against the triple major. I took his advice.

David Edwards, also a pre-ministerial student, and I were married during our senior year of college. We were both quite active in a local Disciples congregation but were growing increasingly dissatisfied with the Church's positions, or lack thereof, on the war in Vietnam and the continuing civil rights struggles. Both of us began to question our calls to ministry in an institution for which we had dwindling respect. Ultimately, David decided to give up his 4-D draft status (an exemption for men going to seminary). In 1970, he sought and was granted status as a conscientious objector to the draft, and we headed to Boston Children's Hospital for his two years of alternative service. I also worked at Boston Children's Hospital as the activities director, or "play lady" as we were then called, with the psychosomatic unit of the hospital.

At the end of the two years in Boston, my call to ministry began to surface again, and I decided to apply for seminary. I didn't follow through with the application, however, because of a visit from a good friend, who just happened to be a seminary professor. He gave me my first truly discouraging words. He expressed disappointment in me and in my decision.

My goals were confused and my direction unclear.

How could it be otherwise when I had little opportunity to discuss my call? I was devastated by his words. He believed that David's goals and direction were more developed. With the encouragement of this good friend, David did apply to seminary. As I reflect, I have to wonder about the part sexism played in this scene. Could not seminary be a time of clarifying and defining my call?

While David was attending Lexington Theological Seminary in Lexington, Kentucky, I worked as the director of a day program for children with profound mental and physical disabilities. My contact with these special children and their families was tremendously satisfying, but I knew in my heart that I still needed to explore the call to professional ministry. I entered Lexington Theological Seminary in the fall of 1974. By this time it was very clear that I was called to work with children.

I was still firmly rooted in my prejudices about Christian education.

I was not about to do what others expected me to do because I was a woman—my own sexism at work. The question then became, "How could I answer the call to ministry with children and avoid teaching?" Enter Jim and Petie McLean. I did my seminary field education with this extraordinary couple who helped me see that Christian educating could be challenging and fun. I fell in love with the creative process of developing ideas and programs to teach, yes, teach, all ages of God's children.

In 1980, after the adoption of our son, Kent, and the birth of our daughter, Shelley, I was ordained at Antioch Christian Church (Disciples of Christ) in Lexington, Kentucky. Around that same time, I began to serve as the director of the Lexington Mother-to-Mother program (Mother-to-Mother brings together, in mutually supportive friendships, mothers from different racial, economic, and social situations). When David was called to a church in another state, I found a job working with the children of abused women. I also worked with teenage moms and their babies through a family service organization. The coming of my own children and all of these jobs brought me to the realization that a faith-based commitment to children had to go beyond education.

I was being called to educate and to advocate for children inside churches and beyond church walls.

I worked for about ten years as an associate minister in Christian education and youth before accepting a call, in 1996, to be the director of Family and Children's Ministries with what is now Disciples Home Ministries. This ministry has given me the opportunity of working with other general units, regions, and local congregations to expand and renew children's ministry programs. The Children Welcome! Conferences, begun in 2001, have helped all of us to understand the importance of every aspect

of children's ministry. I, along with many other children's advocates, have worked long and hard to encourage the recognition and reception of the ministry gifts children bring to faith communities. Having assembly hall space at the 2007 General Assembly in Fort Worth, Texas, where families with young children could more easily participate, was a giant step forward in our effort on behalf of children. With programs such as Kids to Kids and Children Worship & Wonder, we have endless opportunities to enter into ministry with children.

I am grateful for all the experiences of my life, especially David's unwavering belief in me and the contact with children along with the many lessons they continue to teach me. Opportunities to travel and visit people of faith all over the United States and in a few other countries have helped to increase my compassion and reduced my prejudices. Then there is prayer. Prayer gives me a deeper understanding of my faith and a broader perspective of life.

Even the delays, the diversions, and the bad advice are appreciated when prayer is added to the mix.

It is gratifying to know that women make up at least half of the current seminary students and that more and more women are being accepted as leaders in local, regional, and general church settings. Still, we face different struggles today. Because we are human, prejudice will always be at work in our relationships with one another and in our self-understanding. The only antidote is prayerful listening and taking time for quiet reflection.

Though it is important to consider the advice of others, listening to our own hearts is of singular importance—asking questions, such as, "What is it that I love doing? What am I really good at doing? What brings me the most joy?"

Only when we listen carefully to the "inside" answers to these questions do clarity and courage come.

Whoever we are—young women preparing for ministry, older women coming to ministry from another career, or women questioning the current call to professional ministry—first and foremost we need to consider what our own hearts are telling us. I pray that we will continue to strive to be compassionate women who listen to one another, and who support and encourage one another to be all God creates us to be.

Kaye

LETTER 19: *Amy Gopp*
Director for Week of Compassion, Indianapolis, Indiana

The Daily Call

Dearest Church,

To be called to the ministry is a mysterious and often elusive process. It takes a dynamic course, ebbing and flowing throughout our lives. For me, being called is a daily occurrence. While I know, deep down in my bones, the fundamental reasons I get up each morning, I am also open to the leadings of the Holy Spirit. I believe we must say "Yes!" to God each and every morning and go to sleep at night having offered profound prayers of gratitude to the One who accompanied us throughout the day. Looking back at my own life, I see no single moment when I knew that "God" had called me in a special way. Rather, I can trace a series of experiences and revelations that convinced me to say "Yes!" to my beloved Creator and sustainer.

After my father divorced my mother in the summer of 1978, I became utterly convinced that my mom would leave us, too. Each time she opened the front door of our quaint two-story home in Kent, Ohio, to let our dog, Mandy, out, I believed she was right behind her. Upon hearing the screen door screech, my seven-year-old body would freeze until I would hear my mother's unmistakable voice calling our spunky Springer spaniel back into the house. "Mandy, come on girl! Mandy!" Nonetheless, after Mandy was back inside and my mom back in her spot on the crimson red chair, I would jump out of bed, fly around the corner down the wooden banister, and into my one and only mother's arms. She would cradle me as long as I needed to be cradled.

This was where I first met God.

One of my most cherished places on earth is Camp Christian in Magnetic Springs, Ohio. I grew up there, physically and spiritually. Situated on a lake in the middle of nowhere surrounded by great pines, tiny green cabins, mean Canadian geese, and swarms of mosquitoes, Camp Christian was where I experienced the intimacy, responsibility, and joy of being a part of a community of faith. At camp I could begin to make sense of who Jesus Christ was in my life, who God was and what his relationship to Jesus Christ was, and perhaps most importantly, who I was.

It's hard to pinpoint just what made camp so special, especially when I think about the nitty-gritty details of camp life: the songs–the silly, stupid ones and the beautiful, serious ones; the chipped beef on toast; the way the bugs would somehow, ever so slyly, creep into all areas of your body, bed, and Bible; the counselor with the bad breath who insisted on sitting right next to you at Vespers. I loved it all, because all of it made camp what it was, a place unlike any other in my life.

There I could explore my different selves in the midst of hundreds of others doing the same.

Camp was also where I tuned into my "call." Not an earth-shattering event by any means, my calling sneaked up on me but did so subtly, unassumingly, organically, yet unapologetically. The director of the camp gathered us hundreds of teenagers in all our hormonal glory into our traditional last-day-of camp closing circle. We sang the usual choruses, "We are climbing Jacob's Ladder" and "Sing Alleluia to the Lord" and clasped hands.

Ever so naturally, Tom, the director, began to describe how to fly a kite. He talked about having just the right windy day and how difficult it is to actually get a kite to ride the wind. As you release the body of the kite into the air, hoping to catch its wind, you slowly let go of the string. As the kite makes its way higher and higher, more of the string has to be let loose, until finally the kite is so high that you can no longer see the top of it. You can't see the kite, but you feel its pull. You feel the pull of the string that is thinly but solidly connecting you to something above. Where the kite leads is unknown, so to follow the kite is to follow the wind, trusting that it will take you in the right direction.

"Some of you here today may feel the pull of the kite-string," Tom exclaimed. At that very moment, my body seemed to function without the rest of me. I found myself walking to the middle of the closing circle. In front of all my friends and beloved counselors, I was claiming to have felt the pull of God. Where God was leading me I had no idea. My sixteen-year-old mind could have no way of anticipating all that was in store.

My mind didn't matter so much that day; my heart mattered–and how full it felt, as if it could have exploded out of my chest.

Years later, my pastor-stepfather was diagnosed a sex addict, and he and my mother divorced. I finished college and knew it was time for me to see the world with new eyes. I dusted off my kite and followed its pull as far as it would lead me. I had always known that I wanted to travel far and wide to lands unknown. Beginning when I was a little girl, I would fantasize about Africa and the adventures on which I would embark. Images

of people dancing and singing together under an African sky surrounded by thatch-roof huts were vivid.

In my dreams, I knew someday I would be in Africa. Yet my kite did not land there. Instead it crashed in a place I had barely heard of, a place raging at war, a place where I didn't speak the language or know the people or understand the situation. My kite landed in the former Yugoslavia.

That's when I learned how much God loves to surprise me.

For the next four years, I volunteered with Mennonite Central Committee (MCC) in Croatia and Bosnia, former republics of Yugoslavia and now independent countries. I had no way to prepare myself for the journey as a young and innocent twenty-three-year-old. I only knew that I had to do it. I had no choice. Watching the evening news in my college dorm floor lounge, I would be bombarded with horrific images from the war in Bosnia. Old women with wrinkly faces would stare at me on the screen as it they themselves were begging me to come help them. Clips of the aftermath of sniper attacks that targeted and killed people on their way to the outdoor market or standing in bread lines; children left to die in the streets of Sarajevo; houses burned and demolished one by one–these pictures consumed me and forced me to go.

Having majored in international relations in undergraduate school and with a fresh master's degree in conflict resolution under my arm, I was absolutely certain I was well on my way to a Nobel Peace Prize. What could be nobler? I could read the headlines in my mind: "Young American Woman Single-handedly Brings Warring Yugoslav Factions Together." It didn't take long to discover just how ill prepared I was. My shiny new set of communication and conflict resolution skills were not going to bring peace to the Balkans. In fact, they couldn't even bring my heart peace.

The inner turmoil I experienced my first year in Croatia was beyond what I could have ever imagined I would endure.

Living in a war zone demands you show up with your whole self. I never could guess which parts of me would be called on at any given moment. My assignment with MCC was to connect to local groups. For the first two years in Zagreb, Croatia, I worked with Christian Information Service, an alternative media source sent to churches all over the Balkans and worldwide.

Eventually the Service's advocacy grew into a peace organization, and I was asked to organize a Peace Circle. The circle invited members from all the various religious communities in Zagreb. Our small but committed group planned monthly ecumenical prayers for peace. We would rotate to our various places of worship. Each prayer would gather more attention

and more people. By the end of my two years, the monthly prayers were well established.

Another aspect was humanitarian aid. I would accompany our local partners on distributions. Trips that took four hours before the war now took sixteen hours because of the lack of infrastructure, destruction of bridges, and continuous fighting in the region. I'll never forget traveling to Bihac, a city along the Una River in Bosnia–ironically deemed one of the four "U.N. Safe Havens" even though nearly everyone there was starving. There I first learned how differently people define "security." Bouncing in the back of a van for hours, we arrived at the hospital in Bihac. I was so proud of our reputable and tasty canned-beef delivery and excited to unload the truck. Much to my disappointment, the director took one look at those gorgeous cans of beef and said, "But we have no way of opening them."

The skills I had come with were simply not the appropriate tools.

I had heard the gospel message about losing one's life to save it a gazillion times. But until I faced the horrors of war, discovered my own capacity for violence, and confronted my inability to save the world on my own, I didn't really get it. "If any want to become my followers, let them deny themselves and take up their cross and follow me. For those who want to save their life will lose it, and those who lose their life for my sake, and for the sake of the gospel, will save it." (Mk. 8:34–35). This different and terrifying culture forced me to my knees. I knew that I had to empty myself so I could be fully open to all that was new.

I had to abandon my former and familiar ways of communicating, coping, knowing, and working for God to move through me in brand new ways.

Learning a different language is a humbling and profoundly spiritual experience. Not knowing a word of Croatian, I entered a world where I had no voice. For a verbal and emotive communicator, this was pure torture. Being without voice was not a condition I was used to, and it felt like a disease. People treated me differently. When you don't speak the language, this mysterious childlike quality takes over. All of a sudden adults are patting you on the head saying, "Isn't she cute?" after you've succeeded in mumbling *dobar dan* (good day) correctly.

Having no voice also meant that I was better able to relate to, accompany, and be in solidarity with those I had come to serve. Refugees whose homes, land, and families had been taken from them, women whose bodies had been savagely raped, children whose innocence has been stolen–these were the souls of war, all of whom had been stripped of their dignity and their voice. Their cries had fallen on deaf ears, and the international community was too late in responding. Wounded, exhausted,

and despondent but still full of hope, they taught me how to dance in the midst of suffering.

I became their advocate and they mine.

More importantly, I became their friend. It only took four years to realize that I really had no more noble a task than to be a friend: to listen, laugh, keep promises, drink coffee (what any good Bosnian does at least five times a day), write, sing, and weep. These are the tasks of friendship. I searched in vain for my "true" calling as a peacemaker, for that one special calling of God reserved only for me, only to find that there is no such thing. Peacemaking calls upon a multiplicity of roles. It is generational work. I was only a planter of seeds and a keeper of stories–not a Nobel Peace Prize candidate. I had to admit there was some relief to learning that my calling was to drink coffee and not to move mountains.

God had not called me to be "successful" but to be faithful, to be a friend.

When Fra Ivo Markovic, a Bosnian Franciscan priest whom I knew from the Peace Circle, invited me to move to Sarajevo to help him found an interfaith dialogue center, I was elated. Ivo is the male role model I always wanted: gentle, steady, wise, witty, safe, affectionate, and challenging. In every way he became my spiritual mentor. I swallowed up whole this man's theology and approach to being in this mad world.

Our mission was to become a bridge on which people could reconnect and rebuild trust. Our grass-roots approach was effective. Before we knew it, imams and their Muslim communities were helping the Catholic village next door rebuild their church. To experience such reconciliation was a rare joy.

Instant gratification is usually not the name of the game in peace and justice work.

Our baby was our choir. *Pontanima,* or "spiritual bridge" in Latin, started out as a small group of people who were either artists out of work because of the war or people who just loved to sing. With more than seventy-five voices, we represented every ethno-religious group in Bosnia and Herzegovina. We sang songs from each tradition. Singing each other's songs proved to be the most strategic step toward peace we could have made. For me, God's voice is the united voice of my Bosnian interfaith choir, the voice of people just trying to carry a tune together. I understand why God is often understood as the breath of life.

That breath has filled me along the rest of my journeys. My skin was finally bathed in an African sun. Sudan–sad but seductive–broke my heart and put Bosnia in brand-new perspective. Through my current ministry

with Week of Compassion, I have dedicated much of my advocacy to the southern Sudanese and Darfuri people and their hopes for a peaceful future. The images of abject poverty and oppression witnessed in Sudan haunt me still. So do the memories of women ululating, drumming, and welcoming *kwaja* into their mud hut-church. Deliberately dumped in the depths of the desert, somehow the southern Sudanese transformed that cursed space into sacred space singing their choral mantra: "*When Jesus says yes, nobody can say no.*"

No matter what–abandonment, questioning, uprootedness, suffering, poverty, isolation–God is in the midst of it. Even more miraculous, God hangs in there and never leaves. Seems wherever I travel, God has already been there.

From my mother's lap to dates with Jesus to hearing the good news from the poor, God is. God will be what God will be.

And I will be what I will be because of God's love. Created, claimed, and called by God am I! The old screen door may screech shut, and the monsters of fear may surround me; but I can somehow manage to fall peacefully asleep again, with a song in my head, a can opener under my pillow, and an empty coffee cup on the nightstand.

My prayer for you, an individual considering a call to ministry or a congregation seeking leadership, is that you too will know that you have been created, claimed, and called by our great God.

The world is waiting for you. Say yes!

Amy

LETTER 20: *Julia Brown Karimu*
Vice President, Executive, Missionary Personnel Office
Division of Overseas Ministries, Indianapolis, Indiana

Listen! God Is Speaking

Dear Church,

It has been a while since anyone asked me the question, "How did you come to ministry?" It is a relevant question, because every day I am confronted with a new challenge, and sometimes I doubt my worthiness to be a minister in the Church of Jesus Christ. On these occasions, God's grace overwhelms me.

I realize anew that God would call a sinner such as I for such a sacred ministry.

My journey began as a child in Yazoo City, Mississippi. I was immersed in the life and witness of my home congregation, Chapel Hill Missionary Baptist Church. I held various leadership positions, but what had the most profound impact on me was the role of the church in the Civil Rights Movement. A local community organizer, Rudy Shields, mentored me. He taught me how faith and activism were essential to the mission and witness of the church. He nurtured my leadership skills and taught me what it meant to truly be a Christian by one's willingness to put the interests of others above one's own.

I grew up in a marginalized and oppressed community. My understanding of justice for all of God's people was a driving force for my life as a Christian. As a child growing up in Yazoo City, I experienced directly the limited possibilities that African Americans faced–poor schools, inadequate health care, low-paying jobs, and even the threat of death if you looked at an Anglo person the wrong way. However, my church challenged this oppression through the reading and teaching of the Gospel.

At this point, I considered myself to be a liberationist.

I entered Jackson State University as a seventeen-year-old in 1969. I joined a student protest over the expansion of the Vietnam War into Cambodia during the spring of 1970. Mississippi State Troopers attacked me violently. This incident transformed my life.

I worked with the NAACP and with the Black United Front, an activist organization. After completing a degree in education at Jackson State, I moved to Cleveland, Ohio, and began my first vocation as a junior high

school teacher. I became a member of Fifth Christian Church. Dr. William Hannah was my pastor. His theology was very similar to mine. I came to admire the depth of his spirituality and his leadership in the community.

Dr. Hannah was called to serve as the executive secretary for the department of Church in Society of the Division of Homeland Ministries. After moving to Indianapolis, he continued to serve as my mentor. He knew I wanted to move into an area of work that related to human rights and social justice. He encouraged me to apply for a position in the department of Church in Society. I became the director of the volunteer program on July 1, 1977. I worked with volunteers in the rehabilitation of homes destroyed by natural disasters and served as coordinator of the Mother-to-Mother Program, which addressed advocacy issues related to low-income mothers. The volunteer program allowed me to have a hands-on experience working with Christian sisters and brothers who were not only engaged in improving the lives of victims of natural disasters and poverty but were in a real sense working toward reconciliation.

I entered this position as a layperson. I never thought about being an ordained minister.

I did not know any ordained African American women, and the African American female evangelists (the title given to female preachers) were mocked within my community. I loved my work. Every day we engaged in life-giving ministries. As a result, I sensed a call to enter seminary. I enjoyed reading liberation theologians. I did not, however, have a positive view of the feminist theologians because of their focus on gender equality to the exclusion of racial equality.

I understood that my liberation was bound up with the liberation of both male and female African Americans.

An African American male, Rev. Gerald Cunningham, exposed me to Anglo and African American feminist theologians. He engaged my mind in exploring and examining womanist theology. He modeled for me an intellectually progressive African American ordained Disciples of Christ minister. His example and that of others such as Garnett Day, Rolland Pfile, Ian McCrae, Frisco Gilchrist, Thomas Russell, and Paul Wilson motivated me to enter seminary.

With my M.Div. in hand in 1985, I accepted a call to become vice president and mission personnel executive for the Division of Overseas Ministries, but did not seek ordination. Why didn't I? I did not want to live triple jeopardy–African American, female, and ordained minister. I was single. I wanted to marry and have children. Most African American males I met were put off by the notion of having a relationship with an ordained female minister. I immersed myself in my work.

I encountered Christians in Africa and Latin America who put their lives on the line for the Gospel each day.

I said yes to ordination after meeting Bishop Medardo Gomez of the Lutheran Church in El Salvador. Members of the Death Squad had kidnapped him and constantly threatened him because of his ministry with the poor and abandoned. I was ordained November 18, 1990, at Geist Christian Church in Indianapolis, Indiana.

On December 1, 1990, I married Chris Karimu and on August 11, 1992, gave birth to twins, Christopher and Kona. Being a wife, mother, and minister continues to be challenging as I carry out an extensive travel schedule for the national staff of the Christian Church (Disciples of Christ) and the United Church of Christ. I work extremely hard to be fully present for my children and all of their activities. I have served as the president of the PTO and presently serve on the Site Base Decision-Making Team at Broad Ripple High School. I enjoy chauffeuring my children to their different activities and sitting in the stands cheering for football and basketball games. I know that God calls me to be a good wife and mother as well as a minister.

Many times I fall short of living up to all of my roles but know that it is only God who allows me to function and only grace that keeps me steady.

I would say to women who are considering a call to the ministry–be still and listen because God is still speaking. Sometimes God claims us in such a way that we are not aware of our movement toward the call. Do not allow anyone to define who you are as a minister; do not waste time arguing or debating with those who would deny or disrespect your call. You are not to answer to them. You are to answer to God. Be strong and disciplined in your practice of the faith, and maintain a sense of humor. You will need it.

I owe a great deal of thanks to Rev. William Nottingham, Rev. David Vargas, and Dr. William Fox, in addition to those already named, for shaping my ministry. As I look back, a truth emerges: my ministry has been mostly affected by Disciples male leadership. I give thanks for their support and the opportunity to have served for eight years with the Division of Homeland Ministries and twenty-three years with the Division of Overseas Ministries.

Julia

LETTER 21: *Ellen L. Mitchell*
Vice President for Donor and Investor Relations
Board of Church Extension, Indianapolis, Indiana

Gifted to Serve

Dear Church,

It is an honor to be afforded this opportunity to bring you words of love, connection, and, yes, even understanding from my life to yours.

My journey began while I was serving through and being challenged by the financial ministry of Church Extension. I heard the stories of and brushed shoulders with new church pastors who had a passion for ministry and an eagerness to witness. I had grown up as a PK or "preacher's kid" and knew that meant others treated me a bit differently. My life at times felt like I was living in a fish bowl with all eyes on me. It also meant that I heard again and again from my parents that I could do anything.

Often in my home after a church meeting, a discussion would arise concerning the need to not think in simple either/or options. I can, to this day, hear my father say that good decisions come when we think of "both or all" sides of the issue. These discussions caused me to see how many of us love to label things as black or white.

Jesus did his entire ministry in the gray areas of life–always being present when the answers were not easy.

My deepest early memories of Sunday worship services focus on a scene after the meditation was given at the communion table. My father would sit beneath a large, wooden cross that had a light shining on it, creating a shadow of an open Bible. I often thought, and even focused on it during sermons, about how that cross seemed to always be there at his back as if to nudge my father. It wasn't a painful image but one of a gentle nudging. I believe that if we can receive communion each Sunday and allow the cross to nudge each one of us, we can be reminded to share our witness with others, bring up leaders in the church (of all races, genders, and ages), and encourage the blossoming of all the gifts of the mind and spirit that God places in our congregations.

For me, God gently placed on my heart the notion to consider ministry.

I had seen my father shepherd his congregational flock with joy and watched him recover and be stronger when he had to deal with feelings

of being cast aside. The only way that I, a child of God, could ever have considered the challenges of ministry was to be nudged just like with the cross at the communion table. I did not even realize that I was doing ministry until a colleague said that was indeed what he was observing. God has His ways.

Regardless of how you help someone explore the call or feel it yourself, know that even when you feel discouraged, or left out or held to a different yardstick to be measured, you are a child of God who can do anything with His help. You can pioneer new roles for others. You can plant seeds because you see the potential. You can be a change agent or name that elephant in the middle of the room so that truth prevails.

You can lead at tables where no woman has led before.

To those of you who have already answered the call and are serving, you can embrace your weaknesses and move forward with your strengths because you are truly gifted to serve or you would have never been called. You can listen because you have those skills, and you can coach others who need that nudge or word of encouragement. Like me, you can be the third female officer in a ministry that is more than 100 years old because you have an appetite for inspiration.

Will there be trials and setbacks? Sure, but what you will do with them will be to learn from them, grow stronger, move beyond quick fix and engage others for the best solutions.

If you are reading this letter as a member of a congregation considering a woman as a pastor, always *celebrate the gifts* of your leaders. If you are a pastor, celebrate your own gifts. The gifts you bring and your experiences have shown you how you can positively influence others for the best solutions that move beyond either/or thinking. Grow your circles of influence. Sharpen your patience quotient, for the very seeds you plant now may *not* come to fruition in your lifetime.

And, most of all, bathe everything in prayer.

Perhaps you are reading this letter as a woman considering educational goals toward a degree in ministry or maybe now, later in life, you are hearing the call. Perhaps, like me, you have fought the very notion of ministry and even said, "Oh, not me – I'm not certifiable!" Perhaps the tug at your heart has remained constant until you are just now feeling that it is right.

However you began, you were called! God called you for a reason and will equip you for the path. So, my sister, work hard, pray harder, balance ministry with life, family, and friends and please, have some fun. God loves a cheerful giver. I believe that as you give your life to Christ that applies as well.

Ellen

LETTER 22: *Jennifer L. Riggs*
Director of Refugee and Immigration Ministries
Division of Homeland Ministries, Indianapolis, Indiana

Increasing Our Diversity

Dear Church,

Thanks for inviting me to share with the church my recollections of how I came to ministry and my words of encouragement to other women ministers. I appreciate this opportunity to both walk down memory lane and speak to the future. Dot France and I shared my early years in refugee ministry in the 1980s. We worked on the resettlement of refugees through Church World Service–Dot ecumenically in Virginia and I with Disciples across the United States.

From birth, I was part of a Disciples congregation in Winamac, a small town in northern Indiana. As a child, I remember especially the experience of hearing stories of missionary work in what was then the Belgian Congo, later Zaire, and now the Democratic Republic of Congo. Those stories were shared with our congregation by Clayton and Helen Weeks, family friends who were Disciple missionaries. When they were home on furlough, they would broaden my world beyond our small town to consider people from other cultures.

That started my fascination with the global family of God and made me think about the possibility of becoming a missionary.

When I was in high school, Richard Berkey, my pastor, urged me to consider a Disciples college. I decided to attend Bethany College and major in religion with the intention of perhaps becoming a missionary, but certainly going into some kind of church work. Under the influence of Bob Preston, Hiram Lester, and Richard Kenney (religion professors at Bethany), I began to gain a more mature vision of the church and the world. I questioned whether or not I could become a missionary without unduly inserting American culture wherever I might go. However, I knew that I still wanted to work for the church in some capacity. I spent one summer during those years working for the Indiana Council of Churches Migrant Ministry program with the tomato and pickle pickers in Berne, Indiana. That also reinforced my attraction to people from other cultures, which had so much to teach me.

My college professors encouraged me to attend Yale Divinity School (YDS). There I ran up against the truly male-dominated nature of the church. It wasn't an easy experience. After a year, I began to question if seminary was the path I wanted. I decided to take an intern year and ended up working in the South End of Boston. There I was immersed into another cultural experience, directing a church-run day care for inner-city children in the same room used by the Black Panthers for their breakfast program. That reinforced my sense of appreciation for the variety of God's family and what we can learn from each other. It continued to reinforce my sense of call to the ministry. I eventually decided to return to seminary and complete my degree.

I was at YDS when the seminary went from having about ten percent women students to having more than one-third women students. One year my field work assignment was to be part of a two-person team to help create a program for the women students to be assistant chaplains at the university. That meant spending time with William Sloane Coffin, head of the chaplains, to explore the possibilities. It was a learning experience to see how a man, liberal on many issues, could still be struggling on issues related to women's liberation. Bill's hesitancy about women students' participation in the chaplaincy of Yale only strengthened our resolve. The next year, eight of us served as assistant chaplains. A broken neck from a car accident took me out of that ministry for a few months. By the time I returned, Bill had expanded his views and come to see the importance of women in ministry.

My experience cemented my commitment to working ecumenically.

I valued the interaction between people of different denominations that were a part of an ecumenical seminary. I am sure those experiences led to my heavy involvement with Church World Service (CWS), the National Council of Churches of Christ in the U.S.A. (NCC) and the World Council of Churches (WCC), but I'm getting ahead of myself telling the story.

The classes I took with Henri Nouwen provided an additional influence on my thinking regarding ministry. I participated in his class discussions as he wrote his book *The Wounded Healer*. That experience helped give me a solid understanding of ministry and what it means to be a minister. It certainly helped me write my statement of ministry for my ordination council interview in the Indiana Region which occurred on the same day that Spencer Austin, then president of Church Finance Council, was speaking at our church. Spencer was invited to the interview. His words of encouragement and his presentation to me of an ebony and ivory cross from the Disciples Church in Bolenge, Zaire, brought my call to ministry full circle.

After ordination and two years in campus ministry at Ohio Wesleyan University, I came to Indianapolis as associate minister of Downey Avenue Christian Church. In those days, the majority of staff at Missions Building and many former missionaries were members of that congregation. The interview by the Downey Avenue search committee was a breeze compared to the congregational meeting. They had planned to have the search committee ask me questions so the congregation could get to know me, but that was sidetracked when several members who were staff at Missions Building decided they should have the right to question me.

It seemed like the Spanish Inquisition. I was the first woman they had considered to be an associate minister, and it wasn't going to be an easy process. I remember one of the leaders of our denomination saying that he had to travel and was gone from home a lot. How could I bring up his sons in the faith as well as a male associate minister? There was the usual question asked in those days about my belief in or lack of belief in the virgin birth, but Mae Yoho Ward stood up and stopped that question in mid-stream. The end result was that they hired me with only a handful of dissenters.

Mae and other women leaders of our denomination who were members of Downey Avenue became strong supporters and spiritual leaders for me in my first experience as a minister in a local church. Their positive feedback and that of many of the male members of Downey Avenue gave me a sense of confidence in my call that has gotten me through many stressful situations throughout the rest of my years of ministry.

After almost five years at Downey Avenue, I was ready to move on. I thought I was looking for a position where I would be the only pastor, but those positions were very hard for women to find. While I continued to search, my continuing commitment to the global family of God led me to accept a one-year position with the Division of Homeland Ministries, now Disciples Home Missions, helping Ella Grimes with the resettlement of the overwhelming numbers of Southeast Asian refugees who were arriving. That one-year position was expanded to a year and a half, and then Ella decided to retire. I was given her position as director of what we now call Refugee and Immigration Ministries (RIM).

I thought I'd stay for five years or so, but the nature of the work was so interesting and varied that I was never motivated to seek a different kind of ministry.

Up to this point I've talked about the significant people of the church who influenced my life. In refugee and immigration ministry, it has been the insignificant people of the world, the people few persons in authority care about, who have had the greatest influence.

After twenty-eight years with RIM, travels to more than thirty-five countries, the resettlement of more than 26,000 refugees involving hundreds

of churches, hearing thousands of stories of both persecution and survival, and being called upon to help in many very sad immigration situations, I now see how my initial desire to be a missionary has opened an even broader world to me. If I had become a missionary, I would know a lot about another country in the world. Instead, I know a little about very many countries in the world. I have been privileged to have the one job in our denomination in which I can truly experience the diversity of God's creation.

The God I worship is no longer confined by just my own cultural experiences.

I also have had my faith strengthened by the faith of the refugees and immigrants with whom I've come in contact. How can I doubt the love of God, how can I complain about my problems, and how can I despair about today's world? I can't, when those who have suffered unspeakable mistreatment witness to me about their faith and trust in God.

At an All-Africa Conference of Churches meeting, I met a woman working with Tutsi refugees in Rwanda. When the genocide took place in Rwanda two weeks later, it was more than an interesting segment on the nightly news. It resulted in her husband's death and made me realize that God had bound me spiritually with the suffering of the world in a very personal way.

For the most part, refugees and immigrants have deep faith in God despite the suffering they have endured and continue to endure. One Ethiopian man whom I met near the beginning of my refugee ministry stands out in my memory. When I asked him how long he thought he would be in the refugee camp in the Sudan, he said, "I will be here until God is done with my being here. I will be here until I have learned what God wants me to learn by being here."

He and other refugees and immigrants have taught me many lessons in faith.

Because the Disciples ministry with refugees and immigrants is done ecumenically, I have had the opportunity to work with other denominations through Church World Service and the World Council of Churches. Cultural differences tend to divide denominations, and that has provided an additional learning experience. Serving for the past nine years as an officer of the CWS Board of Directors has given me additional opportunities to work on global relief and development issues, expanding my global understanding beyond refugee and immigration issues.

Working with the officers of the National Council of Churches in the USA (NCC) on new directions in relationship between the NCC and CWS has expanded my understanding of the nature of the Church universal. The opportunity to attend a World Council General Assembly was a blessing multiplied by the opportunity to see again so many of the people I had

met in my travels. As I walked down a hall, I heard my name being called and turned to see someone I had met in Cuba eight years before. He had actually remembered my name! We really are one family of God!

My ecumenical involvements have brought me some of the greatest expressions of appreciation for my gifts and professionally some of the greatest support for my ministry.

My only regret in all these years is that I have not found a way to help other Disciples have the same experiences. By resettling a refugee or helping an immigrant, congregations have had a little taste of what it means to be part of a global family. That one-on-one experience needs to grow and prosper in our congregations. The world is getting smaller, and we need to be better prepared for it. We need more opportunities to see the diversity of God's creation.

When I was ordained and for a few years following that, I knew almost every Disciple clergywoman in the denomination, there being so few of us then. I celebrate that that is not possible today.

For those who are younger, I would say: The best job in our denomination will be available when I retire.

When I was young, women ministers dreamed about being the first woman regional minister or General Minister and President. I have seen women fill those roles in my lifetime! Now, what should young women in ministry dream about? From my perspective, they should dream about ministry in a denomination that is being born anew—a denomination that is starting to reflect the diversity of God's creation. Think of all the immigrant congregations in formation. By the third generation, they will be integrated into the whole life of the denomination.

What a difference that will make in our understanding of God's family!

It won't be an easy transition for those who like the old ways of doing things. That is exactly the reason capable young women will be needed. Clergywomen who already have an understanding of exclusion can work against the exclusion of others. They can facilitate reconciliation and affirmation of the diversity of God's family. It is a ministry that God is calling us to. It is a ministry that I hope young women will be open to experience. The mission field has come to us and we cannot remain the same. I'm grateful that I have been able to play a small part in increasing the diversity of this country and this denomination.

Thanks to the women, who like Dot France, led the way for my ministry. Best wishes to all those who will follow, helping our church become more aware of the diverse family of God.

Jennifer

LETTER 23: *Marianne Scott*
Corporate Secretary/Director of Communications
Pension Fund, Indianapolis, Indiana

Never Heard a "Call"

Dear Church,

Every manifestation of the Church creates talk about being "Called," or hearing "God's Call," in determining where we should be headed. To this day, I have not heard a call, nor do I think I will ever hear one. I really don't feel cheated, for I believe ministry has come to me just as God would have it.

What I do know is that God has a way of nudging people in different ways.

For some, it is a clear-cut vision of what they are to do. For others, like me, it takes years of osmosis, stumbling, grumbling, absorbing, and a few lumps along the way for the whole concept to take shape. Sometimes I have paid attention and gone willingly. At other times, my red-haired stubborn nature took over and delayed God's plan in my life. We are most fortunate that our God is a very patient God.

When I came to the Pension Fund in 1979, we were making changes and moving to our third generation computer. The '70s fascination of an electric pencil sharpener and stapler was losing its novelty. The computer that used to fill a whole room now sits under a desk, fifty filing cabinets filled with correspondence and information about Pension Fund members are now imaged and accessed at the click of the mouse. A work force of forty-two has been reduced to twenty-eight.

While the business of personnel and electronic transformation took place, I was surrounded by people such as William Martin Smith, V. Rex Thomas, Lester D. Palmer, Rex Horne, and Arthur A. Hanna. I remember being asked to give the devotional at one of my first staff retreats. As I looked around the table at these great voices of the Church, I couldn't imagine what I could say that would be remotely interesting, enlightening, or dare I say innovative. And yet, they listened! Well, let's just say they put up with the ramblings of a staunch United Methodist wannabe school teacher trying to find her way in the world of Disciples.

It's funny, really! I took the job at the Pension Fund while I looked for a real job, a teaching job. Thirty years later, I still haven't really looked

for that teaching job. My theory is that children in the state of Indiana are, or should be, eternally grateful that I didn't teach. For these children, my absence from the classroom is proof that God really does answer prayer. I don't know what happened; but as the years passed, I became keenly aware that the Pension Fund is so much more than field staff venturing out to tell seminarians and church secretaries about the various programs available to them. It is more than an office of clerical staff punching in numbers to satisfy a report.

The ministry that takes place here happens in small ways.

I witness pastoral care and concern when our staff attend meetings and form bonds of friendship. I hear the same pastoral care and concern in the voice of those in the "Call Center" as they receive calls telling them someone has died. I see it in the handwritten notes expressing appreciation for bringing dignity to those who have served the church. I witness it at General Assemblies when we meet face to face with those who have or are serving churches and seminaries.

Over the years, my job, my ministry, has changed not only in job title (four times) but also in being allowed to find what my true gifts are. Early on I realized that number crunching was not my cup of tea. However, give me a glue gun and some construction paper, and I'll make you an offering box. The theory holds true that creative persons are not necessarily great abstract thinkers. Along the way, I was afforded the opportunity to take on the print media portion of the Pension Fund. This seemed like a natural progression as I had supervised, for a short time, the print shop for a large insurance company. The lessons learned there have served me well in understanding processes and implementation. And yet, even in print media, the days of shooting copy, burning plates, and blanket wash are fading at the feet of files being zapped by e-mail.

More recently, I find myself writing the cover of our gift publication, *"Remembering the Gifts."* That has been fun and has allowed me to combine several creative gifts into one outcome. I am constantly reminded, however, that the long shadow of Mrs. Rhoma Peterson is looking over my shoulder and just shaking her head. Mrs. Peterson is that high school English teacher everyone has that is the guru of grammar. Let me see, I think she said my writing was a grammatical disaster and "way too folksy." To this day, I can hear her dramatically stretch out the phrase, "dangling participle" and "comma splice." So, Rhoma, keep watching over me. I need all the help I can get!

The idea of becoming a licensed minister came at the urging of Lester Palmer. "What you are doing *is* ministry, why not claim that aspect in your life with this intentional step," he said.

For me, he was the nudge that formed the call.

"Ok fine," I'm thinking, "but no one at Disciples Center is intentionally a licensed minister!" In fact, no licensed ministers were at Disciples Center at all at that time! Will what I am claiming be perceived as merely office work with someone stomping her foot saying it really is ministry? So, off I went to request licensing with the support of the Pension Fund and Eastgate Christian Church in Indianapolis. At my first Nurture and Certification meeting, I got the feeling they really didn't know what to do with me! I didn't fit the mold of a local church pastor, and I wasn't leaning toward Christian education either. I was church administration from "that building." Soooo, what is *she* all about?

Funny, isn't it, how when you have to verbally claim your God, when you have to verbally claim your ministry and verbally claim your intent to further serve those who serve, the way becomes clear and you define your call? They learned who I am, and I learned what their concerns were for me. Now, fifteen years later, the process continues.

You see, for me the nudge that became a call is an ongoing process that defines and redefines itself on a daily basis.

I don't think I would have had it any other way: ministry finding its way through a temporary job ... patience from those who knew who would be the ultimate potter ... the right people nudging at the right time ... a Nurture and Certification Team daring to call the work of a corporate secretary/director of communications ministry ... the shadow of an English teacher whispering "dangling participle" ... and, ultimately fulfilling God's plan in my life through licensed ministry.

All things considered, I do believe I have been "called" to ministry. Perhaps my call is not the dramatic "Damascus Road" experience, or the vision of someone crying, "Come over to Macedonia and help us." It was more subtle. The "call" came as I considered the needs of the church and when I discerned the unique opportunities I had to serve God in my work and service at the Pension Fund of the Christian Church (Disciples of Christ).

To those considering ministry, keep your eyes and ears open to the understanding that God's call might not be what you conjure up in your mind. If you're waiting for those angels to sing in your ear–might not happen! God needs all kinds of people doing all kinds of things. What you are "doing" now might just be the precursor to what God is preparing you to do.

Seek it out–don't be shy–stomp your foot–get going–claim your calling.

Marianne

Dear Church
Academic Staff & Students

LETTER 24: *Sarah Webb*
Chaplain, Bethany College, and
Pastor of Bethany Memorial Church,
Bethany, West Virginia

Waiting for a New Call

Dear Church,

We've had a long love affair, you and I. It dates back as far as memory carries me. It began at home–our family home on Old Garst Mill Road in Roanoke, Virginia. It's the home my sisters and I have just sold with a great deal of heartache. It was a home our parents carved out of a wooded wonderland more than fifty years ago. It was a home filled with hard work and good food (our mother was an artist in the kitchen); fine antique furniture and a sculpted yard that could compete with the best of any *Lawn and Garden* issue (our father was an artist with wood and nature); three little girls (who have grown up to be three, fine women); several dogs, a multitude of cats, an abundance of love–and still there is more.

It was the home in which my call to ministry took root.

Church was never an option in our home. Our congregation, Westhampton Christian, gathered just a mile down the road where our parents, Garnett and Hester Webb, were charter members. When it was Sunday, we were at church. If memory serves me, our mother was the first woman

elder in the congregation. She was my first model of the strong and capable leadership women can give to the Church.

I didn't realize it at the time, but Westhampton was like an extension of our home. Who could count the hours we spent there? My sisters and I grew up through the channels of nurturing care: nursery, Sunday school, Chi Rho and CYF, and camps and conferences at Craig Springs. This was the congregation that witnessed my confession of faith and my baptism under the ministry of my mentoring pastor, Rev. Robert L. Bradley.

Much of my pastoral style is still fashioned after his.

This was the congregation that willingly supported the youth and our leadership during countless Easter sunrise services and youth Sundays with the special touch of Bill "Crusher" Bowers and our Sunday school teacher, David Blevins. This was the congregation that gave tender pastoral care to our family at our mother's death. We will always be grateful to Rev. James Burton and Rev. Walter Bingham, Jr., for carrying us through those days. This was the congregation that pursued me and kept in touch with me through my years at Lynchburg College and Brite Divinity School. This was the congregation that sponsored my ordination, October 15, 1987, under the guidance of Rev. Johnny Loughridge. This was the congregation that in January 2008 reached out to our family again after our father's death. We didn't know the new interim pastor, Rev. Sam Fuson, but he quickly earned his way into our hearts.

As church pastors, we don't often realize the impact our ministry has on others until we are on the receiving end of that care.

I've been a congregational pastor now for twenty years. I have loved it as I lived it. But often only in the broken moments when I was the recipient of someone else's ministry was I reminded what it is that we pastors do. I can think of no other vocation that stands with people in all the sacred moments of life. Is there any other calling that is so fundamental and life-giving?

Ministry has led me into some remarkable places and experiences. I have done weddings on a yacht in Vancouver, British Columbia, and at a medieval castle in Tuscany. Then again, I have lived in West Virginia long enough that there was a wedding themed around NASCAR and another that the bride labeled "Redneck Chic." (I never imagined I would have an appropriate chance to say, "Yee haw!" in a wedding.)

In the early years, the Region of Virginia and the General Church of the Disciples of Christ offered me numerous opportunities to serve on various boards and committees. It gave me great exposure to the structure of our denomination and opened doors to a network of friends and colleagues across the globe. Through the church I have had travel/mission

opportunities to five countries in South America, four in Central America, and two in Africa. I have served three pastoral-sized congregations and formed lasting relationships with some of the finest of God's servants on this green earth. My heart overflows with gratitude.

God and the Church have been gracious to me with a wealth of invaluable experiences.

I am writing this letter at a time of significant personal transition. It has been a year of loss and letting go. We had to put down our yellow lab. I pray we never face that decision again. A few days afterward, my father suddenly became critically ill. We counted those days by hours, and four precious weeks later, we gathered around his grave. With a year of deliberation under my belt, I resigned from a yoked church pastorate and chaplaincy in Bethany, West Virginia, that I served and dearly loved for fourteen years. It may be the single most difficult decision I have made in my life. Then just this week, we closed on the sale of my childhood home. It is a common theme—letting go. We do it every day on some level: from cleaning out the garage, to watching our bodies change with time, to saying good-bye to loved ones.

Loss and letting go have been my companions this past year, and they have become valuable teachers.

I am just beginning the third month of an indefinite period of sabbatical. I knew I wasn't ready to launch into another congregation. Perhaps God wants me to pursue another avenue of ministry? The road to that place is unclear, and my reserves are low. It was time for Sabbath.

In Richmond, Virginia, July 22–24, 2008, I attended the *Fundamentals of Transitional Ministry* course sponsored by the Interim Ministry Network. In one of the breakout sessions, everyone in the group was clergy, each of whom was in transition between positions. An Episcopal colleague voiced the concern, "What I really want to do is be a priest. I don't want to be a rector." My response was simply, "That's what we all want."

Many of us who are drawn to congregational ministry are inspired by the pastoral care, the preaching, the teaching, the joy of leading worship, the basic shepherding of a flock. We do get those things. The sweet moments we share with our parishioners are worth more than I believe any other job could offer—those sacred occasions when we pray with them in the hospital, stand with them at grave's side, witness their marriage vows, and bless their children in the waters of baptism—all holy ground. Those *kairos* times replenish all who are involved.

As we know too well, life is messy. Congregations are complicated systems. Power struggles for which we were never prepared erupt. Difficult personalities and demands on our time and energy deplete our wells. As

my colleague disclosed, we want to be priests (and pastors and preachers), but we don't want the hassles of church politics.

The general question we were asked to address in these letters was, "How did you come to ministry?" In light of my current transitional and uncertain status, I would add to that question the following, "Why do you stay in ministry?"

That's not a question to be answered hastily. In my early years in ministry, I wouldn't have understood the need for it. Things came easily to me in parish life. It's not that I don't have to work at it—I do. I've had good matches with congregations, and I have encountered few major obstacles or setbacks along the way. The question is more a thing of energy and direction. After more than 900 sermons, the work heightens to keep the sermon fresh to the preacher.

Unrealistic (and often unspoken) expectations from congregants take their toll.

Why is it we stay in ministry? We stay if the Call is still vital. During my middle school years, I began to consider ministry as a vocation. I've always given credit to Roberta Moore for first pointing the way. On Chi Rho's turn to lead Youth Sunday, all the parts of the service had been claimed—except for the sermon. Roberta turned to me and said, "Sarah, I bet you wouldn't mind preaching." And she was right.

She had no idea that simple statement would open a door that would change my life. I never cease to be amazed at how the Spirit works through people in unsuspecting ways. That was my first (remembered) awareness of a call. It is still with me, though it has changed through the years. I feel it stirring, and it hasn't taken up another residence yet.

We stay in ministry if God wants us there, for we are a small argument against the divine will.

A vocation in ministry has its cycles, its ups and downs, its moments of glory and its stretches in the wilderness. Our inclination may be to run when we find ourselves in the wasteland. We get burned out and used up, and so we seek shelter in another home. We are afraid to wait for morning. Yet scripture and experience teach us that even in the struggle of the desert we receive grace. Signposts and people and events point out the way. Those who came before us have wrestled through the night and limped away changed. In that wrestling, we may find our call is revitalized. We can be regenerated for a different step to come.

My "words of wisdom" to my sisters entering parish ministry and to congregations seeking new pastors would be to tread gently with each other as you are on holy ground. Look to each other as vessels of God's grace, but do not lean solely on each other. Only one well can fill your souls. Neither of you is the living water. Neither of you is solely responsible for your

successes or your failures as a team. Your time together is a shared sacred trust. You come together for a precious short time, fulfill your covenant with each other as God gives, and then you bless each other upon parting. You are called to challenge each other in love for the highest good of all as you live out the gospel. May you do so as partners in grace.

Dear Church, my dear, dear church. You are among my oldest and truest of friends. You found me at an early age and seeped into my heart. You have grown with me as I grew and unfolded when I was open to seeing more. When I rejoiced, you gathered around in celebration. When I was wounded, you picked me up and set me on my feet to start again. And when time is spent and the things of this earth fall away ... *even there your hand shall lead us, and your right hand shall hold us fast.* The God who breathed life into us both will love us to the end.

I do not see the way in front of me, but I trust in the One who does; and that is enough to carry us for now.

Sarah

LETTER 25: *Lisa Davison*
Professor of 1st Testament,
Lexington Theological Seminary, Lexington, Kentucky

Natural Thing to Do

Dear Church,

There it was, out in the open, the words just hanging there in the air. I knew it was coming, but I kept ignoring its approach. What to say? What would be the "right" response? I squirmed in my seat and felt the sweat beading up on my forehead. My heart beat rapidly in my chest and ears, and I was sure that everyone else in the room could hear it too. I licked my lips and swallowed, trying to ease the aridness of my throat. The others became impatient and uncomfortable. Hoping to ease the tension, one of them asked the question again: "Tell us about your call to ministry, Lisa."

How easy it would have been to describe a bright light, a near-death experience, handwriting on the wall, or any of the other fantastic stories I had heard other seminary students describe as their "call to ministry." Unfortunately, I had no great story. I had experienced no meteorological event, no booming voice, no vision. Compared to their stories, mine seemed puny and anti-climactic, perhaps even inauthentic.

How do you explain that going into the ministry just seemed natural?

I couldn't remember the date, time, or place when I had actually formulated the words, "I want to be a minister," in my head. Rather it was a quiet, gradual development in my life. When the time came for me to apply to colleges, I knew that I wanted to go to Lynchburg College because they had a good religion department. The cost of a private college was too high for my parents to pay, so it only seemed natural when I received a full scholarship as a Disciple of Christ pre-ministerial student. The process of enrolling in seminary had been just as easy and uneventful. But, sitting there in front of a committee on the ministry in Fort Worth, Texas, I somehow felt that my "call" experience was not going to impress them.

I needed a call story like that of Samuel. A tale of being asleep in the sanctuary and having God wake me up in the middle of the night to tell me what my mission in life was supposed to be. Unfortunately, I spent many nights sleeping in churches, for lock-ins and committee meetings, but truth be told, I had slept very little and heard no strange voice from heaven.

Or maybe a story like Mary Magdalene's: having seen the risen Jesus and being directed by *Him* to go and preach the good news of his resurrection. However, I had not spent much time in tombs and had received no direct orders from an apparition. What I would have given for a burning bush like Moses encountered when God called him to lead the Hebrew people out of bondage! Now these are "call" stories that would impress any committee on the ministry, seminary, or congregation.

In reality, though, I imagine that my call might have been more like that of Miriam rather than that of Moses.

I have always been involved in church. From the time I was in the nursery, church has been a central part of my life. My home congregation, First Christian Church, Radford, Virginia, nurtured me in the faith and helped me to understand the grace and love of God. My faith journey was forever changed by the progressive views of my home church in calling a clergy couple to be our pastors in 1979. At a time when the larger church was only beginning to recognize and appreciate the validity of women as ministers, this congregation in a small town boldly took a stand in support of equality for men and women in ministry.

I was thirteen at the time, and the impact of this decision on my life would not be fully realized until many years later. Although I had always known strong women in the leadership of the congregation, seeing a woman in the pulpit was a great influence for my developing identity and sense of call, as were the other female pastors with whom I had contact during these formative years. As a result, I grew up with an understanding that my gender presented no obstacle to my future vocation. My faith community never told me anything different. Only later did I realize what a blessing this was as I heard the countless stories of women who were told that they could not do something, specifically become a minister, simply because they were not men.

With the change in ministers at my home church came a renewed effort to involve the youth of First Christian Church in church camp and other regional activities. Because of the suggestion by one of my ministers, I applied for and was elected to serve on the Youth Ministry Committee, a group of high school kids and adult sponsors who planned and led state-wide youth events.

Through this involvement, I began to sense what must have been a "call" to ministry, though I did not recognize it as such.

My gifts for ministry were confirmed by those with whom I worked and by the members of my church. In college, I pursued this sense of call but on my own terms. I did not want to be a preacher, so I decided to become a missionary. When a professor suggested that I consider teaching, this

seemed like another option to keep me out of the pulpit. I decided I would teach New Testament either at a Disciples' college or seminary.

My plans took a new turn during the three years at Brite. My Hebrew Bible professor opened this part of the Christian canon for me in a whole new way. Among these stories and prayers of my faith ancestors I found nourishment for my being. I wanted to experience congregational ministry first, if I were to teach some day in a seminary.

Since graduating from Brite, I have not been able to serve in a congregation the way I had envisioned. Some of that was due to being married to a minister but not wanting to serve as co-pastors.

Some was also due to the Church's continuing prejudice against women ministers.

When we were looking to relocate, my husband received several inquiries from congregations, but I had only one. Despite these obstacles, I have had opportunities to minister in a variety of contexts, which would not have been possible if I had served in a local church. My call to serve God and God's people has taken me into different manifestations of the Church. From working as a Congregational Campus Ministry Developer for the region of Kentucky to serving as chaplain at Culver Stockton College, I have been blessed by the opportunities afforded me to work with many local congregations, to teach and counsel students, and to see the power of the ecumenical church.

At the current time, I love teaching seminarians to interpret scripture and share their learning with the churches they serve. Teaching laity, either through seminary sponsored events or by speaking in local churches, is my passion. I feel called to help people in the church become readers and interpreters of the biblical texts, to claim their theological voices. I have learned to be open to whatever new direction God presents for me. In the past five years, I have been called to serve as the interim pastor of two different congregations. Both positions required that I preach regularly.

So much for telling God that I would serve in ministry but never preach!

As I reflect on my faith development, I number many mentors, both female and male, who have helped me to find my call to ministry. From Sunday school teachers to college professors, pastors to church elders, each has played an important role in my journey. Two were influential members of First Christian Church in Radford, Virginia. Mrs. Ethel Kirby, a longtime member of the congregation, had kept me as an infant in the nursery. As I grew up, Mrs. Kirby was always there, loving and caring about me. Years later, when I visited her in the hospital as the student intern at the church, she introduced me to someone as "one of her pastors." Another important influence in my journey of faith was Darlene Collins, my first grade teacher and my Sunday school teacher. A wonderful woman of grace

and compassion, Ms. Collins not only instilled in me a passion to learn in school but also in church.

Probably the most influential minister in my life has been Rev. Gina Rhea. A part of the clergy couple First Christian Church called in 1979, her presence in my life was truly transformative. Gina has always been a wonderful role model of a minister, but specifically as a woman minister. She understood that women have to be better than men to get the credit that men do. She was truly outstanding in every area of ministry. Gina helped me to understand the importance of using language that included rather than excluded people from the gospel and that broadened the faith community's experience of the Divine. Having faithfully served First Christian Church for twenty-nine years, she has been there for me and my family through all of life's most important events.

Although I know that I can never be her, I strive to have the courage and commitment that Gina lives daily.

Along my academic path, one woman always provides reassurance and wisdom that I need, and always at the right time. Dr. Toni Craven is the I. Wylie and Elizabeth M. Briscoe Professor of Hebrew Bible at Brite Divinity School. Toni was the reason I changed my focus from New Testament to Hebrew Bible. Her teaching ignited a passion in me for studying and teaching the Bible. In my teaching career, Toni has been the role model for me of a great professor. Each new semester, I try to reflect the qualities Toni exhibited in my own interactions with students.

After serving for seventeen years as an ordained minister of the Christian Church (Disciples of Christ), I know that this was my true calling. I get frustrated with the Church in its resistance to change and continuing exclusion of others (particularly gay, lesbian, bisexual, and transgendered people) who have been called by God to serve in ministry, yet I love the Church for all the good that I have seen it do and the blessing I have received. Although much has changed, some parts of the Church still will not accept women as ministers. Church members make a great mistake to think that we have totally overcome the exclusive theology that kept women out of the pulpit for the majority of Christian history. It exists overtly in some places and bubbles under the surface in others.

The struggle continues.

Given these facts, I tell women who are considering ministry that it is a terribly difficult calling but also extremely satisfying. As women, they must be better prepared than their male counterparts and must always seek to be as close to perfect as possible. They, individually, represent all women ministers. If a female pastor screws up, then a congregation will have the tendency to see this as a mark against all women clergy. Of course, if a male

pastor does the same thing, his mistake has very little chance of becoming a mark against all men clergy.

As discouraging as this might sound, it gives a woman no reason for ignoring God's call in one's life. Throughout time, most all of the people God has called to special tasks have faced resistance or worse rejection.

Being faithful is not about taking the easy way out; faithfulness is following one's call wherever it might lead.

The bottom line is: the Church needs women clergy. The gifts that women bring to ministry are invaluable. While many of the unique characteristics of female pastors are more a result of socialization than genetics, they are necessary if the Church is to come closer to the wholeness that God desires. Anyone, male or female, who feels called to ministry, needs to nurture that call through service, education, and spiritual formation that will serve her well in facing the variety of situations that call for pastoral leadership. From bedside prayers to board meetings, having a sound theological background is invaluable for ministry.

To any woman who is feeling a call to ordained ministry, I believe nothing is more valuable than listening to your heart. Seek out a supportive community that will help in the discernment process of deciding on how best to answer the call. If this seems like a crazy idea, remember that one of the distinguishing marks of a prophet is a resistance to God's call. Yet, God will be faithful to you in this journey. She will not fail you in the most difficult times and will sing with you during the joyful ones. Sarah, Rebekah, Miriam, Huldah—God has always called women to do God's work.

Come and join the sisterhood!

Lisa

(Now Professor of Religious Studies at Lynchburg College in Virginia)

LETTER 26: *Carolyn R. Higginbotham*
Dean, Christian Theology Seminary
Indianapolis, Indiana

Called to Do the Impossible

Dear Church,

As I look back on my own journey of faith and vocation, I am cognizant above all that this journey has taken me many places I never dreamed were possible. Thanks be to God whose vision is greater and broader than mine or yours and who opened doors and pathways to opportunities I didn't dream about because I "knew" they were impossible.

I "knew" it was impossible for foreigners to teach Bible and theology at seminaries in the People's Republic of China. Although my family heritage includes generations of missionary service in China, I never dreamed of teaching there. Why waste time dreaming of something that could never be? I was well aware that all the foreigners had been expelled in the early 1950s as the Communist Party came to power and instituted a strict policy of independence (self-governance, self-propagation, and self-support) to prevent a return to foreign domination.

Yet by 2001, the church and the state, aware of the need for improved pastoral education, were ready for an experiment with a few foreign scholars teaching at the national protestant seminary in Nanjing. Providentially, the moment came just as I was eligible for my first sabbatical leave. My husband and I first got wind of the opportunity in January. By August, we were settling into an apartment in Nanjing. I spent a year teaching Old Testament and Biblical Hebrew in the very place where my great-grandfather taught Old Testament a century earlier.

Many of my former students are now teaching at regional and provincial seminaries across China.

Some of our "knowing" is on a more unconscious level. Publicly and consciously we dream and hope and pray, but deep down inside we never quite allow ourselves to believe until the impossible happens and we are surprised. I was surprised to find my eyes tearing up as Sharon Watkins was installed as General Minister and President. I suddenly realized that I had never really believed that I would live to see someone who looks like me leading our denomination. Yet she was standing before the General Assembly receiving the symbols of office and the enthusiastic acclaim of the

assembled. I was caught off-guard by my own reaction. I hadn't let myself face my doubts and mistrust of a system that was still male-dominated.

I felt a similar, though less intense, wash of emotion as I sat in a restaurant a couple of years later as part of the planning group for the next day's session of Team Leadership Conference (an unofficial body comprising regional ministers, general ministry residents, and seminary leadership). As I looked around the table, we were all women. Women were planning an event for leadership of the whole church.

A similar transformation has occurred in the leadership of our seminaries. Although women have long led two of the three divinity houses/foundations, six years ago I was the first woman to be called as a seminary dean, followed by Nancy Ramsey at Brite and Daisy Machado, now at Union in New York.

What a difference it makes when women are present in more than token numbers, when we can comfortably take our place at the table, confident that our voices will be heard and taken seriously!

Of course, we in positions of leadership today stand on the shoulders of those who went before us. My call to serve as academic dean at Christian Theological Seminary was not predicated solely on my talents and experience. I am the beneficiary of countless women who prepared the way, some of whose names I'll never know. I remain deeply grateful to Dr. Sue Cardwell, who broke new ground as the first woman to be granted tenure on the CTS faculty. She persisted through many tough years in a system that didn't always value or affirm her tremendous gifts and knowledge. Other women followed Dr. Cardwell on the CTS faculty or provided leadership as department directors. Their hard work and faithful service, alongside the witness and prophetic voices of women students and alumnae, paved the way for me and made it possible for the CTS president, Rev. Dr. Edward L. Wheeler, to commit to calling a Disciple woman to work with him as academic dean.

Another group of women helped to open this door: an association of women religion scholars who are Disciples and/or who serve on the faculties of Disciples institutions of higher education. Known as the Forrest-Moss Institute after two Disciples women scholars, this informal organization gathers once or twice a year to network, collaborate on book projects, and support and mentor one another. I first learned of the opening at LTS through Forrest-Moss. CTS was always well represented, so it was not surprising that at a breakfast meeting we spent time discussing the vacancy and potential candidates.

I don't remember who first suggested that my installation at CTS be a celebration of women's leadership; but once the idea took hold, we really ran with it. Women filled almost all the speaking roles. What a sight to

behold! I was literally and figuratively surrounded by a cloud of witness, women of many races and ethnicities, laywomen and clergywomen, faculty, staff, students, alumnae and trustees of CTS, regional and general church leaders. We sang hymns with lyrics written by women, and the Indianapolis Women's Chorus provided special music. Being surrounded and upheld by so many extraordinary women proved a powerful experience. I knew each woman represented a myriad of other women in our church and in the academy. I sensed then, as I do now, that I am but a part of a rich tapestry woven by women of diverse backgrounds and gifts.

Together we seek to serve the Church of Jesus Christ and share God's creative and transforming work.

I come from a line of professional women who, while very committed to their families, also had identities and careers outside the home. My maternal grandmother, Rose Garret Holroyd, born on the mission field in China, earned a bachelor's degree from Drake University and a master's degree in English from Columbia University before returning to China as a single woman missionary in her own right. (She met my grandfather in language school in Nanjing.)

Her sister, Mardie Garrett Smythe, earned a medical degree and served in China until the last missionaries were expelled in 1951. My mother, Barbara Holroyd Roderick, earned a Master of Social Work degree and was the first woman to hold the rank of commissioner in the city of Cleveland Heights, Ohio, where as housing commissioner she enforced Fair Housing regulations in the 1970s. Her sister, Joyce Holroyd Hull, earned a master's degree in engineering and worked for Martin Marietta Aircraft.

Although my paternal grandmother, Goldie Roderick, lacked access to education beyond primary school, she was as unconventional as the women in my mother's family. She played catcher on a women's baseball team and persevered through divorce and remarriage in small town Ohio in the 1920s. What role models I had, just within my own family! As the ad slogan says: "Impossible is nothing."

I knew women could be or do anything because I had seen it.

In a similar vein, my family and home church taught me to see justice and equality as issues of faith. My parents were active in the civil rights movement in the 1960s and '70s. They participated in interracial dialogue groups and the Poor Peoples March. Their primary focus was fair housing, which did not exactly make us popular with many of our neighbors!

My sister and I learned early on that those who take a stand pay a price. We grew used to verbal threats and abuse–to being unwelcome in some homes and backyards. We also learned to respect African American leaders and professionals. Our parents worked for Carl Stokes' mayoral campaign and entrusted our medical care to an African American pediatrician and

an African American dentist. At Heights Christian Church, we were fed a steady diet of Social Gospel. We understood that church members, including our parents, were living out their faith through the Civil Rights Movement and other justice activities. We watched as the first women were elected elders. Our own mother became the first woman elected moderator.

The road has not always been easy.

I've been called "aggressive" for speaking up and participating as an equal partner in conversation. I've met people who are uncomfortable with women in leadership. One family left the congregation my husband and I served because they had concluded that it was contrary to the Bible for a woman to preach and lead a church.

Ironically, seminary proved one of the bumpiest patches. Vanderbilt Divinity School was a mixed experience for Disciples women in the early 1980s. On the one hand, the school offered much support for women seminarians. Women students were numerous, visible, and well organized. We had strong faculty role models, including Peggy Way, Sallie McFague, and Mary Ann Tolbert. Specific courses addressed the concerns and perspectives of women. I was able to participate in Sallie McFague's seminar on models of God. My small group's project was to reflect on God as Mother. The official school policies institutionalized a woman-friendly environment, mandating the use of inclusive language and non-discrimination in admissions, hiring, and field education.

On the other hand, some policy violations were quietly ignored. Although technically all field education placements were to be open to women as well as men, most field positions at Disciples churches in Tennessee would not consider women. Relationships with the congregations were nurtured through the dean of the Disciples House, then Herman Norton, rather than through the field education office, placing these positions outside the policy.

The system resisted change through peer pressure. "Don't ruin it for everyone else. The congregations will eventually come around if they aren't pushed too hard too fast. Trust the male students to help them grow toward a more inclusive theology." From a strategic perspective, that might have been wise, with positive results over the long term; but it left women with few options for field placements. For me it meant completing seminary without ever having served a Disciples congregation. I had one placement at a community ministry and one as the youth pastor of a Presbyterian church. They were good experiences, but I missed out on the opportunity to be formed as a pastor in a Disciples context and to practice the full range of pastoral responsibilities.

As a woman, I was typecast in community and youth ministries. Similarly, my Clinical Pastoral Education site placed me in the labor and delivery unit. The supervisors thought I needed to address the question

of whether I would one day have children. Of course, no one thought my husband, enrolled in the same program, needed to address that question. He was placed in the pulmonary unit.

These experiences were frustrating and discouraging, but they were processed within the context of the Divinity School, which became for me and I think for many other women as well, a laboratory for empowerment. We were immersed in a critical analysis that pushed us to examine our experiences and assumptions and quickly sensitized us to the subtle and not-so-subtle biases in our culture and community. Not everyone was patient with our steep learning curve.

The push to transform our worldview, our language, and our behavior was intense and unrelenting.

Slips of the tongue (as in "mankind" or "the minister ... he") often elicited a stern rebuke. More significant were the formal and informal exchanges in which we puzzled through our feelings and experiences and nurtured and nudged each other to new understandings of our context and our options. I learned to channel my anger into determination not to let myself be defined or limited by narrow attitudes and prejudices and to focus on small successes as signs of hope, like the welcome and positive feedback I got when I preached at my husband's student church.

For me, the hardest question in a job interview has always been: where do you see yourself in five or ten years? I never quite know what to say, because the future seems so open to me, so full of imagined and unimagined possibilities. Teaching in China wasn't on my radar screen even ten months beforehand.

How can I possibly claim to know what opportunities might emerge a few years down the road?

Sure, we need a sense of direction. It's not a good idea to wander aimlessly, but I've come to believe it's an equally bad idea to let oneself get too wedded to any one path or plan. Too often, I almost missed out on a real blessing because my vision was too narrow. My word of advice to my sisters in ministry is: Do not limit your vision to what you can imagine.

Keep your eyes and ears open to what God might be up to. I don't know exactly what it will be, but I sure don't want to miss it.

Carolyn

LETTER 27: *Tamara Nichols Rodenberg*
Dean, Claremont School of Theology
Disciples Seminary Foundation, Claremont, California

From Broken Child to Champion

Dear Church,

My story like many before me is a testimony of hopes and fears as well as inadequacies and surprising revelations of capability. It is a narrative shaped by inspirational people who have taken the time to care, to encourage, and to teach. I write this letter as an expression of gratitude and joy as well as a confession of profound struggle and growth. Perhaps the best way for me to tell this story is to begin with struggle and end with growth! Born and raised in the Christian Church (Disciples of Christ), this community of faith has surrounded me every moment of my life. How blessed am I!

I learned, in the arms of this church, that God will use the simple and the broken.

My mother recalls a child born with twisted hips and feet, a child so shy and timid she developed a stutter and was not able to speak clearly, a child who fell when she tried to run, and above all a child who needed love. This is where my story begins. At birth my hips were twisted, and I was put into a cast from my waist to my feet. The doctors believed, by casting early, I would be able to walk later in life. By the time I entered school, the doctors put me in "reverse-last" shoes (specially designed to hold my feet in the opposite direction). I remember trying to participate in school field day activities, tripping and falling–the children laughing and pointing.

Yes, I know what it feels like to "wear the shoe on the wrong foot!"

Unfortunately, the casting and reverse-last shoes were not enough to keep my hips from continuing to turn inward misaligning my legs and feet. In an attempt to find alternative solutions, the doctor encouraged my parents to put me into a sport that would force my hips outward and strengthen my legs.

Painfully, I learned to ice-skate. The skating boots held my legs and feet straight while the ice required me to try harder to stand. I began to grow stronger and more confident. I even found the courage to try new things, meet new people, and speak in public! Fifteen years of figure skating, competing, and performing laid a foundation for a life in ministry in ways

that I could never have anticipated. Eventually, I not only learned to walk and talk but also held two state titles and gained national competitive experience. I learned, through it all, the meaning of perseverance, faith, hard work, and triumph.

I learned what it meant to go from a fearful child to a young woman who could be a champion—not just in figure skating but also in life.

I believe a champion is one who learns, through a series of attempts and failures, a kind of humility and grace that leads to a far greater purpose than one can envision on his or her own. Most of us would not call ourselves champions. I submit the possibility that we are champions of life! Each with our own challenges, we are all learning to stand up, to walk. When I take a moment and think of the people who held me up or guided my path, I am humbled. They are, in my view, champions in life. The first and foremost are my parents, Harvey and Martha Nichols. They taught me to believe in myself and to listen to God. My father left me the gift of reverent prayer. My mother gave me the gift of unfailing faith. Both entrusted my life to God. Both made sure that church was a part of my identity. My champions!

Outstanding teachers and gifted pastors, likewise, continued to help me as I began to form a personal and pastoral identity. Leaving the world of figure skating, I needed their wisdom and reassurance to guide me on this new and unfamiliar path called ministry. I remember another champion: Rev. Marge Underwood. Rev. Underwood, one of the first women ordained in the Disciples, attended my home congregation. She wrote me a significant letter as I entered seminary. In her wisdom she said:

> Tamara, you are inheriting a gift. The women of my generation prepared the way, and now we hand the gift of ministry to you. Be ever prayerful. Do not think more or less of yourself than you ought. Stand up and stand firm while also remembering how to be gentle and graceful. God has prepared you—trust what God is doing in you.

Another champion in my seminary life was Dr. Michael Kinnamon. He introduced me to the Disciples vision of Christian unity and to the ecumenical church. I recall going into his office one afternoon at Lexington Theological Seminary and telling him that I wanted to be involved in the ecumenical movement. I wanted to study overseas. With Dr. Kinnamon's help, the opportunity to go overseas came in my final year of seminary. Together with my husband John I had the opportunity to travel to the United Theological College in Bangalore, South India. India was a long way from home for this child who was afraid of others, who stuttered in English, let alone Hindi! Yet, someone believed in me. I woke up one morning, and there I was stepping off the plane in India!

My heart pounding wildly, I realized perhaps for the first time that I was not just an individual Christian but also a member of a larger world—of the greater body of Christ.

India afforded me a new vision of ministry. As much as I love the Disciples of Christ, I found a greater love for the full expression of church as it is lived out in each place. From India, John and I returned to the United States and were ordained together in a beautiful church in Crittenden, Kentucky. We began our formal ministry as co-associate ministers in Bowling Green, Kentucky.

We enjoyed serving the church together, but individually my heart remained called to overseas ministry. I remember convincing John to accept a joint-call to Southern Africa. What now? English, Hindi and SiSwati!

God does have a sense of humor!

We were assigned, in God's infinite wisdom, to Kukhany'okusha Zion Church in the Kingdom of Swaziland. Bishop Amos Mali Dlamini and Sarah Twala Dlamini became for me more than mentors. They became family. Once again, I found myself being nurtured in the arms of church. Only this time it was the ecumenical church. Once again, I found myself surrounded with new challenges and meeting new champions. Rev. Daniel Hoffman, Africa area executive, leaned over at the commissioning and said, "*What does God have in mind?*"

My job description was to *"be an ecumenical presence, sharing in witness and ministry with Kukhany'okusha Zion Church."* Further, I was called to teach theology in an African Indigenous Church and work with women in rural development. What could God do with this young, white, American female pastor in relationship with elder, black, African male pastors? I was afraid. Would I stumble? Would I fall?

As it turns out, all God was asking was to be myself, just as I am, an authentic presence.

I noticed one hot afternoon while walking with the clergy in a funeral procession that the widow of the man who died was covered with a heavy blanket. The tradition was to blanket the widow as a sign of respect, a symbol of her belonging to her husband and of the gravity of her mourning. Watching the women diligently keeping the widow covered, I wondered who would be her minister on this dark hot day? In a moment, as the blanket stopped in front of me, I found myself climbing under the blanket. What was I thinking?! The truth is, I was not thinking. I was being myself!

Something indescribably transforming happened in those brief moments. There in the dark, holding the hand of a woman I had never met and could not see, I felt her fragile elderly fingers and her tears. She held my hand tightly. We did not speak. I simply stayed with her, moved

with her, and held her. I did not know what would happen when I finally found the courage to emerge from the blanket and face the bishop. Would he send me home? Had I broken all the rules of cross-cultural presence? Fearfully, I stepped out only to be received with warmth. Nothing was said of this infraction until many months later when I was called to a meeting of the women. Thinking, this is it, I joined the women. Rather than reprimand me, the women gave me a great gift–they told me that a new ministry will begin: a ministry for women by women!

The Mother Bishop decided that she would join the men and take classes in theological education as would three other women leaders. Over the course of the next five years, I was blessed to teach (and learn from) these incredible women. The women also decided that I needed a pastor's uniform. Much to my surprise, at a late night worship service (umlindzelo), the women of Kukhany'okusha honored me with the first "women's clergy" uniform complete with a pastor's collar.

I did not realize the significance of this gift until I was leaving Africa. The Mother Bishop asked me if I would leave the uniform behind. "Why?" I asked. She smiled and said, "We have a uniform ... now we will need a pastor to fill it!" Sometimes we never know the impact of our presence. Sometimes we are blessed with a glimpse of transformation, of making a difference. Such was my gift. After I returned to the United States, Mother Bishop wrote to me:

> *Make* [ma-kay "mother"] thank you. I have finished my studies as we had hoped. I will graduate with my diploma in theology. I am ready to argue for *make*-pastors [mother-pastors]. We will continue the ministry for the widows and mothers.

Indeed, "What does God have in mind?"

I left a part of my heart in Africa. Mother and Father Bishop are, to this day, a part of my ministry. They remain some of my champions as I now encounter challenging new voices.

A New Voice: The Academy

I never thought I would do ministry outside of the mission field or local congregation. Yet while in Africa I felt compelled to learn more. How could the church make a difference when it came to human suffering? Did the church have a role in physical well-being as well as spiritual? Should the church be a voice for justice in economic, political, and social spheres? These were questions emerging in my conscience. I wanted to know. I wanted to offer something to the world. Again, with the guidance of others, I entered a new chapter in my life: the Academy.

Dr. Karen Lebacqz and Dr. Lewis S. Mudge became, for me, powerful examples of ministry in the academic environment. Both brilliant scholars

and deeply caring pastors, they shepherded me through doctoral studies, exams, and dissertation defense. They helped me find my voice. Honestly, without their faith in me, I would never have finished a Ph.D. I cannot tell you how many resignation letters I wrote in my mind as I drove the 160-mile round trip back and forth from home to Berkeley. A mother of a three-year-old and pregnant with my second child, at times I would cry all the way while navigating my way through Bay Area traffic. I remember drying my eyes on Highway 15 just before arriving in Berkeley, all the while asking, "God, what do you have in mind?"

I have yet to fully understand what God is doing with this new moment in my life.

Who, me? Can a broken child unable to speak be a professor, much less a dean? Today, I hear again the words, "God has prepared you." I share these words here as I write to you. My dear church, what I have learned is to trust. Many times I have not known the next step, could not see, could not speak.

When you inevitably encounter such times, I remind you, as many have reminded me—you have the gifts and grace to accomplish God's will.

God has prepared you for this moment. Trust that God will bring people into your path, champions in life, who will hold you up. Trust that God is with you. Trust when you can no longer see. Trust when you feel as though you will fall. The doctors tell me that my hips will one day return to their twisted position. I will again wear some form of "reverse-last" shoes. I will again find myself stumbling. Yet this time I know, without doubt, someone will be there to catch me should I fall.

With this, I encourage you. Sisters and brothers called to ministry, remember God calls the simple and broken, raises the champion, offers grace to a hurting world, accomplishes ministry in presence, and offers a voice that is perfectly and authentically you. This, I believe, is what God has in mind.

Tamara

LETTER 28: *Sarah Woodford*
Student, Yale Divinity School
New Haven, Connecticut

Gratitude for Grace

Dear Church,

It was a late August night, the sort of evening that stands between the summer heat and the cool of fall—ever connecting past realities to the present, ever ready to push aside that sacred veil that hides the blessings and disappointments of the future. I surveyed the garden where a group of Yale Divinity students gathered for a barbecue to celebrate the arrival of a new school year I wanted to feel like the night. But I could not. Here I was, a first-year seminary student, poised between the undergraduate and the graduate, the liberal arts and the ivy league, the Midwest and the East Coast, the child and the adult. Instead of silently connecting my past and present worlds, I was restlessly darting from one to the other like a frightened rabbit who when seeing the circling hawk is so stricken that she cannot decide which hole to jump into.

As I quietly watched my colleagues interact with one another among the lawn chairs and bamboo, I realized that I had inadvertently made eye contact with someone from across the garden. Joe, a second-year Masters in Religion student, came over and introduced himself. We exchanged pleasantries, our upcoming class schedule, and our impressions of the Divinity School. Then he asked something that no one else had asked me during the course of the evening.

"Well, how are you doing with the transition?"

It was very strange to hear this question outside of my head. I didn't have an answer. It was too soon. I was still that frightened rabbit searching for the right hole. I looked down at my feet as I tried to gather my thoughts.

"Well, it is a bit much: the professors, the university, the expectations I really don't know what I'm doing here ... a bit awestruck, really; awestruck to be in this place."

At this, Joe smiled reassuringly. "There is really no need for you to be awestruck. It is just a place."

He was right. The professors, the university, the expectations, should not cause me to fret. Yet in contemplating his answer, I realized that

something in my reply was deeper than I had first acknowledged. Through Joe's kind cancellation of my paranoia, that deeper voice began to whisper. There in the garden, standing between summer and fall, Midwest and East Coast, child and adult, I felt for the first time a seamless connection to my purpose in New Haven.

I returned his smile, "Yes, you are right. But I'm awestruck for other reasons, too. I'm awestruck, grateful for God's grace in bringing me here."

This conversation helped frame the most important lesson of my call to ministry— past, present, and future. I could not have started on this path or continued had it not been for God's grace. Now I can look back and see the places where I was able to thank God for his goodness. Such places represent treasured moments of a right, intended connection between my Creator and Christ.

Twentieth-century theologian Karl Barth gets it right when he says that "grace and gratitude belong together like heaven and earth. Grace evokes gratitude like the voice an echo. Gratitude follows grace like thunder lightning." I daresay that scripture would agree with him. There is something so poignant about God seeking to make a connection with us through grace.

There is something equally moving when we throw away our own fretting and doubts and simply reach back with joy.

Grace came in the form of bread and juice as I planned and served Friday night communion at Hiram Conference my junior year in high school. My gratitude echoed this gift as I stepped into the center of the Saturday morning circle to pledge my life to serving the living Body of Christ. Grace came again in the form of Jon Moody, a wise listening ear, as I darkly questioned my faith and the earnestness of my call in college. Soon my gratitude quickly followed as I found myself renewed and encouraged by the balm of his kind, honest words. Grace was abundant as I struggled with the business of a thesis, a teaching assistant position, a double major, an internship, and seminary applications my senior year at Hiram College. I could do nothing but be grateful when God finally placed me at Yale Divinity School. Like the child in Elizabeth's womb when meeting the pregnant Mary for the first time, I had to leap for joy because my maker had known me better than I had known myself.

Grace surprised me when I became an exile at YDS. Cut away from my comfortable, Midwestern context and the Disciples of Christ community, I rediscovered what it meant to live within the Body of Christ among Southern Baptists, Pentecostals, Anglicans, the UCCers, and Presbyterians. Amidst all the pain and joy one must live with when dealing with the ecumenical community, I found myself thanking God. Living in a community, especially

a diverse one, is never easy, but the remembrance of God's grace in all human relations makes the difficulties bearable and worthwhile. It is grace through Christ that connects us to each other as well as to our God.

Ah, grace, it has been good. As I continue with my second year, I know that grace will continue to support me as I make difficult decisions. It will sustain me as I find myself sprinting between papers, sermons, and the spiritual and academic business of seminary life.

Grace will carry me into my future as I continue the ordination process and explore my call to the world church.

I know that it will also carry those of you who are considering your call. Grace and gratitude is an exchange that you will always have with God. Sometimes, the exchange is quiet: that smile upon your lips as you open your eyes in the morning. Sometimes, the exchange is loud: that weighty realization of your purpose as you catch a momentary glimpse of how you will fit into God's great plan. But quiet or loud, grace always loves and is always present.

Sarah

Dear Church

Publisher & Editor & Retired

LETTER 29: *Verity T. Jones*
Former Publisher and Editor
DisciplesWorld, Indianapolis, Indiana

Call as a Journey

Dear Church,

I have discovered that receiving a call to ministry from God is a lifelong journey, not a one-time event. The path is not particularly linear nor obvious. Don't let this discourage you! Ministry has many blessings, both subtle and satisfying. Neither should you feel too comforted by the notion that God has hold of your life for the long haul, for life can sometimes be difficult to bear.

I think I knew I was called to ministry as young as seventeen or eighteen, though I did not understand it at the time.

What I knew then was that I was talented and smart, fair and compassionate, that I loved my church and God. I knew that I had a burning desire to make sense of the world so that I could help make it better for those who suffer. It took years of working in social justice ministries and in the inner city for me to realize that my faith fueled this burning desire and that my faith would see me through. I worked with the clerical and technical workers at Yale University in their bid to unionize and was part of the 1980s student divestment movement that petitioned universities to divest of companies with financial holdings in South Africa. After college I worked with the New York City Mission Society offering social services in

Brooklyn, the South Bronx, and Harlem. One particularly astute pastor in Brooklyn told me that God and the church needed me to do this work. My seminary education at Yale Divinity School helped me weave the beauty and power of words and images together with concrete actions on behalf of the lost and downtrodden. It finally made sense, and I was on my way.

Now forty-two years old, I can more honestly acknowledge the embarrassing hubris of my teenage years. I *was* talented and smart and I *did* think I was destined for "great things," to make a *big* difference in the world. I was valedictorian of my high school, off to Yale College, and supported by a gifted family of theologians, lawyers, and teachers. I suppose it says something positive about my experience with you, dear church, that my high regard for self could be directed toward service rather than a more lucrative career or even fame and fortune. I *did* want to give my very best, but I wanted to give it to God and the community. You, the church, helped me see what that could mean.

Thinking back to those days, that self-confidence, while useful at times, also has been my spiritual undoing.

I raise this issue with you now because it seems to me that too often the young ministers who burn out most quickly are the ones who were the brightest and most promising going into it. Despite their commitment to service, to self-sacrifice, to doing the right thing no matter what the consequences, perhaps they, like I did, still think the world, or maybe God, is going to reward them for turning all this talent over to God and the people God loves. Hubris usually thinks it *deserves* something in return, after all. Even if it's not fame and fortune we deserve, it's that special relationship with God that says we're special and will get special treatment. We can rest assured that we've done the right thing by following this call to ministry and therefore, God will make everything all right.

To state the obvious, ordained ministry in the church is hard work. Ministry can be mundane at times and mind-bogglingly frustrating at others.

It is not always all right. I thought the pace of life as a minister would be like the pace of life I had always known—fast, curious, adaptable, and creative. But the pace of ministry is slow. It can be boring. Nothing changes quickly. Creativity is not always recognized or celebrated.

I do not think, however, that the hard work of ministry is the main cause of burnout among young ministers; young ministers have heard these cautions before. We heard them in seminary. We heard them from our mentors, from our home church pastors. We read them in books about the ministry. We knew the work of ministry in the church would be difficult and that we would need strategies to cope. Not just to cope, but to survive and even thrive.

Those strategies are not just bullet points on a mission statement for life. They are the patterns of living as a person of faith. The most important strategy for me has been two-fold: to love God with all my heart, mind, and soul and to love my neighbor as myself.

I'll start with the second first, loving my neighbor. In ministry, I apply this to the people I serve in God's name. I don't just admonish the members of my church to love their neighbors, those other people out there. I love the members of my church. To be perfectly blunt, you cannot survive in ministry if you do not love the people whom God has called you to serve, despite their sometimes strange and irksome ways. I mean a deep, abiding love, not a manufactured love, but the *agape* kind of love. This is essential to ministry.

To love those we serve, we who minister must love God. In our Christian tradition, this means loving Jesus. It doesn't mean that Jesus is an abstract object of our contemplation and study, someone whom we can research fully and then know we are experts. It means loving Jesus as we love the odd, quirky people in your congregation—with all our hearts, mind, and soul.

We have to think, really think, that Jesus is one of the coolest people we know, and that we hope others will get to know him, too.

If we don't think this, no one else in the congregation will either. That would be a terrible shame. Eventually we would all wonder what we are doing together that we couldn't do at the knitting club next door.

These two together—loving God and loving neighbor—can enable our ministry to be the wonderfully rewarding work that we always hoped it would be. We get to be part of people's lives at their most intimate moments and to see God at work therein. Wow. We get to be creative with how we express and share this love. We get to shine with God's light in a darkening world, reaching places that have never before seen light. It's pretty wonderful, indeed.

No, dear church, it's not the hard work that's difficult to bear. We have strategies for fueling the fire that keeps the desire to serve burning within us.

The things that happen beyond your control really take the toll—the bad things, the painful, hurtful, tragic things.

Some of learning to cope with these things is just growing up—maturing, discovering that the world and God will not always bend to our will, even if our will is good and true and faithful. When we get hit with a tragedy in our family, in our church or community, or in the world, a tragedy that is really beyond what we thought was reasonable for God to do or allow, that's when it gets really hard and that's when the hubris not only fails us but actually gets in the way.

One thing I think I'm pretty good at is helping people reflect theologically about the world around them. I have a fairly developed theological perspective that I think holds together pretty well. I think it faithful and true, and it preaches. A bedrock premise of this theological perspective is unmerited grace: God is not in the reward and punishment business. Jesus is fairly clear about this. It didn't seem to work so well in the days before Jesus; the people continued to turn away from God despite the flood and the exile and all that. Perhaps God never was in the reward and punishment business, and it just took Jesus to get through to us about it. I don't know. In any case, the gospels attest to the truth that God *will* have us in the end. Death will not defeat us. Sin will not ultimately alienate us. God will look for that lost coin until it is found and wait for the prodigal until he returns. Neither can we earn God's love and blessing, nor spurn it, finally. God will have us in the end.

You know, apparently I thought I was earning God's reward, because when my life fell apart, I didn't think, "well, that's just the way it goes." I became angry at God for letting it happen because I did not deserve it. Everything had been going so well for so long; apparently I thought that I had been doing something to earn that good life. Ha! That hubris of my youth reared its ugly head, and I didn't like it one bit. I did not like what was happening to me, nor did I like my response to it. I was in trouble.

In my third year of ministry and again in my eighth, I conceived children with my husband. They were both stillborn, lost to me and my husband forever. Despite the wonderful daughter we *do* have today, the loss of the other two still haunts us. I did leave congregational ministry shortly after the second loss. At the time, I didn't think it was because of burnout.

Looking back now six years later, I realize that my anger at God was getting in the way of my ability to minister.

It was spilling over onto others and even onto me. I wish I had understood, truly understood, before this tragedy hit that giftedness, that being wonderful in the eyes of God, that being promising and hopeful in the eyes of the church, brings the temptation to think we are the masters of our own destiny, that God and the world will reward us for being grand and faithful. Even those of us who know it is wrong theologically are tempted to think we are being rewarded. I wish I had understood that being wonderful in the eyes of God is just that. No reward. It's just the way it is, despite what happens.

Today, I understand better how deeply imbedded in our psyches is this notion of reward and punishment. Even more amazing is God's promise in Jesus Christ to love us absolutely, to care for neither our reward nor punishment, to think only of our well-being. My anger at God has faded as

I learn anew about unmerited grace and love and hope. My call to ministry is being renewed. God hasn't let go of me. For this I am deeply grateful.

I began my ministry with *DisciplesWorld* in 2003 and have loved the work ever since. Journalism and publishing are quite different from local church ministry. It used to be that if I told someone I was a pastor, they would be inclined to pour their heart out to me. When I tell them I'm a journalist, they clam up! What I love about working with *DisciplesWorld* is the challenge to be relevant and helpful and interesting to readers for the sake of the whole church. It takes a little grace, love, and hope to do that!

I hope this is a message that you who are in ministry or considering ministry can live and preach during your own ministry. It is not a message that says you should sacrifice your giftedness for ministry, humble yourself to service, and eschew thinking well of your talents.

God thinks highly of you, so why shouldn't you?

The message is that your giftedness does not entitle you to reward. Our God is a different kind of God, loving us in an even more remarkable way. Love this God as God loves us and your neighbor as yourself. That is my prayer for you as you enter and serve in ministry this day.

Verity

LETTER 30: *Narka K. Ryan*
Author, Co-Regional Interim Minister
General Ministry, Christian Church Foundation and Church
Finance Council, Baltimore, Maryland

Continuing the Journey

Dear Church,

"Did you go?" he said as I came up to shake his hand after he spoke at the 1987 General Assembly in Louisville, Kentucky. In 1982, Dr. James O. Forbes, at the time professor at Union Theological Seminary in New York City, had been an exciting weekend retreat leader at Christian Temple in Baltimore, where my husband was pastor. I had asked him to teach my adult church school class that Sunday morning. He said no, he'd rather sit in on that class as I taught. On our way to the airport that afternoon, he said, "Bill tells me you'd like to go to seminary. I want you to go!"

That day at the General Assembly, I told him yes, I'd taken his advice and had gone to Wesley Theological Seminary in Washington, D.C, enrolling at the age of 52. After three years of study, I had graduated and been ordained in May 1986. All these years, I've thought of his words to me as the defining moment along my road to ministry.

Now, in my late 70s, I'm rethinking my road to ministry.

Ministry has really been my life story, not solely that mid-life academic, theological sojourn, for I have loved every minute I have lived.

I grew up in Stone Presbyterian Church in Wheeling, West Virginia. One of my earliest recollections of church involvement is as a nine-year-old participating in a Bible Storytelling Event. My story was David and Goliath. I recall being so proud of David! Later on, high school youth group experiences and summer conferences at Davis-Elkins College were formative in my thinking. One of my fondest memories is being a part of a gang of five or six high school friends gathering around the kitchen table and talking about things like reincarnation, baptism, God's omnipotence, and why Catholics and Protestants couldn't get together.

At Bethany College, I majored in music and minored in history and education. Throughout my life, music has been an integral aspect of my activities and my joy, from directing a church choir to teaching piano for fourteen years before I entered seminary. Even today, music is the primary aspect of worship that moves me.

During the Bethany years, I enthusiastically drank in the teaching of the Old Testament by Osborne Booth, participated in Christian Living Emphasis Week, and was active in Bethany Memorial Church. Ministers James Blair Miller and later Albert O. Kean and his wife Beverly were friends and mentors who encouraged my new relationship with a ministerial student, Bill Ryan, whom I married in 1952. That same year, I became a member of the Christian Church (Disciples of Christ) at Christian Temple, Bill's home church.

Bill was a third-year student at Union Theological Seminary in New York City when we married. I worked that year for the librarian at the seminary, typed manuscripts for one of the professors, absorbed the reading and hearing about lectures by such giants as Paul Tillich and Reinhold Niebuhr.

During Bill's pastorates, I was an active and probably pretty typical minister's wife. I taught church school, wrote curriculum, sang in the choir, taught piano, helped raise four children, and occasionally led a retreat or preached a sermon.

In Columbia, Missouri, I first received an invitation to write curriculum for Christian Board of Publication. I continued the curriculum-writing ministry for more than twenty years. Projects included worship resources, church school curricula, biblical studies, and, with my husband, our Disciples' church membership materials for pastors' classes. Almost always there was a section titled "Thinking Theologically."

I would worry about whether I really was, or was not, "thinking theologically" in an adequate and consistent way.

In Baltimore, I continued to write when an assignment came along and also occasionally preached what I liked to call a sermon. In the congregation, I developed a three-year adult course on the Bible, two years on the Old Testament and one year on the New. In 1974, I was asked to serve on the regional board and in 1976 became the first woman moderator of the Christian Church-Capital Area. Along with that responsibility came opportunities to learn more about the church through participating in groups such as Regional Ministers and Moderators, serving as a lay representative on the Commission on Theology, being a member of the board of the pension fund for ten years, attending Quadrennial Assemblies, and serving on the general board and administrative committee. I also worked in the area of development with William L. Miller and Gertrude Dimke for the National City Christian Church Foundation from 1979 to 1981.

Always, in the back of my mind, was the desire to study theology, but as I protested to Dr. Forbes that day, I figured I was too old to start. After his encouragement, the next step was the Graduate Record Exam, thirty years after Bethany graduation. With acceptance from Wesley Theological

Seminary in Washington, D.C., I embarked on the Camelot experience of studying theology and being stirred by the teachings about process theology by Marjorie H. Suchocki and Roman Catholic priest Robert L. Kinast. Kinast preached at my ordination at Christian Temple in 1986.

One of my significant learnings in seminary was a simple proverb that says, "90 percent of what we see is already behind our eyes." That proverb became especially meaningful to me during a field education internship in which I studied the nature of the conflicts we face within the church. It's still applicable in my life today.

After ordination, my plans basically revolved around doing interim ministries in the Capital Area. Bill was nearing retirement, and I wasn't going to ask him to move away from Baltimore at that point. I drove to D.C. early one evening the week after my ordination for an interview with a congregation's search committee about an interim position. A woman on the committee came in, sat down, and promptly said, "Some people don't like it that you're a woman. Some don't like your age. I don't like it that you live in Baltimore and to phone you would be long distance." At that point, I had the distinct impression that this was not going to be a positive experience. I do recall saying, "Would you mind telling me why you bothered asking me to drive over here this evening?"

Several days later, the chair of the committee called me back and said, "We think we were a little hasty the other night, and we'd like you to come back for dinner and meet with us again." I confess to no little joy in being able to say to him, "I'm sorry. I've taken another position and I'm not available." The day after that notorious "interview," Bill Miller had called me and asked me to take a development position with the American Church in Paris for at least the next six months. It turned out to be a three-year assignment with two trips to Paris and extensive travel around the United States, meeting with delightful people who were former members of the American Church in Paris. I helped raise $600,000 for a new sanctuary Beckerath tracker pipe organ that was dedicated in 1988.

At that point, James R. Reed, then president of the Christian Church Foundation, and James P. Johnson, then president of Church Finance Council, invited me to work in a joint position in development for those two units of the Christian Church (Disciples of Christ). Eventually, I worked full-time as director of stewardship for Church Finance Council.

None of that would have been possible had I not experienced the disastrous "interview" to be an interim minister.

This journey to ministry has included an education for me in the evolution of church and societal issues, including that of inclusive language. In the early 1970s at a Quadrennial Assembly, I was among many of the 5,000 attendees who welcomed the reading of the Assembly study book by James Armstrong, *The Journey That Men Make*. When I attended seminary

in the 1980s, we were not permitted to submit an academic paper that did not use inclusive language. Times indeed change.

I retired in December 1995. It had been a short ten-year professional career but an exciting one. We became members of National City Christian Church in 1996. That spring, Bill and I were asked to be interim regional ministers in Virginia when R. Woods Kent retired. We were located in Lynchburg, Virginia, for thirteen months. In that experience, we learned much more about the way regions and regional staff function.

While we were in Lynchburg, we prepared a document titled "Model for Parish Ministry Retirement." The occasion that necessitated that work was a phone call to the regional office from a pastor who said, "I'm retiring and I'm staying in the community and in the church. I know it's a 'no-no' but I'm doing it." We told him we'd work with him to help make it work out happily for him and the congregation.

The model resulted from our work. Because of today's greater incidents of longer pastorates, home ownership, spouses' employment, grown children living in the community, and many other issues, foremost of which is the great goal of collegiality among clergy, the concern about parish retirement remains a wider church issue that we hope may one day be addressed faithfully and fully by the whole church.

One of the greatest experiences of my life was a sixteen-day journey to China with Bill in the winter of 2007 to attend the dedication of the Drum Tower Hospital Museum in Nanjing, where Bill's aunt Grace Bauer was honored, along with several other dedicated missionaries who chose to stay during the "Rape of Nanking" in 1937–1938 to serve the people of China. Aunt Grace had been director of the Hospital Laboratory from 1919 to 1941. The new Museum honors the founding of the hospital by Christian missionaries in 1892 as well. The trip comprised visits to five cities–Shanghai, Nanjing, Chengdu, Xian. and Beijing–a life-changing experience for both of us.

Throughout the years, our four children, Kathy, Bill, Tom, and Margie and now their spouses and our eight grandchildren, have brought us singular satisfaction and joy. They continue to undergird our lives with happiness as we see them grow and thrive.

Recently I reread a book I had loved as a child: *Hans Brinker or the Silver Skates.*

One sentence stood out to me, inclining me to deem it the best thought I could share with a woman considering ministry today. It reads: "There is an Angel called Charity who often would save our hearts a great deal of trouble if we would but let her in." And so the journey continues, and I'm thankful.

Narka

LETTER 31: *Virginia M. Taylor*
Missionary, Teacher, Associate
National City Christian Church, Washington, D.C.

Missionary Ignorance

Dear Church,

Thank you for nurturing, guiding, encouraging, and always loving me as I have grown in faith and continue to serve. As long as I can remember, I have loved the church. Our family moved from rural Missouri to Denver when I became a teenager. We found a church home at Edgewater Christian Church. I was baptized there and began what I believe was the call of Christ to follow him.

The church was family-oriented with a large, active youth group. The pastor, Rev. Verlin Stump, and the adult leaders were dedicated to their task as teachers, counselors, friends, and role models. As a group we sang in the youth choir, studied together in Sunday school, and in evening meetings led by one of the youth. I took my turn. We played together at picnics in the mountains and in the backyards of members' families. In this church, I started to teach. Perhaps I should say I helped an experienced teacher with the pre-kindergarten and kindergarten class on Sunday mornings. I attended Youth Conference in a beautiful park area just south of Estes Park, Colorado.

In conference, we joined with youth from across the city of Denver to study, pray, worship, and play. Our counselors were local pastors and other adults along with one or two missionaries who told us about their work and the church overseas. I was fascinated by their stories, which lingered with me for weeks and months after we returned home. Around a campfire at the end of one of these conferences, I decided what I wanted to do with my life. I would be a missionary! I made a public declaration that evening.

A few weeks later, our pastor gave a call for anyone interested in full-time Christian service to come forward. I was compelled to go, not by any person but by the knowledge that this was what I must do. The church family and my parents were happy and encouraged me. Yes, they were surprised even though I had told them this was what I wanted to do. Having learned about Phillips University from recruiters who came to the church and youth conferences and from graduates, I decided to attend Phillips.

Phillips seemed like a wonderful extension of summer conference.

Through the "student volunteer movement" I met Richard (Dick), my future husband, who also wanted to be a missionary. We were married the next summer and pursued our studies together toward a common goal. I was ordained on May 2, 1954, in the Edgewater Christian Church in Denver.

After graduating from Phillips, we attended the Hartford Seminary Foundation for special classes in missions, religious education, and Indian culture. The following summer, we were commissioned as missionaries to India. The next year, we studied Hindustani and Southeast Asian anthropology at the University of Pennsylvania. After two years of waiting, we had not received visas for India. With our consent, we were reassigned to the Belgian Congo.

We changed our language focus to French, the official language of Belgium and therefore of Congo. After six weeks of intensive study, we moved to Belgium to attend the Colonial School. One calendar year later, we were finally ready to move to the Belgium Congo. By this time, we had three children, ages seven, two and a half, and one. Linda, our oldest, was speaking fluent French and correcting us.

My ministry in Congo was teaching, listening, learning, and serving.

Our first assignment was to teach in the preacher's school. All the classes were taught in French. For several weeks, I wrote out everything I wanted to say and, of course, had to read it to them. They were always patient and happy and eventually loved to tease me. I learned to joke and tease them as well. These were all male students, older than I, at the ripe old age of twenty-seven!

The Congolese Christians and friends taught me much about life, including patience, friendship, and the importance of listening. They taught me about values–loving my neighbors and being loved in return–and about the expectations of being a minister.

The first New Year's Day, some students from one of the upriver villages invited the family to share in their traditional holiday feast. When they came to invite us, they asked if I would like to cook some of the meat. Thinking that they thought we would not want to eat what they cooked over the open fire behind their houses, I answered "no" but offered to bring a cake for dessert. They graciously thanked me and left. On the afternoon of the feast, we arrived to find a festive area of tables and chairs and lots of happy chatter. Benjamin introduced us to the group and in the introduction said, "We know it is because of Mama's ignorance that she didn't help us cook the dinner." Yes, it was ignorance! Only two or three of the young men were married, so it was difficult for them to cook all the food: goat, banganju (greens with corn), manioc, tea, and my cake.

While we lived in Lotumbe to study the language, Lonkundo, we spent a lot of time with the people in the village, the elementary schools, and

the church. Life in the Congo was simple, full of love and laughter, and sometimes complicated and difficult. How do you mourn with a young father whose infant has just died because he didn't get to the doctor in time or with the stranger who came to leave his only jacket with us so he could borrow money to bury his child? How do you teach women who ask, how not to have more children, when they live in a country where contraceptives are illegal? How do you affirm two families of one father?

The church was and is at the center of life!

It was a real culture shock when our family returned to the United States and settled in Arlington, Virginia. We went from one grocery store that seldom had more than sardines on the shelves to a variety of supermarkets bulging with everything imaginable, from a small bakery that had one kind of bread to whole walls of bread of many varieties, from fresh, sweet bananas hanging from a stalk on the back porch to a handful of bananas that tasted like cardboard .

We soon joined the church family at National City Christian Church in Washington, D.C. I began teaching in the public schools the following year to help with the Taylor budget. We became involved in the church. I taught adult and youth classes and served as a member and later as chair of the Christian Education Committee.

This was a bold step toward my dream of a professional role in ministry.

I was asked to teach in the six-week Summer Enrichment Program for inner-city children who lived near the church. That began a ministry that lasted for many years. I led workshops in the region, sharing teaching ideas and methods for youth and adults, participated in EduCare events in the area, preached for the Women's Day services, and presented special programs on the Congo. I began leading family camp and teaching in Young Adult camps.

In September, 1989, when the associate minister resigned to become senior pastor at another church, our pastor, Dr. William C. Howland Jr., asked me to join the National City staff in a part-time position as an assistant for Christian education. When he retired, I continued the role as assistant or associate, working with interim ministers and later the new senior minister.

I am now retired and an active member of the Gayton Road Christian Church in Richmond, Virginia, where I hope I will always be supportive, affirming, and helpful to our pastor, Rev. Deborah Carlton.

Thank you, church for calling us to ministry. I cherish my collection of notes from you telling how I had helped so many. One gentleman asked me one Sunday if I wrote my pastoral prayers. When I said I did, he asked for a copy of them. After a few weeks, I asked him what he did with the

prayers. He told me he took them to work and reread them. They gave him help for the day.

Thank you for the nudge you have given when I needed encouragement. Thank you for the inspiration we continue to receive as we worship, pray, and share our stories and our abundant resources and as we eat and drink together around the welcome table.

Virginia

Dear Church
Mothers/Daughters

LETTER 32: *Cynthia W. Twedell*
Associate Minister, University Christian Church
Fort Worth Texas

Called in a Faithful Community

Dear Church,

For a lifetime, I have served in ministry at University Christian Church in Fort Worth, Texas–the lifetime of our daughter, Jackie. Twenty-two years ago, just before her first birthday, I began work as an associate minister at UCC. I held her in my arms as my photograph was taken for the church newspaper that would announce the new minister on staff. Now, as she responds to God's call to ministry and begins her seminary training, her dad and I couldn't be more proud of her.

Within the rich soil of this caring community of faith, her gifts for ministry have grown and flourished.

I remember our first years at the church, when the youth group cared for her like older siblings, eagerly offering to be her babysitters. Through their energy and example, those youth taught her about a vital and very present God. The faithful witness of countless people has inspired and influenced her. Their love and prayers support her as she confidently responds to God's call. I am deeply grateful for the blessings of our churchwide extended family accompanying us along the way over these years.

I grew up in the church, too. I'm grateful for the faithful community that taught me the importance of regular worship, singing God's praises,

and sharing the blessings of God's extravagant and amazing love. Although Central Christian Church in Vernon, Texas, had not seen a woman minister, I witnessed the work of my mother and grandmother and other women behind the scenes, engaged in the ministries of teaching, hospitality, music, and caring for those who were sick or in need of a casserole. My mother played the organ and served as youth sponsor to insure that our small church had a youth group for me to participate in. My grandmother helped lead the choir. Every Sunday, we joined her in raising our voices in praise to God. I think we were the first to arrive and the last to leave each Sunday. I loved being there.

Surrounded by my family and a church that loved me, I stepped out in faith.

Although women didn't pray at the communion table, they lovingly washed and filled each of the communion cups. Women didn't stand in the pulpit, but they taught our classes, organized and served the church suppers, sent out the church newsletter, and embodied God's love as they rocked and reassured the children in the nursery. I observed their valued ministries and felt my gifts nurtured and affirmed. I saw myself in the women of that little church as they generously and faithfully lived out their faith.

Encouraged, I was ready to hear God's call within the community gathered at Lake Brownwood Christian Retreat. From junior camp to Christian Youth Fellowship Conference, I didn't miss a summer of church camp. Some summers included two or three weeks participating in leadership seminar as well as conference. As an image for prayer, I still remember the rustic beauty of the camp vespers area. With generations of youth and adults whose lives were changed there, I can sit on the rocks under the trees and focus again on the wooden cross, listening for the steady rhythm of God's blue waters washing against the lake's shore.

So prayerfully and enthusiastically, I headed off to Texas Christian University to begin studying for the ministry. During summers at college, I served as an intern in Texas churches committed to training young ministers. What gifts of grace and encouragement they offered! At First Christian Church in Pecos, I led my first youth trip on river rafts down the Rio Grande. There I observed the tender care of a pastor for his people. At Memorial Drive Christian Church in Houston, I enjoyed the warm hospitality of loving host families whose Christian witness and love shape me still. I served with a wonderful woman minister and mentor, Linda Hanna Walling, at First Christian Church in Richardson. While at Brite Divinity School, I served along with a group of talented ministers at First Christian Church in McKinney.

The church gathered around me through both the sorrow of loss and the celebration of marriage.

Having received such support in the church, it never occurred to me that anyone would question my call to ministry. But question they did. A man in a church I served as a summer student intern strongly suggested I pursue teaching, as it was a more appropriate career choice for a woman. The "joke" told to me after the first time I preached at UCC: "Women preachers are like dogs walking on their hind legs. Unnatural!" Unfortunately, the few negative comments are most vividly retained in my memory. So many more words of support and encouragement have filled these years. Hugs and handshakes after preaching outnumber by far the criticism. Many have expressed gratitude for a welcome presence in the pulpit or a perspective and voice that needed to be heard.

Because of this human tendency to more readily remember the negative remarks we receive, I pass on to my daughter, Jackie, and others who begin their ministries, a bit of advice that was given to me. Start a file and fill it with all the appreciative letters, thank you notes, emails, art work from children, and positive expressions that come your way. Keep it close by and pull it out as needed.

The church is filled with people who appreciate their ministers. Listen carefully to them.

I wish I could tell Jackie that the church won't disappoint or hurt her. I would like to protect her and others preparing for the ministry from the unkind words that will be spoken to or about them. I can't. You will endure rough times. I have navigated the often-rocky road through leadership changes, church politics, and my own self-doubt, strengthened by that important journey. A good sense of humor helps, too.

I also have known the joy that comes from long ministry tenure and a church that gives me room to change and grow. I value the rare and rewarding privilege of sharing in extended, deep relationships, being invited into the meaningful moments in their lives.

Every week, in joy and sorrow, in controversy and convergence, we gather around the table to celebrate and share the living presence of Christ.

Last summer, I finally had the chance to fulfill a longtime goal of standing among the grand sequoias in California. These quiet cathedrals of God's creation are amazing lessons in ministry. I pray that all of us who daily renew and recommit to God's call will remember the redwoods.

Stay rooted, dear church, in the love of God. Like the majestic redwoods, sway to the gentle spirit of God's movement in your life. Value and care for yourself. Breathe deeply the Spirit of your Creator and gratefully rely on God's constant companionship.

Call on the connection of the community. Redwood trees grow in groves reaching such enormous heights because of the support of their

interconnected roots. The roots of one redwood tree are the roots of all of them. Rely on the strength and interconnectedness of God's creation, recognizing the faces of God in those you serve. Be intentional about staying connected to communities of love and support. Stand tall in the love that knows you and calls you by name.

Created, called, and encouraged by God, you are set apart and empowered to serve. You are not alone.

Dear church, many talented, creative, compassionate young men and women are responding to God's call to ministry. What blessings they bring. How fortunate are the churches they will serve. As I hold Jackie still, in my heart and in my prayers, I am grateful to God for her and for all who respond to God's call. Embraced by the unconditional abundant love of God, let us affirm this caring community we call "church" and move courageously into the future.

Cynthia

LETTER 33: *Jackie Twedell*
Seminary student, Vanderbilt Divinity School
Nashville, Tennessee

The Supportive Church

To my loving and supportive church,

As I finish my first semester at Vanderbilt University Divinity School, I want to thank you for all the support you have given me throughout my life. As the daughter of a minister, church became an important aspect of my life. When I was a child, my mom took me with her every Sunday because she wanted me to grow in a church community. I am thankful that she did. When I was old enough to choose whether or not to go to church, I could think of no other place I would rather be than at the church with my mom and my extended family. It felt as if everyone knew who I was and I at least recognized them.

I typically heard many things growing up, the most common being, "oh, you have gotten so tall! I remember when you were this tall." They would always lower their hand to about hip level to indicate my height as a child. Even now, at age twenty-two, six feet tall since I was fourteen, I still get the "You've gotten so much taller since I last saw you!" I just smile and try to convince them that in fact I have not grown taller. These encounters, which happen every time I go to my home church, make me remember how much this family really cares about me.

I appreciate their care, support, and even their comments about how much I've grown.

Since I heard God's call and decided to go to seminary, I have received even more support from the church. Countless words of encouragement from church members and ministers, internship offers to allow me to gain experience, and constant care and love from every member of my extended church family have been great gifts given to me throughout the years. I am extremely thankful for every single gift I have received. They have encouraged me and my ministry and have even reinforced my call.

I have also been incredibly blessed to have so many talented and strong women ministers active in my life.

My mother is a minister, so from as early as I can remember I have known that a woman can be a minister and that nothing limits what I could

be. I also was surrounded by many other clergywomen, friends of my mom's or other ministers at my church. I was encouraged just by seeing all of these women thriving in their ministries. I know my experience of continued support is somewhat different from that of my mother's generation.

I heard stories from mom of a supervisor who told her that she would be happier as a teacher. Others thought that because she was a woman she had no right to be a minister. But she persevered and is one of the best ministers I know, even though I am a tiny bit biased! I am sure that many other clergywomen have helped prepare the way. I'm so grateful that they did. I look up to them; it is from them that I am encouraged.

So I thank you, everyone who has encouraged me throughout my life and those I've yet to meet. Your guidance and support have helped me to develop into the woman I am today and into the minister I will be.

With love and gratitude and hope,

Jackie

LETTER 34: *Deborah M. Wray*
Vice-President, Christian Church Foundation

Follow Your Heart

Dear Church,

At the age of thirty-eight, I discovered two important things: A woman can still answer God's call to ministry, and a woman can work for the church full-time without being ordained.

As a teenager, I had conversations at church with another teen who knew he would attend Eureka College and pursue ministry. We talked for hours at lock-ins and youth group events. He followed his heart, but I didn't. Life took me another direction. All those years later when my family situation had calmed down and a new direction seemed possible, I intentionally sought God's advice. When I heard God telling me to serve the church full-time, I had to turn to my mentor and pastor, Dr. C. William Nichols, to understand this preposterous message. I was a single mother of two young children and saw no way to go to seminary. Within two months, I had learned my two important things. I began to interview and a few months later, I moved to Indianapolis and began my ministry with the Christian Church Foundation.

The focus of the work at the Christian Church Foundation is ministry. As the president and board send out staff to meet with congregations and donors, they want staff to be either licensed or ordained. After about two years with the Foundation, I was able to acknowledge that I was truly doing ministry: preaching, meeting with boards, elders, and trustees of congregations, and helping individuals to live out their faith through their giving.

When I first met with the Nurture and Certification team of the Christian Church in Indiana, I admitted I was answering this call to ministry kicking and screaming, but joyously.

My grandfather, Basil R. Truscott and great-grandfather Thomas Alfred Truscott, had both been missionaries serving in Argentina and Uruguay through the Methodist church. This family heritage no doubt set in my mind the concept of service to the church. The commitment that my parents had to regular church attendance extended to being sure that my three brothers and I went to church even when on vacation. My parents, however, weren't encouraging about a life in the ministry. Society in the

1970s wasn't as supportive of women clergy as it is today. Nevertheless, I knew as a young child and through tough times growing up that God loved me and was faithful to me always.

Somehow my trust in God never wavered.

In the seven years leading up to my discovery of my two important things, my faith continued to be nurtured by C. William and Claudine Nichols at Central Christian Church, Decatur, Illinois. Little did I know when I was dragged, pushed, cajoled, and invited into leadership positions at Central Christian Church that God was preparing me for more. When Dr. Nichols asked me to serve as elder, I was frightened and humbled. Talk about clay feet! I was not and am not a perfect person, nor particularly prepared to be a faith leader for others. But I accepted Dr. Nichols' prayers for me and for my leadership in the church. I trusted that God would help me and show me the way.

The first Sunday I served as elder, I moved to my position behind the communion table and sat next to Dr. Nichols. He smiled at my obviously anxious face to ease my worries. Then I gazed at the backside of the hand-carved communion table. On the shelf, hidden from the view of the congregants, were used wadded tissues, an empty McDonald's soda cup, a broken candle, and used matches. From an image of glory and service in God's holy name to the trash of past worship services, my mind and heart learned an important lesson about ministry.

When you read this letter, I will no longer be with the Foundation. After sixteen years, I am leaving to find a new and different ministry. I have loved the journey, and the adventure will continue. These years have blessed me with a wider view of the work of the church, an understanding of the history of the Christian Church (Disciples of Christ), an appreciation for the gift this church is to the world, and many stories of the saints who have gone before. Once those stories become real and the thread begins to draw you back to a previous generation, then another generation before that, you begin to personalize the stories of the Bible. The saints I have met during these sixteen years have been ordinary people, committed people, delightful and cheerful people, and ones we want to emulate.

From each I have learned a tidbit about how your small decisions along the way can bring boldness and courage to the direction of your life.

When I met the man who would later become my husband, Johnny Wray, I would not have imagined where we would be today. He has served for sixteen years as director of Week of Compassion, the Christian Church (Disciples of Christ) disaster relief, refugee resettlement, and self-help development fund. In the years since marrying in 2002, we have spent an average of one week a month together. His travels and mine for

our separate ministries have enriched both our lives but have limited our time together,

Now boldly I go, not knowing at this time what God has in mind for me. Surely the way will include difficulties, but I trust it will no longer include as many nights on the road away from husband, family, and friends. It is now time to honor and cherish a place that is consistent, time to listen to frogs or cattle or the rustle of small critters in the underbrush, and time to enjoy the peace that comes from knowing today will include blessings from ordinary places. I have learned that God will keep us very busy and that hard work is good and honorable. I don't believe for a minute that I will be working less.

My daughter, Tabitha Knerr, has been studying and preparing for three years for ministry. The women that I see making the decision to answer God's call will still be struggling for their place in pulpits everywhere. Their boldness and courage is inspiring. We need their leadership. Let all of us, ordained and licensed clergy as well as laywomen, continue to lift them up in prayer and speak openly to them about our own yearnings and passions and listen to theirs.

Remind women that their ministry can begin at any age and in any setting.

God places us where we need to be, if we can only imagine what might be possible. Help another woman imagine. Be the face of Christ. Stretch out a helping hand, or shove someone gently to discover her call. God will delight in each woman's response.

Deborah

LETTER 35: *Tabitha Knerr*
Seminary student, University of Chicago
Chicago, Illinois

The Call Came Early

Dear Church,

Before I was born you knew me. Well, maybe not quite that early, but it didn't take long. You called me so early that by the time I was twenty, I couldn't remember when it all happened. I knew that the call had happened. I remembered it not as a private memory but as a story that had been told about me so many times that I couldn't remember who had first told it. It was a story so familiar that it didn't need to be told again and therefore was forgotten.

I was in college when I began to wonder if it had all been make-believe.

The characters were all real. Camp counselors and youth pastors, and laypeople had encouraged me to think deeply and ask the difficult questions, even if the answers were nowhere to be found. They had laughed with me, prayed with me, and encouraged me to take on new responsibilities. My peers looked to me for answers, teased me for caring so much. They simply assumed I would become a pastor. My mother, a gentle hard-working, independent woman taught me to be firm but humble in my faith, in my passion for justice, and in my own ability to think it through, work it out, and make it happen. They were all quite real. I could, in fact, remember several instances in which these teachers and role models had not only suggested that perhaps I was called but had declared it as a matter of fact.

The events were all real. I had attended Central Christian Church in Indianapolis and had asked to make a confession of faith there. I had attended church camp after church camp, talking more than my fair share in small groups, offering to lead evening worship, and developing friendships that far outlasted school friendships. I had joined the Indiana Youth Commission and then the General Youth Commission, where I planned events, wrote curriculum, facilitated discussions, and led workshops. I could remember longing for these events as they approached and crying when they were over because I felt more alive there than in my everyday life.

The tears, too, were real.

I cried through many worship services and prayers. I could remember events that had especially moved me. I could remember that after this event or that event, I was confident that I was called. I remember feeling that I was called. But I could not remember the call itself. Had it really happened? Or had I simply wanted it to be true? Had I heard so many people say it that I had begun to believe it rather than risk disappointing them?

Why, why, couldn't I remember my call?

The uncertainty that I felt, the overwhelming fear that perhaps it was all merely make-believe, pushed me away from you. I didn't want to see you because I didn't want to feel like a fraud. Despite the fact that you were the very people who had told me the fairy tale of a story, I nonetheless feared you would see through me. Perhaps worse, I feared that you still believed in me and that you would be disappointed if I admitted that I no longer knew who I was.

Late in my sophomore year of college, I attended an ecumenical praise and worship service on campus. My expectations were low; but a friend had invited me, and I couldn't think of a good reason to say no. The chapel was dark. I quietly joined the shadowy, anonymous crowd who had already begun singing and swaying. Twenty minutes later, without warning or reason, I was overwhelmed with emotion. I wept openly.

I had no idea what had happened, but as I exited the chapel, I knew, I simply knew, that I was called.

I am called. Time and time again God affirms this fact for me. God never delivers this information to me as breaking news but always as time tested, universally known fact. "As we all know you are called," God says to me, "when can we get down to work?" To this day, I sometimes have the urge to shout back to Got, "When?!? When, Lord, did you call me?!?" After years of trying to change the subject, I am at last beginning to understand the real question at hand. When will I let God use me?

When will I get over my obsession with my own life's story and start telling the story of Christ?

Much of the problem was, and still is, my own vanity. I dare say you bear some of the responsibility for my foolishness as well. So much emphasis in the church is placed on telling the story of your call. As soon as I began the nurture and certification process, the first thing the Ministry Committee asked for was my call story. I imagine the same is true at nearly every seminary.

Some of us do not have a call story, we simply are called.

We must rely on God's affirmations of our call rather than look for a single moment in time when the entire call was made clear. The fact of my

called-ness is continuously being revealed to me, confirmed in me. As I learn to live my life with my called-ness as a bit of background knowledge rather than the central event, I am freed to do that to which I am called. I am not called to receive a call. I am called to take action, to get moving, to roll up my sleeves and get busy.

How, you might ask, did I get from that chapel at Washington University to the University of Chicago Divinity School? The answer is simple. I went to Webster Groves Christian Church. As per usual, you found me there. You recognized my gifts, and you asked me to do something with them. In the doing, I began to remember who I was.

Now, as I begin my final year of school and the last steps toward ordination, I once again find myself wondering about my call. Today, however, I do not wonder *if* I am called or *when* I was called. These facts are old news.

Instead, I wonder to what action will God call me next?

Tabitha

EPILOGUE

Ten Commandments for Clergywomen

1. **Believe in yourself.**
 You are unique. There is only one you! Go out on a limb every once in a while and treat yourself.

2. **Be your own person.**
 Recognize and celebrate your gifts and strengths while recognizing your limitations.

3. **Serve with gentleness and boldness of heart.**
 When tempted to "roar like a lion," remind yourself that you must first learn to "purr like a kitten."

4. **Set priorities.**
 Be mindful of how you spend your time. It's your life! Learn to choose in order to go about doing good rather than just going about.

5. **Trust the big picture.**
 You do not have to know everything. No one has all the answers. Learn to network.

6. **Keep a sense of humor, and learn to laugh at yourself.**
 It is a gift of grace. Humor gives you a new perspective and keeps God and you in control of a situation. It costs less than therapy.

7. **Bloom where you are planted!**
 The great temptation is to follow your own desires, to make your own plans, to be guided by your own will. Sometimes you just have to learn to wait!

8. **Light your own candle. Pick your own battles.**
 You do not have to blow out someone else's candle to light your own.

9. **Trust God's guidance.**
 When possible maintain an attitude of prayer. God will sustain you. Wait and you will receive God's gift of assurance and direction.

10. **Keep your heart moist.**
 Love the people; learn to listen to others and to God as God speaks to you.

(These commandments were written many years ago to serve as my guide. They have been affirmed over and over again through the letters written by others.)
Dorothy D. France